Saint Anselm

Saint Anselm Basic Writings

Proslogium Monologium Gaunilon's In Behalf of the Fool

translated by S. N. Deane with an introduction by Charles Hartshorne Second Edition

> Open Court La Salle, Illinois 61301

Library of Congress Catalog Card Number: 74-3309

St. Anselm: Basic Writings

• 1962 by The Open Court Publishing Company Printed in the United States of America

> Second Edition Fifth Printing, 1974

All rights in this book are reserved

No part of this book may be used or reproduced in any manner whatsoever without written permission except in the case of brief quotations embodied in articles and reviews. For information address The Open Court Publishing Co., Box 599, La Salle, Illinois 61301.

ISBN: 0-87548-109-4

INTRODUCTION TO THE SECOND EDITION

INTRODUCTION TO SECOND EDITION

Anselm, "one of the profoundest and most exalted of spirits" (Koyré), is a philosopher whom it has long been fashionable to discuss, but quite unfashionable to study. There is no more famous philosophical argument than his so-called "ontological" proof for God's existence. It was stated in a few pages, and elaboratedin response to criticism-in a few more. Yet even these few pages have been far too many for the Argument's detractors to read. In Anselm's own life-time, a tradition-we may well call it "the Gaunilo tradition," since he is its founder-began to take shape that one scarcely reads Anselm: rather one refutes him essentially unread, so decisively that reading him would be needless toil. Only upon the assumption that the great majority of commentators upon the Argument which Anselm invented have viewed the original exposition almost entirely at secondhand can it be explained that what Anselm evidently thought were his most important points are left without even a mention, not only in the most widely-cited refutations, but also in some of the better known defenses.1

Of course, certain specialists have achieved intimate knowledge of Anselm's thought (e.g., K. Barth, Koyré, Hasse, Rigg), but their explications, and their protests against the common misunderstandings, have gone largely unheeded. The main mass of reference works, including the *Encyclopaedia Britannica*, the *Catholic*

1. Anselm's Discovery: A Re-Examination of the Ontological Proof of God's Existence (La Salle, Illinois: Open Court, 1964).

INTRODUCTION TO SECOND EDITION

Encyclopaedia, and most dictionaries, histories, textbooks, dealing particularly with philosophy, and written in various languages, give scant information concerning the central Anselmian idea. Even to say this is flattery. For they present their wretched little caricatures as serious accounts of the subject. (Let the reader say what he pleases about this charge—after he has genuinely investigated the matter for himself.) If Anselm is to be refuted, it should be for what he said, taken in something like the context which he provided, and not for something someone else said he said, or a fragment of what he said, torn wholly out of context.

No one should attempt to criticize or defend Anselm's proposal who fails to read, and read carefully, at least Chapters III-IV of the *Proslogium*, and Chapters I, V, and IX of the *Apologium* (reply to Gaunilo). Compared to these, the famous-notorious Chapter II of the *Proslogium* (or at least, its endlessly-quoted last two paragraphs) is, as Barth says in his book on Anselm's argument, altogether secondary. These paragraphs represent but a preliminary try, and an unsuccessful one-elliptical and misleading at best-to state the essential point, which is first explicitly formulated in *Proslogium* III, and reiterated many times in the *Apologetic* I, V, and IX.

Among the many errors which have accumulated about Anselm is the notion that the evaluation of his Argument is a simple task. He himself shared to some extent in this error. It is the very nature of metaphysical questions that they all interlock in such fashion that any one of them is *the* metaphysical question from a certain angle. A defender of the Proof, if he is to understand himself, must have a metaphysics, and so must its attackers. Or at least, they must have a theory about metaphysics, and their refutation of the Proof will be insecure if the theory is so. And vice versa!

The Proof claims to show that one and only one property, divinity, is related by necessity to the existence of a unique individual having the property, so that to conceive the property is to conceive the necessary existence of that individual. In this case "existence" is not a mere question of fact but of logical necessity. Thus "God" is held to be an exception to the ordinary rule that affirmations of existence are contingent. To insist upon the universal validity of the rule is merely to say dogmatically that what the argument claims to show cannot be correct. Moreover that the idea of God must be an exception to certain otherwise valid generalizations is obvious from any usual definition of this idea and has been asserted by many hundreds of philosophers and theologians for nearly two thousand years. From Philo, Plotinus, Dionysius, Erigena, and Anselm to Tillich it has been commonplace that God is not to be supposed simply another being. Indeed, the very term "being" has been declared inadequate, along with all other usual conceptions, including existence, attribute, individual, part-whole, and other basic categories. If then we reject the Proof simply because it treats the object of worship as an exception to ordinary principles, we shall be declaring not only that the ontological argument for theism is invalid but that theism itself is logically impossible!

My own beliefs are: the Proof, properly stated, violates no rule which theism would not have to violate

INTRODUCTION TO SECOND EDITION

4

with or without the Proof; in addition, the rule violated when the Proof is well stated rests on prejudice or illicit extrapolation, not on logical necessity. However, when poorly stated, as it generally has been, the Proof violates a rule which theism as such need not abrogate, and for which also there is clear logical necessity. Finally, the correct or valid statement of the Proof includes a somewhat nontraditional definition of its conclusion, of theism itself, and since this definition contradicts the more usual definition, it follows that the latter, the conventional (neoplatonic) form of theism (which Anselm himself sought to establish), is actually disproved by the Argument.² This is indeed the greatness of Anselm's discovery, greater than he knew: it has the power to reveal contradictions which otherwise might not be noticed, not only in atheism, but also in erroneous conceptions of the object of worship. Thus the proof throws light not simply upon the existence, but also upon the nature, of God. Anselm was in some degree aware of this (see Proslogium VI and following chapters). But prejudices derived chiefly from Greek and Roman sources blinded him to some of its implications.

That deity must be an exception to many otherwise correct rules seems plain from the unique status: "by whom all things, visible and invisible, are made." For surely He is not, in the same sense, "made," whether by Himself or by anything else. Anselm's proposal can therefore be put thus: the contrasts, creature-creator and contingently-necessarily existent, should be seen

2. See, besides the work already mentioned: The Logic of Perfection and Other Essays in Neoclassical Metaphysics (LaSalle, Illinois: Open Court, 1962) Ch. 2.

INTRODUCTION TO SECOND EDITION

as one and the same contrast, somwhat differently expressed. All things except God are contingent-of course, says the theist, since they exist only thanks to the fact that it pleased God (and it might not have) to make their existence possible! But surely God does not exist because it pleased Him (and might not have) to make His own existence possible! In this and many other ways it may be shown that God cannot be contingent in a sense parallel to the contingency of ordinary existents.

To talk about "perfect islands" as analogous to deity is mere trifling, unless insular "perfection" (which, nota bene, is not Anselm's word) is taken to include the status, "creator of all things else." But then "insular" loses its meaning! When one reads some cheap and easy refutations of the Proof one gets the impression of the following strange course of thought: if God can exist necessarily, surely many other things can too; or, what God can do, others can do also; or, surely His unique excellence cannot go so far that His very mode of existing, His very relation to the category of existence, is unique also. Ah, but can it not? This may turn out to be the same as the question whether or not theism (and not simply an argument for theism) is logically possible. And if the logical possibility of theism is what the critic impugns, by all means let him say sol Debate is mere confusion unless we know what a man is contending for or against.

There are at least three reasons why the Anselmian problem is not simple. One is the subtlety of the modal concepts of necessary truth and necessary reality, as to which there are various disagreements among logicians and philosophers generally. To be sure, Anselm does not say "necessary"; he simply says, "cannot be conceived not to exist." However, there is here an unnoticed ambiguity, (and this is our second complication). "God cannot be conceived not to exist" might mean only that the status or property by which He has been defined-his "perfection" or unsurpassability by any conceivable being-cannot be conceived except as embodied somehow, in some appropriate concrete reality, although just how, or in what concrete reality, is subject to alternatives, i.e., is contingent. (Thus God, or unsurpassable reality, is conceivable as creator, and knowing Himself as creator, of our actual world; but also He might conceivably have existed as creator, and knowing Himself as creator, of some other world instead of this one.) But again, the expression might mean that even the concrete embodiment (in whatever sense, if any, one may in that case speak of such a thing) in or by which divinity exists is subject to no conceivable alternatives, so that the divine reality is in every aspect without contingency. Still a third complication is a similar ambiguity in the definition of deity as such that "none greater is conceivable." This might mean, such that no other being could conceivably be greater, although the being itself, in another "state," could be so; or again it might mean, such that nothing at all could be greater, even the same being in another state. Using the word "unsurpassable" to mean that no greater is conceivable, we could define God either as unsurpassable by another, or else as unsurpassable absolutely, that is, whether by another or by himself.

It will be noted that the two ambiguities just referred to are similar, since in both cases we have a choice between necessary (or unsurpassable) absolutely

or in all possible senses, and not in all possible senses. An unqualified or absolute sense is always the easiest to formulate, and the human mind is strongly tempted by simplicity, often by violent oversimplification. It is clear that Anselm resolved both of the ambiguities above mentioned (without consciously noting them) in favor of the simpler rendering. For nine centuries both defenders and critics have (I am tempted to say, blindly) followed him in this. Until the more complex, and one may well say subtler, rendering has been carefully explored, how can we be sure that the stubbornness of the controversy is not due precisely to this unwitting agreement as to how two implicit ambiguities are to be resolved? It may well be equally true that all existence is contingent (at least in some aspect), and that one existence is necessary (in some aspect). Again, it may be equally true that all beings are somehow surpassable, and that one being is surpassable only by itself. Since analysis shows that the unsurpassable aspect implies necessary existence, all parties may have been defending truth, but truth which the terms of the controversy have until now condemned to remain ill-defined.

Among the improper statements of the Proof is the extremely common form (found first in Anselm himself, *Proslogium* II): the perfect must have all desirable or good properties, real or objective existence is such a property, therefore the perfect has such existence, or exists. This is then refuted by the observation that existence is not a property, desirable or otherwise. Every specifiable property distinguishing islands, for example, from other kinds of things is involved in the notion of nonexistent islands as well as in that of existent ones. So, in general, existence is not a propINTRODUCTION TO SECOND EDITION

erty in the sense which the argument seems to require.

The refutation has force, but only against a small part of Anselm's exposition. Taking his entire discussion (or Descartes's entire discussion) into account, we find that Anselm (or Descartes) has no need of a general principle according to which existence is a property. For there is direct reason for taking divine or necessary existence as a property (which inheres in the property of divinity as defined), and to show this no such major premise as the one above impugned about existence in general is needed. Indeed, the sense in which the divine form of existence is a property is shown to be doubly unique, neither existence nor property having here a simply usual meaning. The property Anselm needs is not mere existence but necessary-existence, the unique existence of the creator of all things. Is it so odd to suppose that this sense of "exist" must somehow be unique? True, there must also be a universal meaning of "exist" which applies even here; but is it this universal meaning of which it can be proved that it is "never a predicate?" Existing contingently (or as creatures exist), this indeed is clearly never (except in an innocuous sense) a predicate; but of existence in the all-comprehending meaning which includes the creator, we can, without begging the question, only say that, at least apart from the one supreme form, it is no predicate. The supreme form, however, must be judged directly, and without prejudice; for otherwise we are merely ruling out theism a priori.

One way to put Anselm's contention is this:

A. "Divinity exists" is, though not without difficulty, or without severe qualifications, conceivable by the human mind; **B.** "Divinity does not exist" is strictly inconceivable (in a more than verbal sense) by any mind, being either self-contradictory or meaningless.

Thus the usual symmetry between the conceivability of existence and that of nonexistence is here upset in favor of existence. Taking this as the Anselmian position, refutation must consist in showing either that divine existence and divine nonexistence are alike conceivable, or that divine existence is inconceivable. These two ways of upsetting the asserted asymmetry, though obviously incompatible, are very commonly confused, and this is one of several defects which disfigure this prolonged controversy. The doctrine of symmetrical conceivability may be called empiricism with respect to the theistic question; that of the inconceivability of existence is suitably termed positivism. From Carneades to Carnap this positivistic position has been taken, and Gaunilo in part argues from it. Anselm is willing to debate the point (see Apologetic, Ch. VIII); however, his defense of the conceivability of divinity is rather an after-thought, and the main intent of his discussion is to refute, not positivism, but empiricism.

The first question a critic should consider, therefore, is, Has the "nonexistence of divinity" a conceivable consistent meaning? Kant and Hume assure us that it has. Kant's argument here is: a contradiction arises only if we posit a subject but deny some part of its essential nature; from denying both subject and nature, no contradiction can arise. This simply begs the question, which is, *can* the subject be denied? After all,

"denying the subject" either means, "denying the logical possibility of the concept," or it does not. If it does mean this, then we have the positivistic position, not the empirical one. If it does not, then at least the concept is accepted, and the issue, "does the concept permit the denial of its object," is still to be adjudicated. Kant was here misled by Proslogium II (as repeated in Descartes, Leibniz, Baumgarten, et al.) in which the Proof seems to be, A nonexistent thing cannot be perfect, to which the easy rejoinder is, "A nonexistent entity possesses no actual properties at all, we have only a description of what properties such an entity would have should it exist." But this way of putting the case meets Anselm only at his weakest. His real argument is that the merely contingent exemplification of the unique predicate, divinity, would be contradictory, for contingent existence is an inferior mode of existing, suitable only to a creature not the creator, and hence "that to which a superior cannot be conceived" can exist only noncontingently. And "existing noncontingently" means existing without conceivable alternative of not existing. Very well, but if the nonexistence of divinity were conceivable, it must remain conceivable "even if it (divinity) existed." (Anselm reiterates this phrase). Whether something is conceivable cannot depend upon what happens to exist, but only upon meanings and their mutual compatibility. Either, then, "divinity" means the same as, or is equivalent to, "existing divinity," or if not, the only existence of which divinity is even capable must be contingent existence. But since this implies, "existing in an imperfect manner (or as a creature)," a manner incompatible with the supreme excellence connoted by "divine," it is contradictory. If divinity does mean, or is equivalent to, existing divinity, then it is the "nonexistence of divinity" which is contradictory. Thus, either way, we have contradiction, unless we admit that divinity and existing divinity are equivalent and that consequently the nonexistence of divinity is inconceivable.

Take now Kant's assertion: we can deny the subject and with it all its predicates. How does he show that such a verbal denial expresses a genuine conception of the divine nonexistence? He cannot or ought not to mean that we can stop thinking of the divine essence or existence. To stop thinking of elephants is not the same as thinking that there are none. What then is the difference between not thinking and thinking not? I fail to find any help in Hume, Kant, Russell, Carnap, or Wittgenstein, at this point. To think the nonexistence of elephants is simple: one has but to think of a universe everywhere lacking in the elephantine character. But a universe everywhere lacking in divine character is no such straightforward notion. In what sense can a universe conceivably have divine character, and what could show that it lacked this character? Kant's own view is that ordinary nonexistence means, for us, noninclusion among the objects of our possible experience. But he also holds that God, existent or not, would be no such object! So then what does he mean by the possible nonexistence of God? He is not thinking of a priori evidence for this nonexistence, for he denies the possibility of such evidence. Thus "divine nonexistence" apparently relates itself to no conceivable evidence, empirical or a prioril

Perhaps the implication is that some nonhuman mind could either experience or prove that nothing is divine? Certainly a divine mind could not know its own nonexistence, though it seems it could know its existence. Furthermore, since God, as part of His definition, is thought of as unsurpassably great in creative power, so that all else is His conceivable effect, and since the Cause must in principle be knowable from the effect, the existence of God, supposing it conceivable at all, cannot be unknowable absolutely, even to nondivine mind. On the other hand, it follows from the same considerations that His nonexistence must be unknowable absolutely. For, one who knows cannot know nonentity only, he must know something positive: and if this something is not God, it is either something which He could be conceived to have created, or something which He could not be conceived to have created. Only in the latter case would one be knowing the nonexistence of God; but since divine creative power is conceived as unsurpassably great, nothing other than this power can be supposed incapable of being its creature.

Putting together the considerations just advanced: divine nonexistence is unknowable absolutely, whether by divine or nondivine cognition. By contrast, divine existence is conceivably knowable, both by God Himself and also by any nondivine cognition able to connect effects with their universal Cause (not to mention able to understand the Ontological Proof). I conclude that the asymmetry to which Anselm points is quite real, and that on this main issue he is essentially correct, and his critics essentially mistaken. It is true, like it or not, that divinity, differing in this from all ordinary properties, cannot be conceived (relative to possible knowledge) unless as existent.

INTRODUCTION TO SECOND EDITION

Yet the critics of the proof have seen something which likewise is correct: it cannot be possible, from an abstract formula such as the definition of divinity, to deduce the fullness of the divine reality, which is supposed somehow to sum up all the value of the universe of creatures and incomparably more besides. From abstractions alone nothing but abstract conclusions can follow. Is the necessary being, which Anselm proves divinity to be, a mere abstraction? Here it is Anselm who does not help us. The question is not merely, "How can we know the more than abstract from the merely abstract"? The difficulty is objective and ultimate: how can the necessary be more than abstract?

Let us consider a good logical model of necessitywhich cannot be Kant's "bodies are extended," for this, as he rightly says, is conditional necessity only: perhaps there are no bodies, extended or otherwise. The more helpful model is the sentential axiom: "p or not-p." Why is this an a priori principle? Because any universe must correspond either to "p" or to "not-p." (Assuming that the requirements of unambiguity can be met, the law of excluded middle becomes self-evident.) "P or not-p" commits us to no particular state of affairs rather than any other, but is neutral or noncommittal as between alternative possibilities. According to this model, if "divinity exists" is necessary then it is equally compatible with any ordinary or contingent proposition p and with its negation. Just so "2 and 2 is 4" agrees equally well with (for instance) "it is raining" and "it is not raining," and so for any contingent value of p.

Let us suppose that p is true. Then God may be conceived to exist knowing that p. Or suppose that p is

false. Then God may equally well be conceived to exist, but knowing that non-p. And this formula applies for any value of p, except only those which are equivalent to the proposition, "divinity exists." Since the contingency of this proposition is precisely what is in question, it cannot be used to furnish an exception to the universal compatibility of the existence of deity with any contingent p or not-p. If, instead of "deity exists," we take "men exist," we find many values of p(by no means simply equivalent to the existence of men) with which, or with its negation, the existence of men will be incompatible. Men can exist, knowing the state of affairs obtaining, only thanks to certain favorable circumstances (e.g., the presence of oxygen, rather than various poisonous gases) without which they will not exist or know anything at all. To exist only thanks to favorable circumstances is, Anselm is saying, just what we mean by contingent existence. God, however, cannot exist "thanks to" anything-unless to its being true that He exists, the trivially tautologous character of which shows the inapplicability here of the ordinary notion of conditioned or contingent existence. The notion of anything preventing deity from existing is nonsense or contradiction. Spinoza rightly stresses this consideration. Has he ever been refuted just at this point? Divinity, or unsurpassability, includes unsurpassable or unlimited tolerance to alternative situations and conditions; hence the strict unknowability, and indeed meaninglessness, of the nonexistence of divinity.

However, though deity cannot conceivably not exist, there must yet be qualities which are in the divine reality but might not have been there, and also qual-

ities which might have been there but are not. For example, the divine reality includes the property of creating and knowing what p asserts (whatever true contingent proposition p may be); yet the divine reality might, though it does not, include the property of creating and knowing a state of affairs corresponding to not-p. Evidently the identical God, with wholly identical qualities, could not know that elephants exist and that elephants do not exist, for "X, who is infallible, knows that elephants exist" is incompatible with the truth of "elephants do not exist." Thus the fullness of the divine reality, if there be anything in the least analogous to knowledge in it, cannot be neutral to the distinction between p and not-p, and hence cannot be necessary. The concrete reality, or how divinity is concretized, is thus not to be supposed neutral to contingent alternatives, but rather, infinitely sensitive to them. It must correspond with some propositions, to p and with others, to not-p; but in no case to a mere "p or not-p." It thus lacks the essential or definitive trait of the necessary, which must be on both sides of all the contingent contradictories, and must, therefore, lack the concreteness which distinguishes them from each other. The necessary is abstract or impoverished to the uttermost, and only therefore does it conflict with nothing, being the mere point of agreement of all possible truths or realities.

Here is Anselm's central failure, his only radical one, that he never relates the necessary, and therefore abstract, to anything which is more than abstract in God. And he cannot do so, for neoplatonic theology is committed to the worship of the necessary or eternally immutable as opposed to the contingent or noneternal. Note, for instance, as one of the innumerable signs of this, the way Anselm is forced (Proslogium VI-VIII) to explain away divine "compassion" as not really that at all, though the effects upon us are as if God experienced compassion for us. In just the same way the Saint could be forced, and many others in his tradition were forced, to explain away divine knowledge, and everything else worth talking about, in the object of worship. The excuse is always the same: we must expect to fail to understand deity, but on no account may we admit any contingency, passivity, relativity, or becoming in Him. But, as Berdyaev has suggested, if we understand the need for these denials so well as all that, our pretended modesty does not go very deep, and, for all we know, the trouble at this point is not with the mysteriousness of God, but with the mysterious pretentiousness and stubbornness of the human mind which, having once dared to forbid deity to enjoy the advantages of concreteness (contingency), will not be induced even by contradictions to withdraw this negative legislation!

The century-long persistence in this behavior is only the more remarkable in that a "face-saving" retreat from it is quite open. We need not, indeed we should not, simply retract the negative theology; we need only admit that it applies to God not *simpliciter*, but in one aspect only, the eternal or necessary aspect. To be sure, the negative theology denied any real plurality of aspects; but since this denial is the source of antinomies, why not abandon it? Worshipping God is one thing; worshipping the negative theology is another. The being who is exalted beyond all rivalry, and hence worthy of worship by all, must indeed be unsurpassable-unless it surpasses itself. For this mode of surpassability sets no limit to worship. If even God in a sense, "looks up" to God, then a *fortiori* we ought tol

The weakness inherent in Anselm's negative theology does not refute his contention that the divine nonexistence is inconceivable. What it shows is rather that God's reality must be more than His necessary existence, and must include a wealth of positive and contingent qualities or aspects. An analogy: each moment my personal existence is concretized anew, but just how, in just what experiences, is always an additional fact, not deducible from the bare truth that I continue existing. Moreover, my individuality might not have been, and I might soon not be, concretized in any way at all. The divine individuality, by contrast, has this unique superiority: it must always be and have been concretized somehow. Only the how, not the that, is here contingent.

Let us symbolize as clearly as possible what we have been saying. Let the following symbols have the meanings specified:

"Es" for "essence" (definition, concept, universal) "Ex" for "existence" (there is an actual instance, some instance or other, of the essence)

"Ac" for "actuality" (the concrete instance itself)

"=" for "equal or equivalent to" (implies and is implied by)

"<" for "is less than" (hence does not imply, and is not equivalent to).

Consider then the following:

 $Es \leq Ex < Ac$

Interpretation: Essence is (in the divine form) or is

not (in nondivine forms) equivalent to existing (or somehow actualized) essence; however, in no case is the bare truth that an essence exists, or is somehow actualized, equivalent to the whole truth about the particular instance by which, or how, the essence is actualized.

Anselm pointed to the necessary collapse of inequality between essence and existence in the divine case; his opponents, to the impossibility of a collapse of inequality between essence and actuality. Both were right. But both erred in overlooking the distinction between existence and actuality. Controversies in philosophy often have this character. The parties cannot agree because they agree only too well on the wrong assumption, in this case, the identity of existence and concrete actuality, the *that* and the *how* of an essence's actualization.

It is to be noted that the necessary existence of deity, though it does not entail a particular concrete actuality, does amount to the existence of a unique individual. For only one being can be divine. There is no class of possible divine individuals. Alternative or contingent divine qualities can only be qualities which God, but no one else, may contingently have. The reason universal essence (or class) and individuality here coincide is that this is the individual with strictly universal functions, knowing all, influencing all, being influenced by all. Whereas I for instance, can never influence, or be known to, my remote ancestors, nor yet ever be influenced by or know any remote descendents I may have, God enjoys a "field" of relatedness, whether as influencing or as influenced, which is absolutely infinite and unselective among possible or actual indiv-

18

iduals. Simply "all things" whatever, the actual things actually, the possible things potentially, influence and are influenced by Him. It thus makes no difference to God's individuality what possibilities are realized. Only the actual states of the same God differ according to what actual things there are for Him to relate Himself to.

Anselm had some elements of a systematic and profound theory of contingency and necessity, in relation to the divine unsurpassability. The theory was incomplete, and to complete it without logical absurdity forces one (unless I am mistaken indeed) well beyond his type of philosophy and theology. But it is his own discovery which, carefully reflected upon, can carry us to this beyond.³

CHARLES HARTSHORNE

EMORY UNIVERSITY FEBRUARY, 1962

3. In the first sentence on page 61 of our present translation of the Proslogium there is a lack of clarity which my colleague, Dr. Joseph Conant, has suggested may be remedied as follows: "But as it is absurd to suppose that, because the created being can in no way exceed the immeasureableness of what creates and sustains it, the creating and sustaining being similarly can in no way exceed the universe of things it has created; it is clear that ... etc."

THE present volume of St. Anselm's most important philosophical and theological writings contains: (1) The Proslogium (2) the Monologium, (3) the Cur Deus Homo, and (4) by way of historical complement, an Appendix to the Monologium entitled In Behalf of the Fool by Gaunilon, a monk of Marmoutiers. The Proslogium (which, though subsequent in point of time to the Monologium, is here placed first, as containing the famous ontological argument), the Monologium and the Appendix thereto were translated by Mr. Sidney Norton Deane, of New Haven, Conn.; the Cur Deus Homo was rendered by James Gardiner Vose, formerly of Milton, Conn., and later of Providence, R. I., and published in 1854 and 1855 in the Bibliotheca Sacra, then issued at Andover, Mass., by Warren F. Draper. The thanks of the reading public are due to all these gentlemen for their gratuitous labors in behalf of philosophy.

Welch's recent book Anselm and His Work, by its accessibility, renders any extended biographical notice of Anselm unneccessary. We append, therefore, merely a few brief paragraphs from Weber's admirable History of Philosophy on Anselm's position in the world of thought, and we afterwards add (this, at the suggestion of Prof. George M. Duncan, of Yale University) a series of quotations regarding Anselm's most characteristic contribution to philosophy—the ontological argument—from Descartes, Spinoza, Locke, Leibnitz, Kant, Hegel, Dorner, Lotze, and Professor Flint. A bibliography also has been compiled. Thus the work will give full material and indications for the original study of one of the greatest exponents of Christian doctrine.

ANSELM'S PHILOSOPHY.

(AFTER WEBER.¹)

"The first really speculative thinker after Scotus is St. Anselmus, the disciple of Lanfranc. He was born at Aosta (1033),

1From Weber's History of Philosophy. Trans. by F. Thilly. New York Scribner's. Price, \$2 50.

entered the monastery of Bec in Normandy (1060), succeeded Lanfranc as Abbot (1078), and as Archbishop of Canterbury (1093). He died in 1109. He left a great number of writings, the most important of which are : the Dialogus de grammatico, the Monologium de divinitatis essentia sive Exemplum de ratione fidei, the Proslogium sive Fides quærens intellectum, the De veritate, the De fide trinitatis, and the Cur Deus Homo?

"The second Augustine, as St. Anselmus had been called, starts out from the same principle as the first ; he holds that faith precedes all reflection and all discussion concerning religious things. The unbelievers, he says, strive to understand because they do not believe; we, on the contrary, strive to understand because we believe. They and we have the same object in view: but inasmuch as they do not believe, they cannot arrive at their goal, which is to understand the dogma. The unbeliever will never understand. In religion faith plays the part played by experience in the understanding of the things of this world. The blind man cannot see the light, and therefore does not understand it; the deaf-mute, who has never perceived sound, cannot have a clear idea of sound. Similarly, not to believe means not to perceive, and not to perceive means not to understand. Hence, we do not reflect in order that we may believe; on the contrary, we believe in order that we may arrive at knowledge. A Christian ought never to doubt the beliefs and teachings of the Holy Catholic Church. All he can do is to strive, as humbly as possible, to understand her teachings by believing them, to love them, and resolutely to observe them in his daily life. Should he succeed in understanding the Christian doctrine, let him render thanks to God, the source of all intelligence ! In case he fails, that is no reason why he should obstinately attack the dogma, but a reason why he should bow his head in worship. Faith ought not merely to be the starting-point, -the Christian's aim is not to depart from faith but to remain in it,-but also the fixed rule and goal of thought, the beginning, the middle, and the end of all philosophy.

"The above almost literal quotations might give one the impression that St. Anselmus belongs exclusively to the history of theology. Such is not the case, however. This fervent Catholic is more independent, more of an investigator and philosopher than he himself imagines. He is a typical scholastic doctor and a fine exponent of the alliance between reason and faith which forms the characteristic trait of mediæval philosophy. He assumes, a priori,

that revelation and reason are in perfect accord. These two manifestations of one and the some Supreme Intelligence cannot possibly contradict each other. Hence, his point of view is diametrically opposed to the credo quia absurdum. Moreover, he too had been besieged by doubt. Indeed, the extreme ardor which impels him to search everywhere for arguments favorable to the dogma, is a confession on his part that the dogma needs support, that it is debatable, that it lacks self-evidence, the criterion of truth. Even as a monk, it was his chief concern to find a simple and conclusive argument in support of the existence of God and of all the doctrines of the Church concerning the Supreme Being. Mere affirmation did not satisfy him ; he demanded proofs. This thought was continually before his mind; it caused him to forget his meals, and pursued him even during the solemn moments of worship. He comes to the conclusion that it is a temptation of Satan, and seeks deliverance from it. But in vain. After a night spent in meditation, he at last discovers what he has been seeking for years: the incontrovertible argument in favor of the Christian dogma, and he regards himself as fortunate in having found, not only the proof of the existence of God, but his peace of soul. His demonstrations are like the premises of modern rationalism.

"Everything that exists, he says, has its cause, and this cause may be one or many. If it is one, then we have what we are looking for : God, the unitary being to whom all other beings owe their origin. If it is manifold, there are three possibilities: (1) The manifold may depend on unity as its cause; or (2) Each thing composing the manifold may be self-caused; or (3) Each thing may owe its existence to all the other things. The first case is identical with the hypothesis that everything proceeds from a single cause: for to depend on several causes, all of which depend on a single cause, means to depend on this single cause. In the second case, we must assume that there is a power, force, or faculty of self-existence common to all the particular causes assumed by the hypothesis; a power in which all participate and are comprised. But that would give us what we had in the first case, an absolute unitary cause. The third supposition, which makes each of the 'first causes' depend on all the rest, is absurd; for we cannot hold that a thing has for its cause and condition of existence a thing of which it is itself the cause and condition. Hence we are compelled to believe in a being which is the cause of every existing thing, without being caused by anything itself, and which for

that very reason is infinitely more perfect than anything else: is is the most real (*ens realissimum*), most powerful, and best being. Since it does not depend on any being or on any condition of existence other than itself, it is *a* se and *per se*; it exists, not because something else exists, but it exists because it exists; that is, it exists necessarily, it is necessary being.

"It would be an easy matter to deduce pantheism from the arguments of the *Monologium*. Anselmus, it is true, protests against such an interpretation of his theology. With St. Augustine he assumes that the world is created *ex nihilo*. But though accepting this teaching, he modifies it. Before the creation, he says, things did not exist *by themselves*, independently of God; hence we say they were derived from non-being. But they existed eternally *for God* and in God, as ideas; they existed before their creation in the sense that the Creator foresaw them and predestined them for existence.

"The existence of God, the unitary and absolute cause of the world, being proved, the question is to determine his nature and attributes. God's perfections are like human perfections; with this difference, however, that they are essential to him, which is not the case with us. Man has received a share of certain perfections, but there is no necessary correlation between him and these perfections; it would have been possible for him not to receive them; he could have existed without them. God, on the contrary, does not get his perfections from without; he has not received them, and we cannot say that he has them: he is and must be everything that these perfections imply ; his attributes are identical with his essence. Justice, an attribute of God, and God are not two separate things. We cannot say of God that he has justice or goodness; we cannot even say that he is just: for to be just is to participate in justice after the manner of creatures. God is justice as such, goodness as such, wisdom as such, happiness as such, truth as such, being as such. Moreover, all of God's attributes constitute but a single attribute, by virtue of the unity of his essence (unum est quidquid essentialiter de summa substantia dicitur).

"All this is pure Platonism. But, not content with spiritualising theism, Anselmus really discredits it when, like a new Carneades, he enumerates the difficulties which he finds in the conception. God is a simple being and at the same time eternal, that is, diffused over infinite points of time; he is omnipresent, that is, distributed over all points of space. Shall we say that God is omnipresent and eternal? This proposition contradicts the notion of the simplicity of the divine essence. Shall we say that he is nowhere in space and nowhere in time? But that would be equivalent to denying his existence. Let us therefore reconcile these two extremes and say that God is omnipresent and eternal, without being limited by space or time. The following is an equally serious difficulty: In God there is no change and consequently nothing accidental. Now, there is no substance without accidents. Hence God is not a substance : he transcends all substance. Anselmus is alarmed at these dangerous consequences of his logic, and he therefore prudently adds that, though the term 'substance' may be incorrect, it is, nevertheless, the best we can apply to God-si quid digne dici potest-and that to avoid or condemn it might perhaps jeopardise our faith in the reality of the Divine Being.

"The most formidable theological antinomy is the doctrine of the trinity of persons in the unity of the divine essence. The Word is the object of eternal thought; it is God in so far as he is thought. conceived, or comprehended by himself. The Holy Spirit is the love of God for the Word, and of the Word for God, the love which God bears himself. But is this explanation satisfactory ? And does it not sacrifice the dogma which it professes to explain to the conception of unity? St. Anselmus sees in the Trinity and the notion of God insurmountable difficulties and contradictions. which the human mind cannot reconcile. In his discouragement he is obliged to confess, with Scotus Erigena, St. Augustine, and the Neo-Platonists, that no human word can adequately express the esssence of the All-High. Even the words 'wisdom' (sapientia) and 'being' (essentia) are but imperfect expressions of what he imagines to be the essence of God. All theological phrases are analogies, figures of speech, and mere approximations.

"The Proslogium sive Fides quærens intellectum has the same aim as the Monologium: to prove the existence of God. Our author draws the elements of his argument from St. Augustine and Platonism. He sets out from the idea of a perfect being, from which he infers the existence of such a being. We have in ourselves, he says, the idea of an absolutely perfect being. Now, perfection implies existence. Hence God exists. This argument, which has been termed the ontological argument, found an opponent worthy of Anselmus in Gaunilo, a monk of Marmoutiers in Touraine. Gaunilo emphasises the difference between thought and being, and points out the fact that we may conceive and imagine a being, and yet that being may not exist. We have as much right to conclude from our idea of an enchanted island in the middle of the ocean that such an island actually exists. The criticism is just. Indeed, the ontological argument would be conclusive, only in case the idea of God and the existence of God in the human mind were identical. If our idea of God is God himself, it is evident that this idea is the immediate and incontrovertible proof of the existence of God. But what the theologian aims to prove is not the existence of the God-Idea of Plato and Hegel, but the existence of the personal God. However that may be, we hardly know what to admire most,—St. Anselmus's broad and profound conception, or the sagacity of his opponent who, in the seclusion of his cell, anticipates the Transcendental Dialectic of Kant.

"The rationalistic tendency which we have just noticed in the Monologium and the Proslogium meets us again in the Cur Deus Homo? Why did God become man? The first word of the title sufficiently indicates the philosophical trend of the treatise. The object is to search for the causes of the incarnation. The incarnation, according to St. Anselmus, necessarily follows from the necessity of redemption. Sin is an offence against the majesty of God. In spite of his goodness, God cannot pardon sin without compounding with honor and justice. On the other hand, he cannot revenge himself on man for his offended honor; for sin is an offence of infinite degree, and therefore demands infinite satisfaction ; which means that he must either destroy humanity or inflict upon it the eternal punishments of hell. Now, in either case, the goal of creation, the happiness of his creatures, would be missed and the honor of the Creator compromised. There is but one way for God to escape this dilemma without affecting his honor, and that is to arrange for some kind of satisfaction. He must have infinite satisfaction, because the offence is immeasurable. Now, in so far as man is a finite being and incapable of satisfying divine justice in an infinite measure, the infinite being himself must take the matter in charge; he must have recourse to substitution. Hence, the necessity of the incarnation. God becomes man in Christ; Christ suffers and dies in our stead : thus he acquires an infinite merit and the right to an equivalent recompense. But since the world belongs to the Creator, and nothing can be added to its treasures, the recompense which by right belongs to Christ

falls to the lot of the human race in which he is incorporated: humanity is pardoned, forgiven, and saved.

"Theological criticism has repudiated Anselmus's theory, which bears the stamp of the spirit of chivalry and of feudal customs. But, notwithstanding the attacks of a superficial rationalism, there is an abiding element of truth in it: over and above each personal and variable will there is an absolute, immutable, and incorruptible will, called justice, honor, and duty, in conformity with the customs of the times."

CRITICISMS OF ANSELM'S ONTOLOGICAL ARGUMENT FOR THE BEING OF GOD.

DESCARTES.1

"But now, if from the simple fact that I can draw from my thought the idea of anything it follows that all that I recognise clearly and distinctly to pertain to this thing pertains to it in reality, can I not draw from this an argument and a demonstration of the existence of God? It is certain that I do not find in me the less the idea of him, that is, of a being supremely perfect, than that of any figure or of any number whatever; and I do not know less clearly and distinctly that an actual and eternal existence belongs to his nature than I know that all that I can demonstrate of any figure or of any number belongs truly to the nature of that figure or that number: and accordingly, although all that I have concluded in the preceding meditations may not turn out to be true, the existence of God ought to pass in my mind as being at least as certain as I have up to this time regarded the truths of mathematics to be, which have to do only with numbers and figures : although, indeed, that might not seem at first to be perfectly evident, but might appear to have some appearance of sophistry. For being accustomed in all other things to make a distinction between existence and essence, I easily persuade myself that existence may perhaps be separated from the essence of God, and thus God might be conceived as not existent actually. But nevertheless, when I think more attentively, I find that existence can no more be separated from the essence of God than from the essence of a rectilinear triangle can be separated the equality of its three

1 The Philosophy of Descartes in Extracts from His Writings. H. A. P. Torrey. New York, 1892. P. 161 et seq.

angles to two right angles, or, indeed, if you please, from the idea of a mountain the idea of a valley; so that there would be no less contradiction in conceiving of a God—that is, of a being supremely perfect, to whom existence was wanting, that is to say, to whom there was wanting any perfection—than in conceiving of a mountain which had no valley.

"But although, in reality, I might not be able to conceive of a God without existence, no more than of a mountain without a valley, nevertheless, as from the simple fact that I conceive a mountain with a valley, it does not follow that there exists any mountain in the world, so likewise, although I conceive God as existent, it does not follow, it seems, from that, that God exists, for my thought does not impose any necessity on things; and as there is nothing to prevent my imagining a winged horse, although there is none which has wings, so I might, perhaps, be able to attribute existence to God, although there might not be any God which existed. So far from this being so, it is just here under the appearance of this objection that a sophism lies hid; for from the fact that I cannot conceive a mountain without a valley, it does not follow that there exists in the world any mountain or any valley, but solely that the mountain and the valley, whether they exist or not, are inseparable from one another ; whereas, from the fact alone that I cannot conceive God except as existent, it follows that existence is inseparable from him, and, consequently, that he exists in reality; not that my thought can make it to be so, or that it can impose any necessity upon things; but on the contrary the necessity which is in the thing itself, that is to say, the necessity of the existence of God, determines me to have this thought.

"For it is not at my will to conceive of a God without existence, that is to say, a being supremely perfect without a supreme perfection, as it is at my will to conceive a horse with wings or without wings.

"And it must not also be said here that it is necessarily true that I should affirm that God exists, after I have supposed him to possess all kinds of perfection, since existence is one of these, but that my first supposition is not necessary, no more than it is necessary to affirm that all figures of four sides māy be inscribed in the circle, but that, supposing I had this thought, I should be constrained to admit that the rhombus can be inscribed there, since it is a figure of four sides, and thus I should be constrained to admit something false. One ought not, I say, to allege this; for although

it may not be necessary that I should ever fall to thinking about God, nevertheless, when it happens that I think upon a being first and supreme, and draw, so to speak, the idea of him from the store-house of mind, it is necessary that I attribute to him every sort of perfection, although I may not go on to enumerate them all, and give attention to each one in particular. And this necessity is sufficient to bring it about (as soon as I recognise that I should next conclude that existence is a perfection) that this first and supreme being exists: while, just as it is not necessary that I ever imagine a triangle, but whenever I choose to consider a rectilinear figure, composed solely of three angles, it is absolutely necessary that I attribute to it all the things which serve for the conclusion that there three angles are not greater than two right angles, although, perhaps, I did not then consider this in particular."

SPINOZA.1

"PROP. XI. God, or substance, consisting of infinite attributes, of which each expresses eternal and infinite essentiality, necessarily exists.

"Proof.—If this be denied, conceive, if possible, that God does not exist: then his essence does not involve existence. But this (by Prop. vii.) is absurd. Therefore God necessarily exists.

"Another Proof.—Of everything whatsoever a cause or reason must be assigned, either for its existence, or for its non-existence —e. g., if a triangle exist, a reason or cause must be granted for its existence; if, on the contrary, it does not exist, a cause must also be granted, which prevents it from existing, or annuls its existence. This reason or cause must either be contained in the nature of the thing in question, or be external to it. For instance, the reason for the non-existence of a square circle is indicated in its nature, namely, because it would involve a contradiction. On the other hand, the existence of substance follows also solely from its nature, inasmuch as its nature involves existence. (See Prop. vii.)

"But the reason for the existence of a triangle or a circle does not follow from the nature of those figures, but from the order of universal nature in extension. From the latter it must follow, either that a triangle necessarily exists, or that it is impossible

1 The Chief Works of Benedict de Spinoza. Translated by R. H. M. Elwes. London, 1848. Vol. II., p. 51 et seq. that it should exist. So much is self-evident. It follows therefrom that a thing necessarily exists, if no cause or reason be granted which prevents its existence.

"If, then, no cause or reason can be given, which prevents the existence of God, or which destroys his existence, we must certainly conclude that he necessarily does exist. If such a reason or cause should be given, it must either be drawn from the very nature of God, or be external to him—that is, drawn from another substance of another nature. For if it were of the same nature, God, by that very fact, would be admitted to exist. But substance of another nature could have nothing in common with God (by Prop. ii), and therefore would be unable either to cause or to destroy his existence.

"As, then, a reason or cause which would annul the divine existence cannot be drawn from anything external to the divine nature, such cause must perforce, if God does not exist, be drawn from God's own nature, which would involve a contradiction. To make such an affirmation about a being absolutely infinite and supremely perfect, is absurd; therefore, neither in the nature of God, nor externally to his nature, can a cause or reason be assigned which would annul his existence. Therefore, God necessarily exists. Q. E. D.

"Another proof.—The potentiality of non-existence is a negation of power, and contrariwise the potentiality of existence is a power, as is obvious. If, then, that which necessarily exists is nothing but finite beings, such finite beings are more powerful than a being absolutely infinite, which is obviously absurd; therefore, either nothing exists, or else a being absolutely infinite necessarily exists also. Now we exist either in ourselves, or in something else which necessarily exists (see Axiom i. and Prop. vii.). Therefore a being absolutely infinite—in other words, God (Def. vi.)—necessarily exists. Q. E. D.

"Note.—In this last proof, I have purposely shown God's existence a *posteriori*, so that the proof might be more easily followed, not because, from the same premises, God's existence does not follow a *priori*. For, as the potentiality of existence is a power, it follows that, in proportion as reality increases in the nature of a thing, so also will it increase its strength for existence. Therefore a being absolutely infinite, such as God, has from himself an absolutely infinite power of existence, and hence he does absolutely exist. Perhaps there will be many who will be unable

to see the force of this proof, inasmuch as they are accustomed only to consider those things which flow from external causes. Of such things, they see that those which quickly come to pass—that is, quickly come into existence—quickly also disappear; whereas they regard as more difficult of accomplishment—that is, not so easily brought into existence—those things which they conceive as more complicated.

"However, to do away with this misconception, I need not here show the measure of truth in the proverb, 'What comes quickly, goes quickly,' nor discuss whether, from the point of view of universal nature, all things are equally easy, or otherwise : I need only remark, that I am not here speaking of things, which come to pass through causes external to themselves, but only of substances which (by Prop. vi.) cannot be produced by any external cause. Things which are produced by external causes, whether they consist of many parts or few, owe whatsoever perfection or reality they possess solely to the efficacy of their external cause, and therefore their existence arises solely from the perfection by their external cause, not from their own. Contrariwise, whatsoever perfection is possessed by substance is due to no external cause; wherefore the existence of substance must arise solely from its own nature, which is nothing else but its essence. Thus, the perfection of a thing does not annul its existence, but, on the contrary, asserts it. Imperfection, on the other hand, does annul it: therefore we cannot be more certain of the existence of anything, than of the existence of a being absolutely infinite or perfect-that is, of God. For inasmuch as his essence excludes all imperfection, and involves absolute perfection, all cause for doubt concerning his existence is done away, and the utmost certainty on the question is given. This, I think, will be evident to every moderately attentive reader."

LOCKE.1

"Our idea of a most perfect being, not the sole proof of a God.—How far the idea of a most perfect being which a man may frame in his mind, does or does not prove the existence of a God, I will not here examine. For, in the different make of men's tempers, and application of their thoughts, some arguments prevail

1 An Essay Concerning Human Understanding. London: Ward, Lock, & Co. P. 529 et seq.

more on one, and some on another, for the confirmation of the same truth. But yet, I think this I may say, that it is an ill way of establishing this truth and silencing atheists, to lay the whole stress of so important a point as this upon that sole foundation: and take some men's having that idea of God in their minds (for it is evident some men have none, and some worse than none, and the most very different) for the only proof of a Deity; and out of an over-fondness of that darling invention, cashier, or at least endeavor to invalidate, all other arguments, and forbid us to hearken to those proofs, as being weak or fallacious, which our own existence and the sensible parts of the universe offer so clearly and cogently to our thoughts, that I deem it impossible for a considering man to withstand them."

LEIBNITZ.1

"Although I am for innate ideas, and in particular for that of God. I do not think that the demonstrations of the Cartesians drawn from the idea of God are perfect. I have shown fully elsewhere (in the Actes de Leipsic, and in the Mémoires de Trevoux) that what Descartes has borrowed from Anselm, Archbishop of Canterbury, is very beautiful and really very ingenious, but that there is still a gap therein to be filled. This celebrated archbishop. who was without doubt one of the most able men of his time. congratulates himself, not without reason, for having discovered a means of proving the existence of God a priori, by means of its own notion, without recurring to its effects. And this is very nearly the force of his argument : God is the greatest or (as Descartes says) the most perfect of beings, or rather a being of supreme grandeur and perfection, including all degrees thereof. That is the notion of God. See now how existence follows from this notion. To exist is something more than not to exist, or rather, existence adds a degree to grandeur and perfection, and as Descartes states it, existence is itself a perfection. Therefore this degree of grandeur and perfection, or rather this perfection which consists in existence, is in this supreme all-great, all-perfect being : for otherwise some degree would be wanting to it, contrary to its definition. Consequently this supreme being exists. The Scholastics, not excepting even their Doctor Angelicus, have misunder-

1 New Essays Concerning Human Understanding. Translated by A. G. Langley. New York, 1896. P. 502 et seq.

stood this argument, and have taken it as a paralogism; in which respect they were altogether wrong, and Descartes, who studied quite a long time the scholastic philosophy at the Jesuit College of La Fleche, had great reason for re-establishing it. It is not a paralogism, but it is an imperfect demonstration, which assumes something that must still be proved in order to render it mathematically evident ; that is, it is tacitly assumed that this idea of the all-great or all-perfect being is possible, and implies no contradiction. And it is already something that by this remark it is roved that, assuming that God is possible, he exists, which is the privilege of divinity alone. We have the right to presume the possibility of every being, and especially that of God, until some one proves the contrary. So that this metaphysical argument already gives a morally demonstrative conclusion, which declares that according to the present state of our knowledge we must judge that God exists, and act in conformity thereto. But it is to be desired, nevertheless, that clever men achieve the demonstration with the strictness of a mathematical proof, and I think I have elsewhere said something that may serve this end."

KANT.1

"Being is evidently not a real predicate, or a concept of something that can be added to the concept of a thing. It is merely the admission of a thing, and of certain determinations in it. Logically, it is merely the copula of a judgment. The proposition, God is almighty, contains two concepts, each having its object, namely, God and almightiness. The small word is, is not an additional predicate, but only serves to put the predicate in relation to the subject. If, then, I take the subject (God) with all its predicates (including that of almightiness), and say, God is, or there is a God, I do not put a new predicate to the concept of God, but I only put the subject by itself, with all its predicates, in relation to my concept, as its object. Both must contain exactly the same kind of thing, and nothing can have been added to the concept. which expresses possibility only, by my thinking its object as simply given and saying, it is. And thus the real does not contain more than the possible. A hundred real dollars do not contain a penny more than a hundred possible dollars. For as the latter signify

1 Critique of Pure Reason. Translated by F. Max Müller. New York, 1896. P. 483 et seq. the concept, the former the object and its position by itself, it is clear that, in case the former contained more than the latter, my concept would not express the whole object, and would not therefore be its adequate concept. In my financial position no doubt there exists more by one hundred real dollars, than by their concept only (that is their possibility), because in reality the object is not only contained analytically in my concept, but is added to my concept (which is a determination of my state), synthetically; but the conceived hundred dollars are not in the least increased through the existence which is outside my concept.

"By whatever and by however many predicates I may think a thing (even in completely determining it), nothing is really added to it, if I add that the thing exists. Otherwise, it would not be the same that exists, but something more than was contained in the concept, and I could not say that the exact object of my concept existed. Nay, even if I were to think in a thing all reality, except one, that one missing reality would not be supplied by my saying that so defective a thing exists, but it would exist with the same defect with which I thought it; or what exists would be different from what I thought. If, then, I try to conceive a being, as the highest reality (without any defect), the question still remains, whether it exists or not. For though in my concept there may be wanting nothing of the possible real content of a thing in general. something is wanting in its relation to my whole state of thinking, namely, that the knowledge of that object should be possible a posteriori also. And here we perceive the cause of our difficulty. If we were concerned with an object of our senses, I could not mistake the existence of a thing for the mere concept of it; for by the concept the object is thought as only in harmony with the general conditions of a possible empirical knowledge, while by its existence it is thought as contained in the whole content of experience. Through this connection with the content of the whole experience, the concept of an object is not in the least increased; our thought has only received through it one more possible perception. If, however, we are thinking existence through the pure category alone, we need not wonder that we cannot find any characteristic to distinguish it from mere possibility.

"Whatever, therefore, our concept of an object may contain, we must always step outside it, in order to attribute to it existence. With objects of the senses, this takes place through their connection with any one of my perceptions, according to empirical laws;

with objects of pure thought, however, there is no means of knowing their existence, because it would have to be known entirely *a priori*, while our consciousness of every kind of existence, whether immediately by perception, or by conclusions which connect something with perception, belongs entirely to the unity of experience, and any existence outside that field, though it cannot be declared to be absolutely impossible, is a presupposition that cannot be justified by anything.

"The concept of a Supreme Being is, in many respects, a very useful idea, but, being an idea only, it is quite incapable of increasing, by itself alone, our knowledge with regard to what exists. It cannot even do so much as to inform us any further as to its possibility. The analytical characteristic of possibility, which consists in the absence of contradiction in mere positions (realities), cannot be denied to it; but the connection of all real properties in one and the same thing is a synthesis the possibility of which we cannot judge a priori because these realities are not given to us as such, and because, even if this were so, no judgment whatever takes place, it being necessary to look for the characteristic of the possibility of synthetical knowledge in experience only, to which the object of an idea can never belong. Thus we see that the celebrated Leibnitz is far from having achieved what we thought he had, namely, to understand a priori the possibility of so sublime an ideal Being.

Time and labor therefore are lost on the famous ontological (Cartesian) proof of the existence of a Supreme Being from mere concepts; and a man might as well imagine that he could become richer in knowledge by mere ideas, as a merchant in capital, if, in order to improve his position, he were to add a few noughts to his cash account."

HEGEL.¹

"This proof was included among the various proofs up to the time of Kant, and—by some who have not yet reached the Kantian standpoint—it is so included even to the present day. It is different from what we find and read of amongst the ancients. For it was said that God is absolute thought as objective; for because things in the world are contingent, they are not the truth in and for itself—but this is found in the infinite. The scholastics also

1 Lectures on the History of Philosophy. Translated by E. S. Haldane and **P. H.** Simson. London, 1896. Vol. III., p. 62 et seq.

knew well from the Aristotelian philosophy the metaphysical proposition that potentiality is nothing by itself, but is clearly one with actuality. Later, on the other hand, the opposition between thought itself and Being began to appear with Anselm. It is noteworthy that only now for the first time through the Middle Ages and in Christianity, the universal Notion and Being, as it is to ordinary conception, became established in this pure abstraction as these infinite extremes : and thus the highest law has come to consciousness. But we reach our profoundest depths in bringing the highest opposition into consciousness. Only no advance was made beyond the division as such, although Anselm also tried to find the connection between the sides. But while hitherto God appeared as the absolute existent, and the universal was attributed to Him as predicate, an opposite order begins with Anselm-Being becomes predicate, and the absolute Idea is first of all established as the subject, but the subject of thought. Thus if the existence of God is once abandoned as the first hypothesis, and established as a result of thought, self-consciousness is on the way to turn back within itself. Then we have the question coming in, Does God exist? while on the other side the question of most importance was, What is God?

"The ontological proof, which is the first properly metaphysical proof of the existence of God, consequently came to mean that God as the Idea of existence which unites all reality in itself, also has the reality of existence within Himself; this proof thus follows from the Notion of God, that He is the universal essence of all essence. The drift of this reasoning is, according to Anselm (Proslogium, C. 2), as follows: 'It is one thing to say that a thing is in the understanding, and quite another to perceive that it exists. Even an ignorant person (insibiens) will thus be quite convinced that in thought there is something beyond which nothing greater can be thought: for when he hears this he understands it. and everything that is understood is in the understanding. But that beyond which nothing greater can be thought cannot certainly be in the understanding alone. For if it is accepted as in thought alone, we may go on farther to accept it as existent: that. however, is something greater' than what is merely thought. 'Thus were that beyond which nothing greater can be thought merely in the understanding, that beyond which nothing greater can be thought would be something beyond which something greater can be thought. But that is truly impossible; there thus

without doubt exists both in the understanding and in reality something beyond which nothing greater can be thought.' The highest conception cannot be in the understanding alone; it is essential that it should exist. Thus it is made clear that Being is in a superficial way subsumed under the universal of reality, that to this extent Being does not enter into opposition with the Notion. That is quite right; only the transition is not demonstrated—that the subjective understanding abrogates itself. This, however, is just the question which gives the whole interest to the matter. When reality or completion is expressed in such a way that it is not yet posited as existent, it is something thought, and rather opposed to Being than that this is subsumed under it.

"This mode of arguing held good until the time of Kant; and we see in it the endeavor to apprehend the doctrine of the Church through reason. This opposition between Being and thought is the starting-point in philosophy, the absolute that contains the two opposites within itself-a conception, according to Spinoza, which involves its existence likewise. Of Anselm it is however to be remarked that the formal logical mode of the understanding, the process of scholastic reasoning is to be found in him; the content indeed is right, but the form faulty. For in the first place the expression 'the thought of a Highest' is assumed as the prius. Secondly, there are two sorts of objects of thought-one that is and another that is not; the object that is only thought and does not exist, is as imperfect as that which only is without being thought. The third point is that what is highest must likewise exist. But what is highest, the standard to which all else must conform, must be no mere hypothesis, as we find it represented in the conception of a highest acme of perfection, as a content which is thought and likewise is. This very content, the unity of Being and thought, is thus indeed the true content : but because Anselm has it before him only in the form of the understanding, the opposites are identical and conformable to unity in a third determination only-the Highest-which, in as far as it is regulative, is outside of them. In this it is involved that we should first of all have subjective thought, and then distinguished from that, Being. We allow that if we think a content (and it is apparently indifferent whether this is God or any other), it may be the case that this content does not exist. The assertion 'Something that is thought does not exist' is now subsumed under the above standard and is not conformable to it. We grant that the truth is that which is not merely thought

but which likewise is. But of this opposition nothing here is said. Undoubtedly God would be imperfect, if He were merely thought and did not also have the determination of Being. But in relation to God we must not take thought as merely subjective; thought here signifies the absolute, pure thought, and thus we must ascribe to Him the quality of Being. On the other hand if God were merely Being, if He were not conscious of Himself as self-consciousness, He would not be Spirit, a thought that thinks itself.

"Kant, on the other hand, attacked and rejected Anselm's proof-which rejection the whole world afterwards followed upon the ground of its being an assumption that the unity of Being and thought is the highest perfection. What Kant thus demonstrates in the present day-that Being is different from thought and that Being is not by any means posited with thought-was a criticism offered even in that time by a monk named Gaunilo. He combated this proof of Anselm's in a Liber pro insipiente to which Anselm himself directed a reply in his Liber apologeticus adversus insipientem. Thus Kant says (Kritik der reinen Vernunft, p. 464 of the sixth edition): If we think a hundred dollars, this conception does not involve existence. That is certainly true: what is only a conception does not exist, but it is likewise not a true content, for what does not exist, is merely an untrue conception. Of such we do not however here speak, but of pure thought: it is nothing new to say they are different-Anselm knew this just as well as we do. God is the infinite, just as body and soul, Being and thought are eternally united; this is the speculative, true definition of God. To the proof which Kant criticises in a manner which it is the fashion to follow now-a-days, there is thus lacking only the perception of the unity of thought and of existence in the infinite; and this alone must form the commencement."

J. A. DORNER.¹

"According to the *Monologium*, we arrive at the mental representation of God by the agency of faith and conscience, therefore by a combined religious and moral method; by the same means we arrive at the representation of the relativity of the world. But as there seemed to Anselm something inadequate in making the Being of the Absolute dependent upon the existence

1A System of Christian Doctrine. Translated by A. Cave and J. S. Banks, Edinburgh, 1880. Vol. I., p. 216 et seq.

of the Relative, as if the latter were more certain than the former, he has interpolated in the Proslogium (Alloquium Dei) the Ontological method. The thought of God, which is always given, and the being of which is to be proved, claims, at any rate, to be the highest thought possible; indeed, upon close comparison with all other thoughts which come and go, with thoughts of such things as may just as well not exist as exist, it has the essential peculiarity, the prerogative, so to speak, -and this is Anselm's discovery, -that, if it is actually thought of as the highest conceivable thought, it is also thought of as existent. Were it not thought of as being, it would not for a moment be actually thought. Anselm then proceeds with his proof as follows: 'We believe Thou art something, beyond which nothing greater can be thought. The fool (Ps. xiv.) denies the existence of such a Being. Is He therefore non-existent? But the very fool hears and understands what I say, "something, greater than which there is nothing," and what he understands is in his understanding. That it also exists without him would thus have to be proved. But that, beyond which nothing greater can be thought, cannot exist in mere intellect. For did it exist only in intellect, the thought might be framed that it was realised, and that would be a greater thought. Consequently, were that, a greater than which cannot be thought, existent in mere intellect, the thought quo majus cogitari non potest would at the same time be quo majus cogitari potest, which is impossible. Consequently, there exists, in reality as well as in the understanding, something a greater than which cannot be thought. And this is so true that its non-existence cannot be thought. Something may be thought which is only to be thought as existent, and that is a majus than that the non-existence of which may be thought, and that Thou art, O Lord, my God, I must think though I did not believe.' The nerve of the Anselmic argument lies therefore in the notion that an idea which has an objective existence is a majus than that to which mere subjective existence appertains; that, consequently, as under the idea of God the highest thought possible is at any rate expressed, the idea of God is not thought unless it is thought as existent. For, he says in another place, it may be thought of everything that it does not exist, with the exception of that quod summe est to which being pre-eminently belongs. That is, the non-existence may be thought of everything which has beginning or end, or which is constituted of parts and is nowhere whole. But that, and it alone, cannot be thought as

non-existent which has neither beginning nor end, and is not constituted of parts, but is thought of as everywhere existing whole. Gaunilo, Count of Montigny, makes a twofold answer in defence of the atheist. He says that that highest essence has no being in the understanding; it only exists therein by the ear, not by being; it only exists as a man who has heard a sound endeavors to embrace a thing wholly unknown to him in an image. And therein, he says, it is concluded that the mental representation of God in mankind is already a purely contingent one, and is produced from without by the sound of words; its necessary presence in the spirit is not proved. Thus, he adds, much is wanting to the ability of inferring its existence from the finding of such an image in the spirit. In the sphere of mere imagination no one thing has a less or a greater existence than any other thing; each has equally no existence at all. Therefore, he writes, granted that the presence of the idea of God in the spirit is not contingent, still the thought or the concept of God does not essentially argue the being of God. Similarly says Kant later on : 'We are no richer if we think of our ability as one cipher more.' That Anselm also undoubtedly knew, but he opined that the concept of God is different to any other thought, which remains unaltered, whether it is thought of as existent or non-existent; the concept of God is that thought, which is no longer thought unless it is thought as existent, and which. therefore, essentially involves being. But, of course, it is insufficiently established by Anselm that a concept of God which does not necessarily include existence, is not the highest thought, and therefore is not the concept of God, and that, consequently, the really highest thought must also be thought of as existent. To this the following objection attaches. Inasmuch as Anselm treated existence as a majus compared with non-existence, he treated existence as an attribute, whereas it is the bearer of all attributes. So it is not proved by Anselm that the origin of this idea, which, when thought, is thought as existent, is not contingent to the reason, but necessary; and that reason only remains reason by virtue of this idea. Finally, Anselm thinks, thus overrating the Ontological moment, that he has already attained therein the full concept of God. These shortcomings were to be obviated, stage by stage, by his successors."

"To conclude that because the notion of a most perfect Being includes reality as one of its perfections, therefore a most perfect Being necessarily exists, is so obviously to conclude falsely, that after Kant's incisive refutation any attempt to defend such reasoning would be useless. Anselm, in his more free and spontaneous reflection, has here and there touched the thought that the greatest which we can think, if we think it as only thought, is less than the same greatest if we think it as existent. It is not possible that from this reflection either any one should develop a logically cogent proof, but the way in which it is put seems to reveal another fundamental thought which is seeking for expression. For what would it matter if that which is thought as most perfect were, as thought, less than the least reality? Why should this thought disturb us? Plainly for this reason, that it is an immediate certainty that what is greatest, most beautiful, most worthy is not a mere thought, but must be a reality, because it would be intolerable to believe of our ideal that it is an idea produced by the action of thought but having no existence, no power, and no validity in the world of reality. We do not from the perfection of that which is perfect immediately deduce its reality as a logical consequence: but without the circumlocution of a deduction we directly feel the impossibility of its non-existence, and all semblance of syllogistic proof only serves to make more clear the directness of this certainty. If what is greatest did not exist, then what is greatest would not be, and it is not impossible that that which is greatest of all conceivable things should not be."

PROFESSOR ROBERT FLINT.²

"Anselm was the founder of that kind of argumentation which, in the opinion of many, is alone entitled to be described as a *priori* or ontological. He reasoned thus: 'The fool may say in his heart, There is no God; but he only proves thereby that he is a fool, for what he says is self-contradictory. Since he denies that there is a God, he has in his mind the idea of God, and that idea implies the

1 Microcosmus. Translated by E. Hamilton and E. E. C. Jones. Edinburgh, 1887. Vol. II., p. 669 et seq.

2 Theism. New York, 1893. Seventh edition. P. 278 et seq.

existence of God, for it is the idea of a Being than which a higher cannot be conceived. That than which a higher cannot be conceived cannot exist merely as an idea, because what exists merely as an idea is inferior to what exists in reality as well as in idea. The idea of a highest Being which exists merely in thought, is the idea of a highest Being which is not the highest even in thought, but inferior to a highest Being which exists in fact as well as in thought.' This reasoning found unfavorable critics even among the contemporaries of Anselm, and has commended itself completely to few. Yet it may fairly be doubted whether it has been conclusively refuted, and some of the objections most frequently urged against it are certainly inadmissible. It is no answer to it, for example, to deny that the idea of God is innate or universal. The argument merely assumes that he who denies that there is a God must have an idea of God. There is also no force, as Anselm showed, in the objection of Gaunilo, that the existence of God can no more be inferred from the idea of a perfect being, than the existence of a perfect island is to be inferred from the idea of such an island. There neither is nor can be an idea of an island which is greater and better than any other that can ever be conceived. Anselm could safely promise that he would make Gaunilo a present of such an island when he had really imagined it. Only one being -an infinite, independent, necessary being-can be perfect in the sense of being greater and better than every other conceivable being. The objection that the ideal can never logically yield the real-that the transition from thought to fact must be in every instance illegitimate-is merely an assertion that the argument is fallacious. It is an assertion which cannot fairly be made until the argument has been exposed and refuted. The argument is that a certain thought of God is found necessarily to imply His existence. The objection that existence is not a predicate, and that the idea of a God who exists is not more complete and perfect than the idea of a God who does not exist, is, perhaps, not incapable of being satisfactorily repelled. Mere existence is not a predicate, but specifications cr determinations of existence are predicable. Now the argument nowhere implies that existence is a predicate; it implies only that reality, necessity, and independence of existence are predicates of existence; and it implies this on the ground that existence in re can be distinguished from existence in conceptu, necessary from contingent existence, self-existence from derived existence. Specific distinctions must surely admit of being

xxiv

predicated. That the exclusion of existence—which here means real and necessary existence—from the idea of God does not leave us with an incomplete idea of God, is not a position, I think, which can be maintained. Take away existence from among the elements in the idea of a perfect being, and the idea becomes either the idea of a nonentity or the idea of an idea, and not the idea of a perfect being at all. Thus, the argument of Anselm is unwarrantably represented as an argument of four terms instead of three. Those who urge the objection seem to me to prove only that if our thought of God be imperfect, a being who merely realised that thought would be an imperfect being; but there is a vast distance between this truism and the paradox that an unreal being may be an ideally perfect being."

BIBLIOGRAPHY.

Patrologiæ Cursus Completus. Series Secunda. Tomi CLVIII-CLIX. S. Anselmus. [Ed. Abbé MIGNE]. Paris, 1853.

CHURCH. A. W. St. Anselm. [Tbird Edition]. London, 1873

FRANCK, G F. Anselm von Canterbury. Tübingen, 1842.

HASSE, F. R. Anselm von Canterbury. Leipzig, 1843. 2 volumes.

------ The same. Translated and abridged by W. Turner. London, 1850.

RÉMUSAT, CHARLES DE. Anselme de Canterbury. Paris, 1854; 2nd ed., 1868.

- RIGG, J. M. St. Anselm of Canterbury. London, 1896.
- RULE M. The Life and Times of St. Anselm. London, 1883. 2 volumes.

DE VOSGES, LE COMTE DOMET. Saint Anselme, in the series Les Grands Philosophes. Paris, 1901.

WELCH, A. C. Anselm and His Work. Edinburgh, 1901.

BAUR, F. C. Vorlesungen über die christliche Dogmengeschichte. Leipzig, 1866. Zweiter Band, 249-251, 298 ff.

ERDMANN, J. E. A History of Philosophy. English Translation [Ed. W. S. HOUGH]. London, 1891. Vol. I., 303-314.

- HEGEL, G. W. F. Lectures on the History of Philosophy. Translated from the German by E. S. Haldane and F. H. Simson. London, 1896. Vol. III., 61-67.
- HOOK, W. T. Lives of the Archbishops of Canterbury. London, 1862. Vol. VIII., 169-276.
- MAURICE, F. D. Moral and Metaphysical Philosophy. London, 1882. Vol. I., 507-533.
- PFLEIDERER, O. The Philosophy of Religion. Translated by A. Menzies. London, 1888. Vol. III., 271-276.

UEBERWEG, F.¹ History of Philosophy. Translated by G. S.

Morris. New York, 1892. Vol. I., 377-386.

1 Ueberweg gives the titles of German and Latin dissertations on Anselm not included in this list.

xxvi

PROSLOGIUM. MONOLOGIUM. AN APPENDIX IN BEHALF OF THE FOOL BY GAUNILON.

PROSLOGIUM.

1

	PAGE
Preface	I
I. Exhortation of the mind to the contemplation of God.	3
II. Truly there is a God, although the fool hath said in	
his heart, etc	7
III. God cannot be conceived not to exist	8
IV. How the fool has said in his heart what cannot be	
conceived	9
V. God, as the only self-existent being, creates all things	
from nothing	10
VI. How God is sensible (sensibilis) although he is not a	
body	II
VII. How he is omnipotent, although there are many things	
of which he is not capable	
VIII. How he is compassionate and passionless	13
IX. How God is supremely just	14
X. How he justly punishes and justly spares the wicked.	17
XI. How all the ways of God are compassion and truth	
and yet God is just in all his ways	18
XII. God is the very life whereby he lives	19
XIII. How he alone is uncircumscribed and eternal	19
XIV. How and why God is seen and yet not seen by those	
who seek him	20
XV. He is greater than can be conceived	22
XVI. This is the unapproachable light wherein he dwells.	22
XVII. In God is harmony, etc	23
XVIII. God is life, wisdom, eternity, and every true good	23
XIX. He does not exist in place or time, but all things exis	t
in him	. 25
XX. He exists before all things and transcends all things	
oven the eternal things	

		PAGE
XXI.	Is this the age of the age, or ages of ages	27
XXII.	He alone is what he is and who he is	27
XXIII.	This good is equally Father, and Son and Holy Spirit	28
	Conjecture as to the character and the magnitude of	
	this good	29
XXV.	What goods, and how great, belong to those who enjoy	
	this good	30
XXVI.	Is this joy which the Lord promises made full,	33

MONOLOGIUM.

Preface		35
\ I.	There is a being which is best, and greatest, and high-	
	est of all existing beings	37
II.	The same subject continued	40
III.	There is a certain Nature through which whatever is	
	exists, etc	41
	The same subject continued	43
v.	Just as this Nature exists through itself, and other beings through it, so it derives existence from it-	
	self, and other beings from it	45
VI.	This Nature was not brought into existence with the	
	help of any external cause, yet it does not exist	
	through nothing, or derive existence from nothing.	46
VII.	In what way all other beings exist through this Nature	
	and derive existence from it	49
VIII.	How it is to be understood that this Nature created all	
	things from nothing	52
IX.	Those things which were created from nothing had an	
	existence before their creation in the thought of the	
	Creator	55
Χ.	This thought is a kind of expression of the thoughts	
	created (locutio rerum), like the expression which	
	an artisan forms in his mind for what he intends to	
	make	56
XI.	The analogy, however, between the expression of the	
	Creator and the expression of the artisan is very	
	complete	58
XII.	This expression of the supreme Being is the supreme	
	Being	59
	U	

XXX

		AGE
XIII.	As all things were created through the supreme	
	Being, so all live through it	60
XIV.	This Being is in all things, and throughout all	60
XV.	What can or cannot be stated concerning the sub-	
	stance of this Being	61
XVI.	For this Being it is the same to be just that it is to	
	be justice	64
XVII.	It is simple in such a way that all things that can	
	be said of its essence are one and the same in it.	66
XVIII.	It is without beginning and without end	68
	In what sense nothing existed before or will exist	
	after this Being	70
XX.	It exists in every place and at every time	72
	It exists in no place or time	73
XXII.	How it exists in every place and time, and in none.	78
	How it is better conceived to exist everywhere than	
	in every place	82
XXIV.	How it is better understood to exist always than at	
	every time	82
XXV.	It cannot suffer change by any accidents	84
XXVI.	How this Being is said to be substance	85
XXVII.	It is not included among substances as commonly	
	treated, yet it is a substance and an indivisible	
	spirit	86
XVIII.	This Spirit exists simply, and created beings are not	
	comparable with him	87
XXIX.	His expression is identical with himself, and con-	
	substantial with him	89
XXX.	This expression does not consist of more words than	
	one, but is one Word	90
XXXI.	This Word itself is not the likeness of created beings,	
	but the reality of their being	91
XXXII.	The supreme Spirit expresses himself by a coeternal	
	Word	94
XXXIII.	He utters himself and what he creates by a single	
	consubstantial Word	95
	How he can express the created world by his Word	98
XXXV.	Whatever has been created is in his Word and	
	knowledge, life and truth	99
XXXVI.	In how incomprehensible a way he expresses or	
	knows the objects created by him	99

3

xxxi

XXXVII.	Whatever his relations to his creatures, this rela-	AGE
XXXVIII.	tion his Word also sustains It cannot be explained why they are two, although	
XXXIX.	they must be so This Word derives existence from the supreme	
XL.	Spirit by birth He is most truly a parent, and that Word his off-	
	spring	
	He most truly begets, and it is most truly begotten	104
XLII.	It is the property of the one to be most truly pro- genitor and Father, and of the other to be begot-	
XLIII.	ten and Son Consideration of the common attributes of both and the individual properties of each	
¥T TV	How one is the essence of the other	100
	The Son may more appropriately be called the	107
ALV.	essence of the Father, than the Father the es- sence of the son	
XLVI.	How some of these truths which are thus expounded may also be conceived of in another	
	way	III
XLVII.	The Son is the intelligence of intelligence and the	
	truth of truth	III
XLVIII.	How the Son is the intelligence or wisdom of mem-	
	ory or the memory of the Father and of memory	
	The supreme Spirit loves himself	113
L.	The same love proceeds equally from Father and	
	Son Each loves himself and the other with equal love.	
	This love is as great as the supreme Spirit himself	
	This Love is identical with the supreme Spirit nimself	115
1 111.	yet it is itself with the Father and the Son one spirit.	
TTV	It proceeds as a whole from the Father, and as a	115
131V.	whole from the Son, and yet does not exist ex- cept as one love	
TV	This love is not their Son	
	Only the Father begets and is unbegotten; only	117
LV1.	the Son is begotten; only love neither begotten	
	nor unbegotten	118

xxxii

	P	AGE
LVII. 1	This love is uncreated and creator, as are Father and Son; it may be called the Spirit of Father	
		119
LVIII. A	as the Son is the essence or wisdom of the Father	
	In the sense that he had the banne etter	4
	dom that the Father has; so likewise the Spirit	
	is the essence and wisdom etc. of Father and	
	Son	120
LIX. 7	The Father and the Son and their Spirit exist	
	equality the one in the entertertertertertertertertertertertertert	120
LX. 7	To none of these is another necessary that he may	
		121
LXI. Y	Yet there are not three, but one Father and one	
	bon and one opinition in the state of the	122
LXII. I	How it seems that of these three more sons than	
	one are born How among them there is only one Son of one Fa-	123
LAIII. I	ther, that is, one Word, and that from the Father	
	alone	125
TVIV	Though this truth is inexplicable, it demands be-	
LAIV.		127
LXV	How real truth may be reached in the discussion	,
	of an ineffable subject	128
LXVI.	Through the rational mind is the nearest approach	
	to the supreme Being	131
LXVII.	The mind itself is the mirror and image of that	
	Being	132
LXVIII.	The rational creature was created in order that it	
	might love this Being	132
LXIX.	The soul that ever loves this Essence lives at some	
	time in true blessedness	134
LXX.	This Being gives itself in return to the creature	
	that loves it, that that creature may be eternally	
	blessed	135
LXXI.	The soul that despises this being will be eternally	
	miserable	137
LXXII.	Every human soul is immortal. And it is either	
	forever miserable, or at some time truly blessed.	130
LAXIII.	No soul is unjustly deprived of the supreme good, and every effort must be directed toward that	
	and every enort must be unected toward that	138
	2000	- 30

LXXIV.	The supreme Being is to be hoped for	PAGE
LXXV.	We must believe in this Being, that is, by believ-	
	ing we must reach for it	139
LXXVI.	We should believe in Father and Son and in their	
	Spirit equally, and in each separately, and in the	
	three at once	140
LXXVII.	What is living and what dead faith	141
LXXVIII.	The supreme Being may in some sort be called	
	Three	142
LXXIX.	The Essence itself is God, who alone is lord and	
	ruler of all	143

APPENDIX.

IN BEHALF OF THE FOOL.

An answer	to the argument of	Anselm	in the	Pros	logium.	By	
	Gaunilon						145

ANSELM'S APOLOGETIC.

I.	A general refutation of Gaunilon's argument. It is	
	shown that a being than which a greater cannot be conceived exists in reality	153
11.	The argument is continued. It is shown that a being than which a greater is inconceivable can be con-	
111.	ceived, and also in so far, exists A criticism of Gaunilon's example, in which he tries to show that in this way the real existence of a lost	157
	island might be inferred from the fact of its being conceived	0
IV.	The difference between the possibility of conceiving of non-existence, and understanding non-existence	
v.	A particular discussion of certain statements of Gauni-	
VI.	lon's A discussion of Gaunilon's argument, that any unreal beings can be understood in the same way, and would,	
711.	to that extent, exist In answer to another objection; that the supremely great being may be conceived not to exist, just as by	164
	the fool God is conceived not to exist	The

xxxiv

XXXV

		AGE
VIII.	The example of the picture, treated in Gaunilon's third	
	chapter, is examinedFrom what source a notion	
	may be formed of the supremely great being of which	
	Gaunilon inquired in his fourth chapter	166
IX.	The possibility of understanding and conceiving of the	
	supremely great being. The argument advanced	
	against the fool is confirmed	168
X.	The certainty of the foregoing argumentThe conclu-	
	sion of the book	169

ANSELM'S PROSLOGIUM

OR DISCOURSE ON THE EXISTENCE OF GOD

PREFACE.

It Anis brief work the author aims at proving in a single argument the existence of God, and whatsoever we believe of God.—The difficulty of the task.—The author writes in the person of one who contemplates God, and seeks to understand what he believes. To this work he had given this title: Faith Seeking Understanding. He finally named it Proslogium,—that is, A Discourse.

AFTER I had published, at the solicitous entreaties of certain brethren, a brief work (the *Monologium*) as an example of meditation on the grounds of faith, in the person of one who investigates, in a course of silent reasoning with himself, matters of which he is ignorant; considering that this book was knit together by the linking of many arguments, I began to ask myself whether there might be found a single argument which would require no other for its proof than itself alone; and alone would suffice to demonstrate that God truly exists, and that there is a supreme good requiring nothing else, which all other things require for their existence and well-being; and whatever we believe regarding the divine Being.

Although I often and earnestly directed my thought to this end, and at some times that which I sought

ANSELM.

seemed to be just within my reach, while again it wholly evaded my mental vision, at last in despair I was about to cease, as if from the search for a thing which could not be found. But when I wished to exclude this thought altogether, lest, by busying my mind to no purpose, it should keep me from other thoughts, in which I might be successful; then more and more, though I was unwilling and shunned it, it began to force itself upon me, with a kind of importunity. So, one day, when I was exceedingly wearied with resisting its importunity, in the very conflict of my thoughts, the proof of which I had despaired offered itself, so that I eagerly embraced the thoughts which I was strenuously repelling.

Thinking, therefore, that what I rejoiced to have found, would, if put in writing, be welcome to some readers, of this very matter, and of some others, I have written the following treatise, in the person of one who strives to lift his mind to the contemplation of God, and seeks to understand what he believes. In my judgment, neither this work nor the other, which I mentioned above, deserved to be called a book, or to bear the name of an author; and yet I thought they ought not to be sent forth without some title by which they might, in some sort, invite one into whose hands they fell to their perusal. I accordingly gave each a title, that the first might be known as, An Example of Meditation on the Grounds of Faith, and its sequel as, Faith Seeking Understanding. But, after both had been copied by many under these titles, many urged me, and especially Hugo, the reverend Archbishop of Lyons, who discharges the apostolic office in Gaul, who instructed me to this effect on his apostolic authority-to prefix my name to these writ-

PROSLOGIUM.

ings. And that this might be done more fitly, I named the first, *Monologium*, that is, A Soliloquy; but the second, *Proslogium*, that is, A Discourse.

CHAPTER I.

Exhortation of the mind to the contemplation of God.—It casts aside cares, and excludes all thoughts save that of God, that it may seek Him. Man was created to see God. Man by sin lost the blessedness for which he was made, and found the misery for which he was not made. He did not keep this good when he could keep it easily. Without God it is ill with us. Our labors and attempts are in vain without God. Man cannot seek God, unless God himself teaches him; nor find him, unless he reveals himself. God created man in his image, that he might be mindful of him, think of him, and love him. The believer does not seek to understand, that he may believe, but he believes that he may understand : for unless he believed he would not understand.

UP now, slight man! flee, for a little while, thy occupations; hide thyself, for a time, from thy disturbing thoughts. Cast aside, now, thy burdensome cares, and put away thy toilsome business. Yield room for some little time to God; and rest for a little time in him. Enter the inner chamber of thy mind; shut out all thoughts save that of God, and such as can aid thee in seeking him; close thy door and seek him. Speak now, my whole heart! speak now to God, saying, I seek thy face; thy face, Lord, will I seek (Psalms xxvii. 8). And come thou now, O Lord my God, teach my heart where and how it may seek thee, where and how it may find thee.

Lord, if thou art not here, where shall I seek thee, being absent? But if thou art everywhere, why do I not see thee present? Truly thou dwellest in unap-

ANSELM.

proachable light. But where is unapproachable light. or how shall I come to it? Or who shall lead me to that light and into it. that I may see thee in it? Again, by what marks, under what form, shall I seek thee? I have never seen thee. O Lord. my God: I do not know thy form. What, O most high Lord, shall this man do, an exile far from thee? What shall thy servant do, anxious in his love of thee, and cast out afar from thy face? He pants to see thee, and thy face is too far from him. He longs to come to thee, and thy dwelling-place is inaccessible. He is eager to find thee, and knows not thy place. He desires to seek thee, and does not know thy face. Lord, thou art my God, and thou art my Lord, and never have I seen It is thou that hast made me, and hast made thee. me anew, and hast bestowed upon me all the blessings I enjoy; and not yet do I know thee. Finally, I was created to see thee, and not yet have I done that for which I was made.

O wretched lot of man, when he hath lost that for which he was made! O hard and terrible fate! Alas, what has he lost, and what has he found? What has departed, and what remains? He has lost the blessedness for which he was made, and has found the misery for which he was not made. That has departed without which nothing is happy, and that remains which, in itself, is only miserable. Man once did eat the bread of angels, for which he hungers now; he eateth now the bread of sorrows, of which he knew not then. Alas! for the mourning of all mankind, for the universal lamentation of the sons of Hades! He choked with satiety, we sigh with hunger. He abounded, we beg. He possessed in happiness, and miserably forsook his possession; we suffer want in unhappiness, and feel a miserable longing, and alas! we remain empty.

Why did he not keep for us, when he could so easily, that whose lack we should feel so heavily? Why did he shut us away from the light, and cover us over with darkness? With what purpose did he rob us of life, and inflict death upon us? Wretches that we are, whence have we been driven out; whither are we driven on? Whence hurled? Whither consigned to ruin? From a native country into exile, from the vision of God into our present blindness, from the joy of immortality into the bitterness and horror of death. Miserable exchange of how great a good, for how great an evil ! Heavy loss, heavy grief heavy all our fate !

But alas! wretched that I am, one of the sons of Eve, far removed from God! What have I undertaken? What have I accomplished? Whither was I striving? How far have I come? To what did I as pire? Amid what thoughts am I sighing? I sought blessings, and lo! confusion. I strove toward God, and I stumbled on myself. I sought calm in privacy, and I found tribulation and grief, in my inmost thoughts. I wished to smile in the joy of my mind, and I am compelled to frown by the sorrow of my heart. Gladness was hoped for, and lo! a source of frequent sighs!

And thou too, O Lord, how long? How long, O Lord, dost thou forget us; how long dost thou turn thy face from us? When wilt thou look upon us, and hear us? When wilt thou enlighten our eyes, and show us thy face? When wilt thou restore thyself to us? Look upon us, Lord; hear us, enlighten us, reveal thyself to us. Restore thyself to us, that it may

ANSELM.

be well with us,-thyself, without whom it is so ill with us. Pity our toilings and strivings toward thee, since we can do nothing without thee. Thou dost invite us; do thou help us. I beseech thee, O Lord, that I may not lose hope in sighs, but may breathe anew in hope. Lord, my heart is made bitter by its desolation; sweeten thou it, I beseech thee, with thy consolation. Lord, in hunger I began to seek thee: I beseech thee that I may not cease to hunger for thee. In hunger I have come to thee; let me not go unfed. I have come in poverty to the Rich, in misery to the Compassionate; let me not return empty and despised. And if, before I eat, I sigh, grant, even after sighs, that which I may eat. Lord, I am bowed down and can only look downward; raise me up that I may look upward. My iniquities have gone over my head; they overwhelm me; and, like a heavy load, they weigh me down. Free me from them ; unburden me, that the pit of iniquities may not close over me.

Be it mine to look up to thy light, even from afar, even from the depths. Teach me to seek thee, and reveal thyself to me, when I seek thee, for I cannot seek thee, except thou teach me, nor find thee, except thou reveal thyself. Let me seek thee in longing, let me long for thee in seeking; let me find thee in love, and love thee in finding. Lord, I acknowledge and I thank thee that thou hast created me in this thine image, in order that I may be mindful of thee, may conceive of thee, and love thee; but that image has been so consumed and wasted away by vices, and obscured by the smoke of wrong-doing, that it cannot achieve that for which it was made, except thou renew it, and create it anew. I do not endeavor, O Lord, to penetrate thy sublimity, for in no wise do I

PROSLOGIUM.

compare my understanding with that; but I long to understand in some degree thy truth, which my heart believes and loves. For I do not seek to understand that I may believe, but I believe in order to understand. For this also I believe,—that unless I believed, I should not understand.

CHAPTER II.

Truly there is a God, although the fool hath said in his heart, There is no God.

AND so, Lord, do thou, who dost give understanding to faith, give me, so far as thou knowest it to be profitable, to understand that thou art as we believe; and that thou art that which we believe. And, indeed, we believe that thou art a being than which nothing greater can be conceived. Or is there no such nature, since the fool hath said in his heart, there is no God? (Psalms xiv. 1). But, at any rate, this very fool, when he hears of this being of which I speak—a being than which nothing greater can be conceived—understands what he hears, and what he understands is in his understanding; although he does not understand it to exist.

For, it is one thing for an object to be in the understanding, and another to understand that the object exists. When a painter first conceives of what he will afterwards perform, he has it in his understanding, but he does not yet understand it to be, because he has not yet performed it. But after he has made the painting, he both has it in his understanding, and he understands that it exists, because he has made it.

ANSELM.

Hence, even the fool is convinced that something exists in the understanding, at least, than which nothing greater can be conceived. For, when he hears of this, he understands it. And whatever is understood, exists in the understanding. And assuredly that, than which nothing greater can be conceived, cannot exist in the understanding alone. For, suppose it exists in the understanding alone: then it can be conceived to exist in reality; which is greater.

Therefore, if that, than which nothing greater can be conceived, exists in the understanding alone, the very being, than which nothing greater can be conceived, is one, than which a greater can be conceived. But obviously this is impossible. Hence, there is no doubt that there exists a being, than which nothing greater can be conceived, and it exists both in the understanding and in reality.

CHAPTER III.

God cannot be conceived not to exist.—God is that, than which nothing greater can be conceived.—That which can be conceived not to exist is not God.

AND it assuredly exists so truly, that it cannot be conceived not to exist. For, it is possible to conceive of a being which cannot be conceived not to exist; and this is greater than one which can be conceived not to exist. Hence, if that, than which nothing greater can be conceived, can be conceived not to exist, it is not that, than which nothing greater can be conceived. But this is an irreconcilable contradiction. There is, then, so truly a being than which nothing greater can be conceived to exist, that it cannot even be conceived not to exist; and this being thou art, O Lord, our God.

So truly, therefore, dost thou exist, O Lord, my God, that thou canst not be conceived not to exist; and rightly. For, if a mind could conceive of a being better than thee, the creature would rise above the Creator; and this is most absurd. And, indeed, whatever else there is, except thee alone, can be conceived not to exist. To thee alone, therefore, it belongs to exist more truly than all other beings, and hence in a higher degree than all others. For, whatever else exists does not exist so truly, and hence in a less degree it belongs to it to exist. Why, then, has the fool said in his heart, there is no God (Psalms xiv. 1), since it is so evident, to a rational mind, that thou dost exist in the highest degree of all? Why, except that he is dull and a fool?

CHAPTER IV.

How the fool has said in his heart what cannot be conceived.—A thing may be conceived in two ways: (1) when the word signifying it is conceived; (2) when the thing itself is understood As far as the word goes, God can be conceived not to exist; in reality he cannot.

But how has the fool said in his heart what he could not conceive; or how is it that he could not conceive what he said in his heart? since it is the same to say in the heart, and to conceive.

But, if really, nay, since really, he both conceived, because he said in his heart; and did not say in his heart, because he could not conceive; there is more than one way in which a thing is said in the heart or conceived. For, in one sense, an object is conceived, when the word signifying it is conceived; and in another, when the very entity, which the object is, is understood.

In the former sense, then, God can be conceived not to exist; but in the latter, not at all. For no one who understands what fire and water are can conceive fire to be water, in accordance with the nature of the facts themselves, although this is possible according to the words. So, then, no one who understands what God is can conceive that God does not exist; although he says these words in his heart, either without any. or with some foreign, signification. For, God is that than which a greater cannot be conceived. And he who thoroughly understands this, assuredly understands that this being so truly exists, that not even in concept can it be non-existent. Therefore, he who understands that God so exists, cannot conceive that he does not exist.

I thank thee, gracious Lord, I thank thee; because what I formerly believed by thy bounty, I now so understand by thine illumination, that if I were unwilling to believe that thou dost exist, I should not be able not to understand this to be true.

CHAPTER V.

God is whatever it is better to be than not to be; and he, as the only self-existent being, creates all things from nothing.

WHAT art thou, then, Lord God, than whom nothing greater can be conceived? But what art thou, except that which, as the highest of all beings, alone exists through itself, and creates all other things from nothing? For, whatever is not this is less than a thing which can be conceived of. But this cannot be con-

PROSLOGIUM.

ceived of thee. What good, therefore, does the supreme Good lack, through which every good is? Therefore, thou art just, truthful, blessed, and whatever it is better to be than not to be. For it is better to be just than not just; better to be blessed than not blessed.

CHAPTER VI.

How God is sensible (*sensibilis*) although he is not a body.—God is sensible, omnipotent, compassionate, passionless; for it is better to be these than not be. He who in any way knows, is not improperly said in some sort to feel.

Bur, although it is better for thee to be sensible, omnipotent, compassionate, passionless, than not to be these things; how art thou sensible, if thou art not a body; or omnipotent, if thou hast not all powers; or at once compassionate and passionless? For, if only corporeal things are sensible, since the senses encompass a body and are in a body, how art thou sensible, although thou art not a body, but a supreme Spirit, who is superior to body? But, if feeling is only cognition, or for the sake of cognition,—for he who feels obtains knowledge in accordance with the proper functions of his senses; as through sight, of colors; through taste, of flavors,—whatever in any way cognises is not inappropriately said, in some sort, to feel.

Therefore, O Lord, although thou art not a body, yet thou art truly sensible in the highest degree in respect of this, that thou dost cognise all things in the highest degree; and not as an animal cognises, through a corporeal sense.

ANSELM.

CHAPTER VII.

How he is omnipotent, although there are many things of which he is not capable.—To be capable of being corrupted, or of lying, is not power, but impotence. God can do nothing by virtue of impotence, and nothing has power against him.

But how art thou omnipotent, if thou art not capable of all things? Or, if thou canst not be corrupted, and canst not lie, nor make what is true, false —as, for example, if thou shouldst make what has been done not to have been done, and the like—how art thou capable of all things? Or else to be capable of these things is not power, but impotence. For, he who is capable of these things is capable of what is not for his good, and of what he ought not to do; and the more capable of them he is, the more power have adversity and perversity against him; and the less has he himself against these.

He, then, who is thus capable is so not by power, but by impotence. For, he is not said to be able because he is able of himself, but because his impotence gives something else power over him. Or, by a figure of speech, just as many words are improperly applied, as when we use "to be" for "not to be," and "to do" for what is really "not to do," or "to do nothing." For, often we say to a man who denies the existence of something: "It is as you say it to be," though it might seem more proper to say, "It is not, as you say it is not." In the same way, we say: "This man sits just as that man does," or, "This man rests just as that man does"; although to sit is not to do anything, and to rest is to do nothing.

So, then, when one is said to have the power of

doing or experiencing what is not for his good, or what he ought not to do, impotence is understood in the word power. For, the more he possesses this power, the more powerful are adversity and perversity against him, and the more powerless is he against them.

Therefore, O Lord, our God, the more truly art thou omnipotent, since thou art capable of nothing through impotence, and nothing has power against thee.

CHAPTER VIII.

How he is compassionate and passionless. God is compassionate, in terms of our experience, because we experience the effect of compassion. God is not compassionate, in terms of his own being, because he does not experience the feeling (affectus) of compassion.

But how art thou compassionate, and, at the same time, passionless? For, if thou art passionless, thou dost not feel sympathy; and if thou dost not feel sympathy, thy heart is not wretched from sympathy for the wretched; but this it is to be compassionate. But if thou art not compassionate, whence cometh so great consolation to the wretched? How, then, art thou compassionate and not compassionate in terms of our experience, and not compassionate in terms of thy being.

Truly, thou art so in terms of our experience, but thou art not so in terms of thine own. For, when thou beholdest us in our wretchedness, we experience the effect of compassion, but thou dost not experience the feeling. Therefore, thou art both compassionate, because thou dost save the wretched, and spare those

who sin against thee; and not compassionate, because thou art affected by no sympathy for wretchedness.

CHAPTER IX.

How the all-just and supremely just God spares the wicked, and justly pities the wicked. He is better who is good to the righteous and the wicked than he who is good to the righteous alone. Although God is supremely just, the source of his compassion is hidden. God is supremely compassionate, because he is supremely just. He saveth the just, because justice goes with them; he frees sinners by the authority of justice. God spares the wicked out of justice; for it is just that God, than whom none is better or more powerful, should be good even to the wicked, and should make the wicked good. If God ought not to pity, he pities unjustly. But this it is impious to suppose. Therefore, God justly pities.

Bur how dost thou spare the wicked, if thou art all just and supremely just? For how, being all just and supremely just, dost thou aught that is not just? Or, what justice is that to give him who merits eternal death everlasting life? How, then, gracious Lord, good to the righteous and the wicked, canst thou save the wicked, if this is not just, and thou dost not aught that is not just? Or, since thy goodness is incomprehensible, is this hidden in the unapproachable light wherein thou dwellest? Truly, in the deepest and most secret parts of thy goodness is hidden the fountain whence the stream of thy compassion flows.

For thou art all just and supremely just, yet thou art kind even to the wicked, even because thou art all supremely good. For thou wouldst be less good if thou wert not kind to any wicked being. For, he who is good, both to the righteous and the wicked, is better than he who is good to the good alone;

and he who is good to the wicked, both by punishing and sparing them, is better than he who is good by punishing them alone. Therefore, thou art compassionate, because thou art all supremely good. And, although it appears why thou dost reward the good with goods and the evil with evils; yet this, at least, is most wonderful, why thou, the all and supremely just, who lackest nothing, bestowest goods on the wicked and on those who are guilty toward thee.

The depth of thy goodness, O God! The source of thy compassion appears, and yet is not clearly seen! We see whence the river flows, but the spring whence it arises is not seen. For, it is from the abundance of thy goodness that thou art good to those who sin against thee; and in the depth of thy goodness is hidden the reason for this kindness.

For, although thou dost reward the good with goods and the evil with evils, out of goodness, yet this the concept of justice seems to demand. But, when thou dost bestow goods on the evil, and it is known that the supremely Good hath willed to do this, we wonder why the supremely Just has been able to will this.

O compassion, from what abundant sweetness and what sweet abundance dost thou well forth to us! O boundless goodness of God, how passionately should sinners love thee! For thou savest the just, because justice goeth with them; but sinners thou dost free by the authority of justice. Those by the help of their deserts; these, although their deserts oppose. Those by acknowledging the goods thou hast granted; these by pardoning the evils thou hatest. O boundless goodness, which dost so exceed all understanding, let that compassion come upon me, which proceeds from thy so great abundance! Let it flow upon me, for it wells forth from thee. Spare, in mercy; avenge not, in justice.

For, though it is hard to understand how thy compassion is not inconsistent with thy justice; yet we must believe that it does not oppose justice at all, because it flows from goodness, which is no goodness without justice; nay, that it is in true harmony with justice. For, if thou art compassionate only because thou art supremely good, and supremely good only because thou art supremely just, truly thou art compassionate even because thou art supremely just. Help me, just and compassionate God, whose light I seek; help me to understand what I say.

Truly, then, thou art compassionate even because thou art just. Is, then, thy compassion born of thy justice? And dost thou spare the wicked, therefore, out of justice? If this is true, my Lord, if this is true, teach me how it is. Is it because it is just, that thou shouldst be so good that thou canst not be conceived better; and that thou shouldst work so powerfully that thou canst not be conceived more powerful? For what can be more just than this? Assuredly it could not be that thou shouldst be good only by requiring (*retribuendo*) and not by sparing, and that thou shouldst make good only those who are not good, and not the wicked also. In this way, therefore, it is just that thou shouldst spare the wicked, and make good souls of evil.

Finally, what is not done justly ought not to be done; and what ought not to be done is done unjustly. If, then, thou dost not justly pity the wicked, thou oughtest not to pity them. And, if thou oughtest not to pity them, thou pityest them unjustly. And if

it is impious to suppose this, it is right to believe that thou justly pityest the wicked.

CHAPTER X.

How he justly punishes and justly spares the wicked.—God, in sparing the wicked, is just, according to his own nature, because he does what is consistent with his goodness; but he is not just, according to our nature, because he does not inflict the punishment deserved.

But it is also just that thou shouldst punish the wicked. For what is more just than that the good should receive goods, and the evil, evils? How, then, is it just that thou shouldst punish the wicked, and, at the same time, spare the wicked? Or, in one way, dost thou justly punish, and, in another, justly spare them? For, when thou punishest the wicked, it is just, because it is consistent with their deserts; and when, on the other hand, thou sparest the wicked, it is just, not because it is compatible with their deserts, but because it is compatible with thy goodness.

For, in sparing the wicked, thou art as just, according to thy nature, but not according to ours, as thou art compassionate, according to our nature, and not according to thine; seeing that, as in saving us, whom it would be just for thee to destroy, thou art compassionate, not because thou feelest an affection (affectum), but because we feel the effect (effectum); so thou art just, not because thou requitest us as we deserve, but because thou dost that which becomes thee as the supremely good Being. In this way, therefore, without contradiction thou dost justly punish and justly spare.

CHAPTER XI.

How all the ways of God are compassion and truth; and yet God is just in all his ways.—We cannot comprehend why, of the wicked, he saves these rather than those, through his supreme goodness; and condemns those rather than these, through his supreme justice.

But, is there any reason why it is not also just, according to thy nature, O Lord, that thou shouldst punish the wicked? Surely it is just that thou shouldst be so just that thou canst not be conceived more just; and this thou wouldst in no wise be if thou didst only render goods to the good, and not evils to the evil. For, he who requiteth both good and evil according to their deserts is more just than he who so requites the good alone. It is, therefore, just, according to thy nature, O just and gracious God, both when thou dost punish and when thou sparest.

Truly, then, all the paths of the Lord are mercy and truth (Psalms xxv. 10); and yet the Lord is righteous in all his ways (Psalms cxlv. 17). And assuredly without inconsistency: For, it is not just that those whom thou dost will to punish should be saved, and that those whom thou dost will to spare should be condemned. For that alone is just which thou dost will; and that alone unjust which thou dost not will. So, then, thy compassion is born of thy justice.

For it is just that thou shouldst be so good that thou art good in sparing also; and this may be the reason why the supremely Just can will goods for the evil. But if it can be comprehended in any way why thou canst will to save the wicked, yet by no consideration can we comprehend why, of those who are

alike wicked, thou savest some rather than others, through supreme goodness; and why thou dost condemn the latter rather than the former, through supreme justice.

So, then, thou art truly sensible (*sensibilis*), omnipotent, compassionate, and passionless, as thou art living, wise, good, blessed, eternal: and whatever it is better to be than not to be.

CHAPTER XII.

God is the very life whereby he lives; and so of other like attributes.

But undoubtedly, whatever thou art, thou art through nothing else than thyself. Therefore, thou art the very life whereby thou livest; and the wisdom wherewith thou art wise; and the very goodness whereby thou art good to the righteous and the wicked; and so of other like attributes.

CHAPTER XIII.

How he alone is uncircumscribed and eternal, although other spirits are uncircumscribed and eternal.—No place and time contain God. But he is himself everywhere and always. He alone not only does not cease to be, but also does not begin to be.

But everything that is in any way bounded by place or time is less than that which no law of place or time limits. Since, then, nothing is greater than thou, no place or time contains thee; but thou art everywhere and always. And since this can be said of thee alone, thou alone art uncircumscribed and eternal. How is it, then, that other spirits also are said to be uncircumscribed and eternal? Assuredly thou art alone eternal; for thou alone among all beings not only dost not cease to be, but also dost not begin to be.

But how art thou alone uncircumscribed? Is it that a created spirit, when compared with thee, is circumscribed, but when compared with matter, uncircumscribed? For altogether circumscribed is that which, when it is wholly in one place, cannot at the same time be in another. And this is seen to be true of corporeal things alone. But uncircumscribed is that which is, as a whole, at the same time everywhere. And this is understood to be true of thee alone. But circumscribed, and, at the same time, uncircumscribed is that which, when it is anywhere as a whole, can at the same time be somewhere else as a whole, and yet not everywhere. And this is recognised as true of created spirits. For, if the soul were not as a whole in the separate members of the body. it would not feel as a whole in the separate members.

Therefore, thou, Lord, art peculiarly uncircumscribed and eternal; and yet other spirits also are uncircumscribed and eternal.

CHAPTER XIV.

How and why God is seen and yet not seen by those who seek him.

HAST thou found what thou didst seek, my soul? Thou didst seek God. Thou hast found him to be a being which is the highest of all beings, a being than which nothing better can be conceived; that this being is life itself, light, wisdom, goodness, eternal blessedness and blessed eternity; and that it is everywhere and always. For, if thou hast not found thy God, how is he this being which thou hast found, and which thou hast conceived him to be, with so certain truth and so true certainty? But, if thou hast found him, why is it that thou dost not feel thou hast found him? Why, O Lord, our God, does not my soul feel thee, if it hath found thee? Or, has it not found him whom it found to be light and truth? For how did it understand this, except by seeing light and truth? Or, could it understand anything at all of thee, except through thy light and thy truth?

Hence, if it has seen light and truth, it has seen thee; if it has not seen thee, it has not seen light and truth. Or, is what it has seen both light and truth; and still it has not yet seen thee, because it has seen thee only in part, but has not seen thee as thou art? Lord my God, my creator and renewer, speak to the desire of my soul, what thou art other than it hath seen, that it may clearly see what it desires. It strains to see thee more; and sees nothing beyond this which it hath seen, except darkness. Nay, it does not see darkness, of which there is none in thee; but it sees that it cannot see farther, because of its own darkness.

Why is this, Lord, why is this? Is the eye of the soul darkened by its infirmity, or dazzled by thy glory? Surely it is both darkened in itself, and dazzled by thee. Doubtless it is both obscured by its own insignificance, and overwhelmed by thy infinity. Truly, it is both contracted by its own narrowness and overcome by thy greatness.

For how great is that light from which shines every truth that gives light to the rational mind? How great is that truth in which is everything that is

true, and outside which is only nothingness and the false? How boundless is the truth which sees at one glance whatsoever has been made, and by whom, and through whom, and how it has been made from nothing? What purity, what certainty, what splendor where it is? Assuredly more than a creature can conceive.

CHAPTER XV.

He is greater than can be conceived.

THEREFORE, O Lord, thou art not only that than which a greater cannot be conceived, but thou art a being greater than can be conceived. For, since it can be conceived that there is such a being, if thou art not this very being, a greater than thou can be conceived. But this is impossible.

CHAPTER XVI.

This is the unapproachable light wherein he dwells.

TRULY, O Lord, this is the unapproachable light in which thou dwellest; for truly there is nothing else which can penetrate this light, that it may see thee there. Truly, I see it not, because it is too bright for me. And yet, whatsoever I see, I see through it, as the weak eye sees what it sees through the light of the sun, which in the sun itself it cannot look upon. My understanding cannot reach that light, for it shines too bright. It does not comprehend it, nor does the eye of my soul endure to gaze upon it long. It is dazzled by the brightness, it is overcome by the greatness, it is overwhelmed by the infinity, it is dazed by the largeness, of the light.

O supreme and unapproachable light! O whole

and blessed truth, how far art thou from me, who am so near to thee! How far removed art thou from my vision, though I am so near to thine! Everywhere thou art wholly present, and I see thee not. In thee I move, and in thee I have my being; and I cannot come to thee. Thou art within me, and about me, and I feel thee not.

CHAPTER XVII.

In God is harmony, fragrance, sweetness, pleasantness to the touch, beauty, after his ineffable manner.

STILL thou art hidden, O Lord, from my soul in thy light and thy blessedness; and therefore my soul still walks in its darkness and wretchedness. For it looks, and does not see thy beauty. It hearkens, and does not hear thy harmony. It smells, and does not perceive thy fragrance. It tastes, and does not recognise thy sweetness. It touches, and does not feel thy pleasantness. For thou hast these attributes in thyself, Lord God, after thine ineffable manner, who hast given them to objects created by thee, after their sensible manner; but the sinful senses of my soul have grown rigid and dull, and have been obstructed by their long listlessness.

CHAPTER XVIII.

God is life, wisdom, eternity, and every true good.—Whatever is composed of parts is not wholly one; it is capable, either in fact or in concept, of dissolution. In God wisdom, eternity, etc., are not parts, but one, and the very whole which God is, or unity itself, not even in concept divisible.

AND lo, again confusion; lo, again grief and mourning meet him who seeks for joy and gladness. My

soul now hoped for satisfaction; and lo, again it is overwhelmed with need. I desired now to feast, and lo, I hunger more. I tried to rise to the light of God, and I have fallen back into my darkness. Nay, not only have I fallen into it, but I feel that I am enveloped in it. I fell before my mother conceived me. Truly, in darkness I was conceived, and in the cover of darkness I was born. Truly, in him we all fell, in whom we all sinned. In him we all lost, who kept easily, and wickedly lost to himself and to us that which when we wish to seek it, we do not know; when we seek it, we do not find; when we find, it is not that which we seek.

Do thou help me for thy goodness' sake! Lord, I sought thy face; thy face, Lord, will I seek; hide not thy face far from me (Psalms xxvii. 8). Free me from myself toward thee. Cleanse, heal, sharpen, enlighten the eye of my mind, that it may behold thee. Let my soul recover its strength, and with all its understanding let it strive toward thee, O Lord. What art thou, Lord, what art thou? What shall my heart conceive thee to be?

Assuredly thou art life, thou art wisdom, thou art truth, thou art goodness, thou art blessedness, thou art eternity, and thou art every true good. Many are these attributes: my straitened understanding cannot see so many at one view, that it may be gladdened by all at once. How, then, O Lord, art thou all these things? Are they parts of thee, or is each one of these rather the whole, which thou art? For, whatever is composed of parts is not altogether one, but is in some sort plural, and diverse from itself; and either in fact or in concept is capable of dissolution.

But these things are alien to thee, than whom

nothing better can be conceived of. Hence, there are no parts in thee, Lord, nor art thou more than one. But thou art so truly a unitary being, and so identical with thyself, that in no respect art thou unlike thyself; rather thou art unity itself, indivisible by any conception. Therefore, life and wisdom and the rest are not parts of thee, but all are one; and each of these is the whole, which thou art, and which all the rest are.

In this way, then, it appears that thou hast no parts, and that thy eternity, which thou art, is nowhere and never a part of thee or of thy eternity. But everywhere thou art as a whole, and thy eternity exists as a whole forever.

CHAPTER XIX.

He does not exist in place or time, but all things exist in him.

But if through thine eternity thou hast been, and art, and wilt be; and to have been is not to be destined to be; and to be is not to have been, or to be destined to be; how does thine eternity exist as a whole forever? Or is it true that nothing of thy eternity passes away, so that it is not now; and that nothing of it is destined to be, as if it were not yet?

Thou wast not, then, yesterday, nor wilt thou be to-morrow; but yesterday and to-day and to-morrow thou art; or, rather, neither yesterday nor to-day nor to-morrow thou art; but simply, thou art, outside all time. For yesterday and to-day and to-morrow have no existence, except in time; but thou, although nothing exists without thee, nevertheless dost not exist in space or time, but all things exist in thee. For nothing contains thee, but thou containest all.

CHAPTER XX.

He exists before all things and transcends all things, even the eternal things.—The eternity of God is present as a whole with him; while other things have not yet that part of their eternity which is still to be, and have no longer that part which is past.

HENCE, thou dost permeate and embrace all things. Thou art before all, and dost transcend all. And, of a surety, thou art before all; for before they were made, thou art. But how dost thou transcend all? In what way dost thou transcend those beings which will have no end? Is it because they cannot exist at all without thee; while thou art in no wise less, if they should return to nothingness? For so, in a certain sense, thou dost transcend them. Or, is it also because they can be conceived to have an end; but thou by no means? For so they actually have an end, in a certain sense; but thou, in no sense. And certainly, what in no sense has an end transcends what is ended in any sense. Or, in this way also dost thou transcend all things, even the eternal, because thy eternity and theirs is present as a whole with thee; while they have not yet that part of their eternity which is to come, just as they no longer have that part which is past? For so thou dost ever transcend them. since thou art ever present with thyself, and since that to which they have not yet come is ever present with thee.

CHAPTER XXI.

Is this the age of the age, or ages of ages?—The eternity of God contains the ages of time themselves, and can be called the age of the age or ages of ages.

Is this, then, the age of the age, or ages of ages? For, as an age of time contains all temporal things, so thy eternity contains even the ages of time themselves. And these are indeed an age, because of their indivisible unity; but ages, because of their endless immeasurability. And, although thou art so great, O Lord, that all things are full of thee, and exist in thee; yet thou art so without all space, that neither midst, nor half, nor any part, is in thee.

CHAPTER XXII.

He alone is what he is and who he is.—All things need God for their being and their well-being.

THEREFORE, thou alone, O Lord, art what thou art; and thou art he who thou art. For, what is one thing in the whole and another in the parts, and in which there is any mutable element, is not altogether what it is. And what begins from non-existence, and can be conceived not to exist, and unless it subsists through something else, returns to non-existence; and what has a past existence, which is no longer, or a future existence, which is not yet,—this does not properly and absolutely exist.

But thou art what thou art, because, whatever thou art at any time, or in any way, thou art as a whole and forever. And thou art he who thou art, properly and simply; for thou hast neither a past existence nor a future, but only a present existence; nor canst thou be conceived as at any time non-existent. But thou art life, and light, and wisdom, and blessedness, and many goods of this nature. And yet thou art only one supreme good; thou art all-sufficient to thyself, and needest none; and thou art he whom all things need for their existence and wellbeing.

CHAPTER XXIII.

This good is equally Father, and Son, and Holy Spirit. And this is a single, necessary Being, which is every good, and wholly good, and the only good.—Since the Word is true, and is truth itself, there is nothing in the Father, who utters it, which is not accomplished in the Word by which he expresses himself. Neither is the love which proceeds from Father and Son unequal to the Father or the Son, for Father and Son love themselves and one another in the same degree in which what they are is good. Of supreme simplicity nothing can be born, and from it nothing can proceed, except that which is this, of which it is born, or from which it proceeds.

THIS good thou art, thou, God the Father; this is thy Word, that is, thy Son. For nothing, other than what thou art, or greater or less than thou, can be in the Word by which thou dost express thyself; for thy Word is true, as thou art truthful. And hence it is truth itself, just as thou art; no other truth than thou; and thou art of so simple a nature, that of thee nothing can be born other than what thou art. This very good is the one love common to thee and to thy Son, that is, the Holy Spirit proceeding from both. For this love is not unequal to thee or to thy Son; seeing that thou dost love thyself and him, and he, thee and himself, to the whole extent of thy being and his. Nor is there aught else proceeding from

thee and from him, which is not unequal to thee and to him. Nor can anything proceed from the supreme simplicity, other than what this, from which it proceeds, is.

But what each is, separately, this is all the Trinity at once, Father, Son, and Holy Spirit; seeing that each separately is none other than the supremely simple unity, and the supremely unitary simplicity. which can neither be multiplied nor varied. Moreover, there is a single necessary Being. Now, this is that single, necessary Being, in which is every good; nay, which is every good, and a single entire good, and the only good.

CHAPTER XXIV.

Conjecture as to the character and the magnitude of this good.— If the created life is good, how good is the creative life!

AND now, my soul, arouse and lift up all thy understanding, and conceive, so far as thou canst. of what character and how great is that good. For, if individual goods are delectable, conceive in earnestness how delectable is that good which contains the pleasantness of all goods; and not such as we have experienced in created objects, but as different as the Creator from the creature. For, if the created life is good, how good is the creative life! If the salvation given is delightful, how delightful is the salvation which has given all salvation ! If wisdom in the knowledge of the created world is lovely, how lovely is the wisdom which has created all things from nothing ! Finally, if there are many great delights in delectable things, what and how great is the delight in him who has made these delectable things.

CHAPTER XXV.

What goods, and how great, belong to those who enjoy this good. —Joy is multiplied in the blessed from the blessedness and joy of others.

Who shall enjoy this good? And what shall belong to him, and what shall not belong to him? At any rate, whatever he shall wish shall be his, and whatever he shall not wish shall not be his. For, these goods of body and soul will be such as eye hath not seen nor ear heard, neither has the heart of man conceived (Isaiah lxiv. 4; I Corinthians ii. 9).

Why, then, dost thou wander abroad, slight man, in thy search for the goods of thy soul and thy body? Love the one good in which are all goods, and it sufficeth. Desire the simple good which is every good, and it is enough. For, what dost thou love, my flesh? What dost thou desire, my soul? There, there is whatever ye love, whatever ye desire.

If beauty delights thee, there shall the righteous shine forth as the sun (Matthew xiii. 43). If swiftness or endurance, or freedom of body, which naught can withstand, delight thee, they shall be as angels of God,—because it is sown a natural body; it is raised a spiritual body (I Corinthians xv. 44)—in power certainly, though not in nature. If it is a long and sound life that pleases thee, there a healthful eternity is, and an eternal health. For the righteous shall live forever (Wisdom v. 15), and the salvation of the righteous is of the Lord (Psalms xxxvii. 39). If it is satisfaction of hunger, they shall be satisfied when the glory of the Lord hath appeared (Psalms xvii. 15). If it is quenching of thirst, they shall be abundantly

satisfied with the fatness of thy house (Psalms xxxvi. 8). If it is melody, there the choirs of angels sing forever, before God. If it is any not impure, but pure, pleasure, thou shalt make them drink of the river of thy pleasures, O God (Psalms xxxvi. 8).

If it is wisdom that delights thee, the very wisdom of God will reveal itself to them. If friendship, they shall love God more than themselves, and one another as themselves. And God shall love them more than they themselves; for they love him, and themselves, and one another, through him, and he, himself and them, through himself. If concord, they shall all have a single will.

If power, they shall have all power to fulfil their will, as God to fulfil his. For, as God will have power to do what he wills, through himself, so they will have power, through him, to do what they will. For, as they will not will aught else than he, he shall will whatever they will; and what he shall will cannot fail to be. If honor and riches, God shall make his good and faithful servants rulers over many things (Luke xii. 42); nay, they shall be called sons of God, and gods; and where his Son shall be, there they shall be also, heirs indeed of God, and joint-heirs with Christ (Romans viii. 17).

If true security delights thee, undoubtedly they shall be as sure that those goods, or rather that good, will never and in no wise fail them; as they shall be sure that they will not lose it of their own accord; and that God, who loves them, will not take it away from those who love him against their will; and that nothing more powerful than God will separate him from them against his will and theirs.

But what, or how great, is the joy, where such and

so great is the good! Heart of man, needy heart, heart acquainted with sorrows, nay, overwhelmed with sorrows, how greatly wouldst thou rejoice, if thou didst abound in all these things! Ask thy inmost mind whether it could contain its joy over so great a blessedness of its own.

Yet assuredly, if any other whom thou didst love altogether as thyself possessed the same blessedness, thy joy would be doubled, because thou wouldst rejoice not less for him than for thyself. But, if two, or three, or many more, had the same joy, thou wouldst rejoice as much for each one as for thyself, if thou didst love each as thyself. Hence, in that perfect love of innumerable blessed angels and sainted men, where none shall love another less than himself, every one shall rejoice for each of the others as for himself.

If, then the heart of man will scarce contain his joy over his own so great good, how shall it contain so many and so great joys? And doubtless, seeing that every one loves another so far as he rejoices in the other's good, and as, in that perfect felicity, each one should love God beyond compare, more than himself and all the others with him; so he will rejoice beyond reckoning in the felicity of God, more than in his own and that of all the others with him.

But if they shall so love God with all their heart, and all their mind, and all their soul, that still all the heart, and all the mind, and all the soul shall not suffice for the worthiness of this love; doubtless they will so rejoice with all their heart, and all their mind, and all their soul, that all the heart, and all the mind, and all the soul shall not suffice for the fulness of their joy.

CHAPTER XXVI.

Is this joy which the Lord promises made full?—The blessed shall rejoice according as they shall love; and they shall love according as they shall know.

My God and my Lord, my hope and the joy of my heart, speak unto my soul and tell me whether this is the joy of which thou tellest us through thy Son: Ask and ye shall receive, that your joy may be full (John xvi. 24). For I have found a joy that is full, and more than full. For when heart, and mind, and soul, and all the man, are full of that joy, joy beyond measure will still remain. Hence, not all of that joy shall enter into those who rejoice; but they who rejoice shall wholly enter into that joy.

Show me, O Lord, show thy servant in his heart whether this is the joy into which thy servants shall enter, who shall enter into the joy of their Lord. But that joy, surely, with which thy chosen ones shall rejoice, eye hath not seen nor ear heard, neither has it entered into the heart of man (Isaiah lxiv. 4; I Corinthians ii. 9). Not yet, then, have I told or conceived, O Lord, how greatly those blessed ones of thine shall rejoice. Doubtless they shall rejoice according as they shall love; and they shall love according as they shall know. How far they will know thee, Lord, then! and how much they will love thee! Truly, eye hath not seen, nor ear heard, neither has it entered into the heart of man in this life, how far they shall know thee, and how much they shall love ther in that life.

I pray, O God, to know thee, to love thee, that I may rejoice in thee. And if I cannot attain to full joy

in this life, may I at least advance from day to day, until that joy shall come to the full. Let the knowledge of thee advance in me here, and there be made full. Let the love of thee increase, and there let it be full, that here my joy may be great in hope, and there full in truth. Lord, through thy Son thou dost command, nay, thou dost counsel us to ask; and thou dost promise that we shall receive, that our joy may be full. I ask, O Lord, as thou dost counsel through our wonderful Counsellor. I will receive what thou dost promise by virtue of thy truth, that my joy may be full. Faithful God, I ask. I will receive, that my joy may be full. Meanwhile, let my mind meditate upon it; let my tongue speak of it. Let my heart love it; let my mouth talk of it. Let my soul hunger for it; let my flesh thirst for it; let my whole being desire it, until I enter into thy joy, O Lord, who art the Three and the One God, blessed for ever and ever. Amen.

ANSELM'S MONOLOGIUM

ON THE BEING OF GOD.

PREFACE.

In this book Anselm discusses, under the form of a meditation, the Being of God, basing his argument not on the authority of Scripture, but on the force of reason. It contains nothing that is inconsistent with the writings of the Holy Fathers, and especially nothing that is inconsistent with those of St. Augustine.—The Greek terminology is employed in Chapter LXXVIII., where it is stated that the Trinity may be said to consist of three substances, that is, three persons.

CERTAIN brethren have often and earnestly entreated me to put in writing some thoughts that I had offered them in familiar conversation, regarding meditation on the Being of God, and on some other topics connected with this subject, under the form of a meditation on these themes. It is in accordance with their wish, rather than with my ability, that they have prescribed such a form for the writing of this meditation; in order that nothing in Scripture should be urged on the authority of Scripture itself, but that whatever the conclusion of independent investigation should declare to be true, should, in an unadorned style, with common proofs and with a simple argument, be briefly enforced by the cogency of reason, and plainly expounded in the light of truth. It was their wish also, that I should not disdain to meet such simple and almost foolish objections as occur to me.

This task I have long refused to undertake. And, reflecting on the matter, I have tried on many grounds to excuse myself; for the more they wanted this work to be adaptable to practical use, the more was what they enjoined on me difficult of execution. Overcome at last, however, both by the modest importunity of their entreaties and by the not contemptible sincerity of their zeal; and reluctant as I was because of the difficulty of my task and the weakness of my talent, I entered upon the work they asked for. But it is with pleasure inspired by their affection that, so far as I was able, I have prosecuted this work within the limits they set.

I was led to this undertaking in the hope that whatever I might accomplish would soon be overwhelmed with contempt, as by men disgusted with some worthless thing. For I know that in this book I have not so much satisfied those who entreated me. as put an end to the entreaties that followed me so urgently. Yet, somehow it fell out, contrary to my hope, that not only the brethren mentioned above, but several others, by making copies for their own use, condemned this writing to long remembrance. And, after frequent consideration, I have not been able to find that I have made in it any statement which is inconsistent with the writings of the Catholic Fathers, or especially with those of St. Augustine. Wherefore, if it shall appear to any man that I have offered in this work any thought that is either too novel or discordant with the truth, I ask him not to denounce me at once as one who boldly seizes upon new ideas, or as a maintainer of falsehood : but let him first read diligently Augustine's books on the Trinity, and then judge my treatise in the light of those.

In stating that the supreme Trinity may be said to consist of three substances, I have followed the Greeks, who acknowledge three substances in one Essence, in the same faith wherein we acknowledge three persons in one Substance. For they designate by the word *substance* that attribute of God which we designate by the word *person*.

Whatever I have said on that point, however, is put in the mouth of one debating and investigating in solitary reflection, questions to which he had given no attention before. And this method I knew to be in accordance with the wish of those whose request I was striving to fulfil. But it is my prayer and earnest entreaty, that if any shall wish to copy this work. he shall be careful to place this preface at the beginning of the book, before the body of the meditation itself. For I believe that one will be much helped in understanding the matter of this book, if he has taken note of the intention, and the method according to which it is discussed. It is my opinion, too, that one who has first seen this preface will not pronounce a rash judgment, if he shall find offered here any thought that is contrary to his own belief.

CHAPTER I.

There is a being which is best, and greatest, and highest of all existing beings.

IF any man, either from ignorance or unbelief, has no knowledge of the existence of one Nature which is the highest of all existing beings, which is also suffi-

cient to itself in its eternal blessedness, and which confers upon and effects in all other beings, through its omnipotent goodness, the very fact of their existence, and the fact that in any way their existence is good; and if he has no knowledge of many other things, which we necessarily believe regarding God and his creatures, he still believes that he can at least convince himself of these truths in great part, even if his mental powers are very ordinary, by the force of reason alone.

And, although he could do this in many ways, I shall adopt one which I consider easiest for such a man. For, since all desire to enjoy only those things which they suppose to be good, it is natural that this man should, at some time, turn his mind's eve to the examination of that cause by which these things are good, which he does not desire, except as he judges them to be good. So that, as reason leads the way and follows up these considerations, he advances rationally to those truths of which, without reason, he has no knowledge. And if, in this discussion, I use any argument which no greater authority adduces, I wish it to be received in this way: although, on the grounds that I shall see fit to adopt, the conclusion is reached as if necessarily, yet it is not, for this reason, said to be absolutely necessary, but merely that it can appear so for the time being.

It is easy, then, for one to say to himself: Since there are goods so innumerable, whose great diversity we experience by the bodily senses, and discern by our mental faculties, must we not believe that there is some one thing, through which all goods whatever are good? Or are they good, one through one thing, and another through another? To be sure, it is most

MONOLOGIUM.

certain and clear, for all who are willing to see, that whatsoever things are said to possess any attribute in such a way that in mutual comparison they may be said to possess it in greater, or less, or equal degree, are said to possess it by virtue of some fact, which is not understood to be one thing in one case and another in another, but to be the same in different cases, whether it is regarded as existing in these cases in equal or unequal degree. For, whatsoever things are said to be *just*, when compared one with another, whether equally, or more, or less, cannot be understood as just, except through the quality of *justness*, which is not one thing in one instance, and another in another.

Since it is certain, then, that all goods, if mutually compared, would prove either equally or unequally good, necessarily they are all good by virtue of something which is conceived of as the same in different goods, although sometimes they seem to be called good, the one by virtue of one thing, the other by virtue of another. For, apparently it is by virtue of one quality, that a horse is called *good*, because he is strong, and by virtue of another, that he is called *good*, because he is swift. For, though he seems to be called good by virtue of his strength, and good by virtue of his swiftness, yet swiftness and strength do not appear to be the same thing.

But if a horse, because he is strong and swift, is therefore good, how is it that a strong, swift robber is bad? Rather, then, just as a strong, swift robber is bad, because he is harmful, so a strong, swift horse is good, because he is useful. And, indeed, nothing is ordinarily regarded as good, except either for some utility—as, for instance, safety is called good, and those things which promote safety—or for some honorable character—as, for instance, beauty is reckoned to be good, and what promotes beauty.

But, since the reasoning which we have observed is in no wise refutable, necessarily, again, all things, whether useful or honorable, if they are truly good, are good through that same being through which all goods exist, whatever that being is. But who can doubt this very being, through which all goods exist, to be a great good? This must be, then, a good through itself, since every other good is through it.

It follows, therefore, that all other goods are good through another being than that which they themselves are, and this being alone is good through itself. Hence, this alone is supremely good, which is alone good through itself. For it is supreme, in that it so surpasses other beings, that it is neither equalled nor excelled. But that which is supremely good is also supremely great. There is, therefore, some one being which is supremely good, and supremely great, that is, the highest of all existing beings.

CHAPTER II.

The same subject continued.

But, just as it has been proved that there is a being that is supremely good, since all goods are good through a single being, which is good through itself; so it is necessarily inferred that there is something supremely great, which is great through itself. But I do not mean physically great, as a material object is great, but that which, the greater it is, is the better or the more worthy,—wisdom, for instance. And

MONOLOGIUM.

since there can be nothing supremely great except what is supremely good, there must be a being that is greatest and best, i. e., the highest of all existing beings.

CHAPTER III.

There is a certain Nature through which whatever is exists and which exists through itself, and is the highest of all existing beings.

THEREFORE, not only are all good things such through something that is one and the same, and all great things such through something that is one and the same; but whatever is, apparently exists through something that is one and the same. For, everything that is, exists either through something, or through nothing. But nothing exists through nothing. For it is altogether inconceivable that anything should not exist by virtue of something.

Whatever is, then, does not exist except through something. Since this is true, either there is one being, or there are more than one, through which all things that are exist. But if there are more than one, either these are themselves to be referred to some one being, through which they exist, or they exist separately, each through itself, or they exist mutually through one another.

But, if these beings exist through one being, then all things do not exist through more than one, but rather through that one being through which these exist.

If, however, these exist separately, each through itself, there is, at any rate, some power or property of existing through self (*existendi per se*), by which

they are able to exist each through itself. But, there can be no doubt that, in that case, they exist through this very power, which is one, and through which they are able to exist, each through itself. More truly, then, do all things exist through this very being, which is one, than through these, which are more than one, which, without this one, cannot exist.

But that these beings exist mutually through one another, no reason can admit; since it is an irrational conception that anything should exist through a being on which it confers existence. For not even beings of a relative nature exist thus mutually, the one through the other. For, though the terms *master* and *servant* are used with mutual reference, and the men thus designated are mentioned as having mutual relations, yet they do not at all exist mutually, the one through the other, since these relations exist through the subjects to which they are referred.

Therefore, since truth altogether excludes the supposition that there are more beings than one, through which all things exist, that being, through which all exist, must be one. Since, then, all things that are exist through this one being, doubtless this one being exists through itself. Whatever things there are else, then, exist through something other than themselves, and this alone through itself. But whatever exists through another is less than that, through which all things are, and which alone exists through itself. Therefore, that which exists through itself exists in the greatest degree of all things.

There is, then, some one being which alone exists in the greatest and the highest degree of all. But that which is greatest of all, and through which exists whatever is good or great, and, in short, whatever

MONOLOGIUM.

has any existence—that must be supremely good, and supremely great, and the highest of all existing be ings.

CHAPTER IV.

The same subject continued.

FURTHERMORE, if one observes the nature of things he perceives, whether he will or no, that not all are embraced in a single degree of dignity; but that certain among them are distinguished by inequality of degree. For, he who doubts that the horse is superior in its nature to wood, and man more excellent than the horse, assuredly does not deserve the name of man. Therefore, although it cannot be denied that some natures are superior to others, nevertheless reason convinces us that some nature is so preëminent among these, that it has no superior. For, if the distinction of degrees is infinite, so that there is among them no degree, than which no higher can be found, our course of reasoning reaches this conclusion: that the multitude of natures themselves is not limited by any bounds. But only an absurdly foolish man can fail to regard such a conclusion as absurdly foolish. There is, then, necessarily some nature which is so superior to some nature or natures, that there is none in comparison with which it is ranked as inferior.

Now, this nature which is such, either is single, or there are more natures than one of this sort, and they are of equal degree.

But, if they are more than one and equal, since they cannot be equal through any diverse causes, but only through some cause which is one and the same, that one cause, through which they are equally so great, either is itself what they are, that is, the very essence of these natures; or else it is another than what they are.

But if it is nothing else than their very essence itself, just as they have not more than one essence, but a single essence, so they have not more than one nature, but a single nature. For I here understand *nature* as identical with *essence*.

If, however, that through which these natures are so great is another than that which they are, then, certainly, they are less than that through which they are so great. For, whatever is great through something else is less than that through which it is great. Therefore, they are not so great that there is nothing else greater than they.

But if, neither through what they are nor through anything other than themselves, can there be more such natures than one, than which nothing else shall be more excellent, then in no wise can there be more than one nature of this kind. We conclude, then, that there is some nature which is one and single, and which is so superior to others that it is inferior to none. But that which is such is the greatest and best of all existing beings. Hence, there is a certain nature which is the highest of all existing beings. This, however, it cannot be, unless it is what it is through itself, and all existing beings are what they are through it.

For since, as our reasoning showed us not long since, that which exists through itself, and through which all other things exist, is the highest of all existing beings; either conversely, that which is the highest exists through itself, and all others through it; or, there will be more than one supreme being. But it

MONOLOGIUM.

is manifest that there cannot be more than one supreme being. There is, therefore, a certain Nature, or Substance, or Essence, which is through itself good and great, and through itself is what it is; and through which exists whatever is truly good, or great, or has any existence at all; and which is the supreme good being, the supreme great being, being or subsisting as supreme, that is, the highest of all existing beings.

CHAPTER V.

Just as this Nature exists through itself, and other beings through it, so it derives existence from itself, and other beings from it.

Seeing, then, that the truth already discovered has been satisfactorily demonstrated, it is profitable to examine whether this Nature, and all things that have any existence, derive existence from no other source than it, just as they do not exist except through it.

But it is clear that one may say, that what derives existence from something exists through the same thing; and what exists through something also derives existence from it. For instance, what derives existence from matter, and exists through the artificer, may also be said to exist through matter, and to derive existence from the artificer, since it exists through both, and derives existence from both. That is, it is endowed with existence by both, although it exists through matter and from the artificer in another sense than that in which it exists through, and from, the artificer.

It follows, then, that just as all existing beings are what they are, through the supreme Nature, and as that Nature exists through itself, but other beings through another than themselves, so all existing be-

ings derive existence from this supreme Nature. And therefore, this Nature derives existence from itself, but other beings from it.

CHAPTER VI.

This Nature was not brought into existence with the help of any external cause, yet it does not exist through nothing, or derive existence from nothing.—How existence through self, and derived from self, is conceivable.

SINCE the same meaning is not always attached to the phrase, "existence through" something, or, to the phrase, "existence derived from" something, very diligent inquiry must be made, in what way all existing beings exist through the supreme Nature, or derive existence from it. For, what exists through itself, and what exists through another, do not admit the same ground of existence. Let us first consider, separately, this supreme Nature, which exists through self; then these beings which exist through another.

Since it is evident, then, that this Nature is whatever it is, through itself, and all other beings are what they are, through it, how does it exist through itself? For, what is said to exist through anything apparently exists through an efficient agent, or through matter, or through some other external aid, as through some instrument. But, whatever exists in any of these three ways exists through another than itself, and it is of later existence, and, in some sort, less than that through which it obtains existence.

But, in no wise does the supreme Nature exist through another, nor is it later or less than itself or anything else. Therefore, the supreme Nature could be created neither by itself, nor by another; nor could

MONOLOGIUM.

itself or any other be the matter whence it should be created; nor did it assist itself in any way; nor did anything assist it to be what it was not before.

What is to be inferred? For that which cannot have come into existence by any creative agent, or from any matter, or with any external aids, seems either to be nothing, or, if it has any existence, to exist through nothing, and derive existence from nothing. And although, in accordance with the observations I have already made, in the light of reason, regarding the supreme Substance, I should think such propositions could in no wise be true in the case of the supreme Substance; yet, I would not neglect to give a connected demonstration of this matter.

For, seeing that this my meditation has suddenly brought me to an important and interesting point, I am unwilling to pass over carelessly even any simple or almost foolish objection that occurs to me, in my argument; in order that by leaving no ambiguity in my discussion up to this point, I may have the better assured strength to advance toward what follows; and in order that if, perchance, I shall wish to convince any one of the truth of my speculations, even one of the slower minds, through the removal of every obstacle, however slight, may acquiesce in what it finds here.

That this Nature, then, without which no nature exists, is nothing, is as false as it would be absurd to say that whatever is is nothing. And, moreover, it does not exist through nothing, because it is utterly inconceivable that what is something should exist through nothing. But, if in any way it derives existence from nothing, it does so through itself, or through another, or through nothing. But it is evident that

in no wise does anything exist through nothing. If, then, in any way it derives existence from nothing, it does so either through itself or through another.

But nothing can, through itself, derive existence from nothing, because if anything derives existence from nothing, through something, then that through which it exists must exist before it. Seeing that this Being, then, does not exist before itself, by no means does it derive existence from itself.

But if it is supposed to have derived existence from some other nature, then it is not the supreme Nature, but some inferior one, nor is it what it is through itself, but through another.

Again: if this Nature derives existence from nothing, through something, that through which it exists was a great good, since it was the cause of good. But no good can be understood as existing before that good, without which nothing is good; and it is sufficiently clear that this good, without which there is no good, is the supreme Nature which is under discussion. Therefore, it is not even conceivable that this Nature was preceded by any being, through which it derived existence from nothing.

Hence, if it has any existence through nothing, or derives existence from nothing, there is no doubt that either, whatever it is, it does not exist through itself, or derive existence from itself, or else it is itself nothing. It is unnecessary to show that both these suppositions are false. The supreme Substance, then, does not exist through any efficient agent, and does not derive existence from any matter, and was not aided in being brought into existence by any external causes. Nevertheless, it by no means exists through

nothing, or derives existence from nothing; since, through itself and from itself, it is whatever it is.

Finally, as to how it should be understood to exist through itself, and to derive existence from itself: it did not create itself, nor did it spring up as its own matter, nor did it in any way assist itself to become what it was not before, unless, haply, it seems best to conceive of this subject in the way in which one says that the light lights or is lucent, through and from itself. For, as are the mutual relations of the light and to light and lucent (lux, lucere, lucens), such are the relations of essence, and to be and being, that is, existing or subsisting. So the supreme Being, and to be in the highest degree, and being in the highest degree, bear much the same relations, one to another, as the light and to light and lucent.

CHAPTER VII.

In what way all other beings exist through this Nature and derive existence from it.

THERE now remains the discussion of that whole class of beings that exist through another, as to how they exist through the supreme Substance, whether because this Substance created them all, or because it was the material of all. For, there is no need to inquire whether all exist through it, for this reason, namely, that there being another creative agent, or another existing material, this supreme Substance has merely aided in bringing about the existence of all things: since it is inconsistent with what has already been shown, that whatever things are should exist secondarily, and not primarily, through it.

First, then, it seems to me, we ought to inquire

whether that whole class of beings which exist through another derive existence from any material. But I do not doubt that all this solid world, with its parts, just as we see, consists of earth, water, fire, and air. These four elements, of course, can be conceived of without these forms which we see in actual objects, so that their formless, or even confused, nature appears to be the material of all bodies, distinguished by their own forms.—I say that I do not doubt this. But I ask, whence this very material that I have mentioned, the material of the mundane mass, derives its existence. For, if there is some material of this material, then that is more truly the material of the physical universe.

If, then, the universe of things, whether visible or invisible, derives existence from any material, certainly it not only cannot be, but it cannot even be supposed to be, from any other material than from the supreme Nature or from itself, or from some third being—but this last, at any rate, does not exist. For, indeed, nothing is even conceivable except that highest of all beings, which exists through itself, and the universe of beings which exist, not through themselves, but through this supreme Being. Hence, that which has no existence at all is not the material of anything.

From its own nature the universe cannot derive existence, since, if this were the case, it would in some sort exist through itself and so through another than that through which all things exist. But all these suppositions are false.

Again, everything that derives existence from material derives existence from another, and exists later than that other. Therefore, since nothing is other

than itself, or later than itself, it follows that nothing derives material existence from itself.

But if, from the material of the supreme Nature itself, any lesser being can derive existence, the supreme good is subject to change and corruption. But this it is impious to suppose. Hence, since everything that is other than this supreme Nature is less than it, it is impossible that anything other than it in this way derives existence from it.

Furthermore: doubtless that is in no wise good, through which the supreme good is subjected to change or corruption. But, if any lesser nature derives existence from the material of the supreme good, inasmuch as nothing exists whencesoever, except through the supreme Being, the supreme good is subjected to change and corruption through the supreme Being itself. Hence, the supreme Being, which is itself the supreme good, is by no means good; which is a contradiction. There is, therefore, no lesser nature which derives existence in a material way from the supreme Nature.

Since, then, it is evident that the essence of those things which exist through another does not derive existence as if materially, from the supreme Essence, nor from itself, nor from another, it is manifest that it derives existence from no material. Hence, seeing that whatever is exists through the supreme Being, nor can aught else exist through this Being, except by its creation, or by its existence as material, it follows, necessarily, that nothing besides it exists, except by its creation. And, since nothing else is or has been, except that supreme Being and the beings created by it, it could create nothing at all through any other instrument or aid than itself. But all that it has created, it has doubtless created either from something, as from material, or from nothing.

Since, then, it is most patent that the essence of all beings, except the supreme Essence, was created by that supreme Essence, and derives existence from no material, doubtless nothing can be more clear than that this supreme Essence nevertheless produced from nothing, alone and through itself, the world of material things, so numerous a multitude, formed in such beauty, varied in such order, so fitly diversified.

CHAPTER VIII.

How it is to be understood that this Nature created all things from nothing.

But we are confronted with a doubt regarding this term *nothing*. For, from whatever source anything is created, that source is the cause of what is created from it, and, necessarily, every cause affords some assistance to the being of what it effects. This is so firmly believed, as a result of experience, by every one, that the belief can be wrested from no one by argument, and can scarcely be purloined by sophistry.

Accordingly, if anything was created from nothing, this very nothing was the cause of what was created from it. But how could that which had no existence assist anything in coming into existence? If, however, no aid to the existence of anything ever had its source in nothing, who can be convinced, and how, that anything is created out of nothing?

Moreover, nothing either means something, or does not mean something. But if nothing is something, whatever has been created from nothing has been created from something. If, however, nothing is not

something; since it is inconceivable that anything should be created from what does not exist, nothing is created from nothing; just as all agree that nothing comes from nothing. Whence, it evidently follows, that whatever is created is created from something; for it is created either from something or from nothing. Whether, then, nothing is something, or nothing is not something, it apparently follows, that whatever has been created was created from something.

But, if this is posited as a truth, then it is so posited in opposition to the whole argument propounded in the preceding chapter. Hence, since what was nothing will thus be something, that which was something in the highest degree will be nothing. For, from the discovery of a certain Substance existing in the greatest degree of all existing beings, my reasoning had brought me to this conclusion, that all other beings were so created by this Substance, that that from which they were created was nothing. Hence, if that from which they were created, which I supposed to be nothing, is something, whatever I supposed to have been ascertained regarding the supreme Being, is nothing.

What, then, is to be our understanding of the term nothing?—For I have already determined not to neglect in this meditation any possible objection, even if it be almost foolish.—In three ways, then—and this suffices for the removal of the present obstacle—can the statement that any substance was created from nothing be explained.

There is one way, according to which we wish it to be understood, that what is said to have been created from nothing has not been created at all; just as, to one who asks regarding a dumb man, of what he speaks, the answer is given, "of nothing," that is, he does not speak at all. According to this interpretation, to one who enquires regarding the supreme Being, or regarding what never has existed and does not exist at all, as to whence it was created, the answer, "from nothing" may properly be given; that is, it never was created. But this answer is unintelligible in the case of any of those things that actually were created.

There is another interpretation which is, indeed, capable of supposition, but cannot be true; namely, that if anything is said to have been created from nothing, it was created from nothing itself (*de nihilo ipso*), that is, from what does not exist at all, as if this very nothing were some existent being, from which something could be created. But, since this is always false, as often as it is assumed an irreconcilable contradiction follows.

There is a third interpretation, according to which a thing is said to have been created from nothing, when we understand that it was indeed created, but that there is not anything whence it was created. Apparently it is said with a like meaning, when a man is afflicted without cause, that he is afflicted "over nothing."

If, then, the conclusion reached in the preceding chapter is understood in this sense, that with the exception of the supreme Being all things have been created by that Being from nothing, that is, not from anything; just as this conclusion consistently follows the preceding arguments, so, from it, nothing inconsistent is inferred; although it may be said, without inconsistency or any contradiction, that what has been

created by the creative Substance was created from nothing, in the way that one frequently says a rich man has been made from a poor man, or that one has recovered health from sickness; that is, he who was poor before, is rich now, as he was not before; and he who was ill before, is well now, as he was not before.

In this way, then, we can understand, without inconsistency, the statement that the creative Being created all things from nothing, or that all were created through it from nothing; that is, those things which before were nothing, are now something. For, indeed, from the very word that we use, saying that it created them or that they were created, we understand that when this Being created them, it created something, and that when they were created, they were created only as something. For so, beholding a man of very lowly fortunes exalted with many riches and honors by some one, we say, "Lo, he has made that man out of nothing"; that is, the man who was before reputed as nothing is now, by virtue of that other's making, truly reckoned as something.

CHAPTER IX.

Those things which were created from nothing had an existence before their creation in the thought of the Creator.

But I seem to see a truth that compels me to distinguish carefully in what sense those things which were created may be said to have been nothing before their creation. For, in no wise can anything conceivably be created by any, unless there is, in the mind of the creative agent, some example, as it were, or (as is more fittingly supposed) some model, or likeness, or rule. It is evident, then, that before the world was created, it was in the thought of the supreme Nature, what, and of what sort, and how, it should be. Hence, although it is clear that the beings that were created were nothing before their creation, to this extent, that they were not what they now are, nor was there anything whence they should be created, yet they were not nothing, so far as the creator's thought is concerned, through which, and according to which, they were created.

CHAPTER X.

This thought is a kind of expression of the objects created (*locutio* rerum), like the expression which an artisan forms in his mind for what he intends to make.

But this model of things, which preceded their creation in the thought of the creator, what else is it than a kind of expression of these things in his thought itself; just as when an artisan is about to make something after the manner of his craft, he first expresses it to himself through a concept? But by the *expression* of the mind or reason I mean, here, not the conception of words signifying the objects, but the general view in the mind, by the vision of conception, of the objects themselves, whether destined to be, or already existing.

For, from frequent usage, it is recognised that we can express the same object in three ways. For we express objects either by the sensible use of sensible signs, that is, signs which are perceptible to the bodily senses; or by thinking within ourselves insensibly of these signs which, when outwardly used, are sensible; or not by employing these signs, either sensibly or insensibly, but by expressing the things themselves inwardly in our mind, whether by the power of imagining material bodies or of understanding thought, according to the diversity of these objects themselves.

For I express a man in one way, when I signify him by pronouncing these words, a man; in another, when I think of the same words in silence; and in another, when the mind regards the man himself, either through the image of his body, or through the reason; through the image of his body, when the mind imagines his visible form; through the reason. however, when it thinks of his universal essence. which is a rational, mortal animal.

Now, the first two kinds of expression are in the language of one's race. But the words of that kind of expression, which I have put third and last, when they concern objects well known, are natural, and are the same among all nations. And, since all other words owe their invention to these, where these are no other word is necessary for the recognition of an object, and where they cannot be, no other word is of any use for the description of an object.

For, without absurdity, they may also be said to be the truer, the more like they are to the objects to which they correspond, and the more expressively they signify these objects. For, with the exception of those objects, which we employ as their own names, in order to signify them, like certain sounds, the vowel a for instance—with the exception of these, I say, no other word appears so similar to the object to which it is applied, or expresses it as does that likeness which is expressed by the vision of the mind thinking of the object itself.

This last, then, should be called the especially

proper and primary word, corresponding to the thing. Hence, if no expression of any object whatever so nearly approaches the object as that expression which consists of this sort of words, nor can there be in the thought of any another word so like the object, whether destined to be, or already existing, not without reason it may be thought that such an expression of objects existed with (apud) the supreme Substance before their creation, that they might be created; and exists, now that they have been created, that they may be known through it.

CHAPTER XI.

The analogy, however, between the expression of the Creator and the expression of the artisan is very incomplete.

But, though it is most certain that the supreme Substance expressed, as it were, within itself the whole created world, which it established according to, and through, this same most profound expression, just as an artisan first conceives in his mind what he afterwards actually executes in accordance with his mental concept, yet I see that this analogy is very incomplete.

For the supreme Substance took absolutely nothing from any other source, whence it might either frame a model in itself, or make its creatures what they are; while the artisan is wholly unable to conceive in his imagination any bodily thing, except what he has in some way learned from external objects, whether all at once, or part by part; nor can he perform the work mentally conceived, if there is a lack of material, or of anything without which a work premeditated cannot be performed. For, though a man

can, by meditation or representation, frame the idea of some sort of animal, such as has no existence; yet, by no means has he the power to do this, except by uniting in this idea the parts that he has gathered in his memory from objects known externally.

Hence, in this respect, these inner expressions of the works they are to create differ in the creative substance and in the artisan: that the former expression, without being taken or aided from any external source, but as first and sole cause, could suffice the Artificer for the performance of his work, while the latter is neither first, nor sole, nor sufficient, cause for the inception of the artisan's work. Therefore, whatever has been created through the former expression is only what it is through that expression, while whatever has been created through the latter would not exist at all, unless it were something that it is not through this expression itself.

CHAPTER XII.

This expression of the supreme Being is the supreme Being.

But since, as our reasoning shows, it is equally certain that whatever the supreme Substance created, it created through nothing other than itself; and whatever it created, it created through its own most intimate expression, whether separately, by the utterance of separate words, or all at once, by the utterance of one word; what conclusion can be more evidently necessary, than that this expression of the supreme Being is no other than the supreme Being? Therefore, the consideration of this expression should not, in my opinion, be carelessly passed over. But before it can be discussed, I think some of the properties

of this supreme Substance should be diligently and earnestly investigated.

CHAPTER XIII.

As all things were created through the supreme Being, so all live through it.

It is certain, then, that through the supreme Nature whatever is not identical with it has been created. But no rational mind can doubt that all creatures live and continue to exist, so long as they do exist, by the sustenance afforded by that very Being through whose creative act they are endowed with the existence that they have. For, by a like course of reasoning to that by which it has been gathered that all existing beings exist through some one being, hence that being alone exists through itself, and others through another than themselves—by a like course of reasoning, I say, it can be proved that whatever things live, live through some one being; hence that being alone lives through itself, and others through another than themselves.

But, since it cannot but be that those things which have been created live through another, and that by which they have been created lives through itself, necessarily, just as nothing has been created except through the creative, present Being, so nothing lives except through its preserving presence.

CHAPTER XIV.

This Being is in all things, and throughout all : and all derive existence from it and exist through and in it.

But if this is true—rather, since this must be true, it follows that, where this Being is not, nothing is. It is, then, everywhere, and throughout all things, and

in all. But seeing that it is manifestly absurd that as any created being can in no wise exceed the immeasurableness of what creates and cherishes it, so the creative and cherishing Being cannot, in any way, exceed the sum of the things it has created; it is clear that this Being itself, is what supports and surpasses, includes and permeates all other things. If we unite this truth with the truths already discovered, we find it is this same Being which is in all and through all, and from which, and through which, and in which, all exist.

CHAPTER XV.

What can or cannot be stated concerning the substance of this Being.

Nor without reason I am now strongly impelled to inquire as earnestly as I am able, which of all the statements that may be made regarding anything is substantially applicable to this so wonderful Nature. For, though I should be surprised if, among the names or words by which we designate things created from nothing, any should be found that could worthily be applied to the Substance which is the creator of all; yet, we must try and see to what end reason will lead this investigation.

As to relative expressions, at any rate, no one can doubt that no such expression describes what is essential to that in regard to which it is relatively employed. Hence, if any relative predication is made regarding the supreme Nature, it is not significant of its substance.

Therefore, it is manifest that this very expression, that this Nature, is the *highest* of all beings, or greater than those which have been created by it; or any other relative term that can, in like manner, be applied to it, does not describe its natural essence.

For, if none of those things ever existed, in relation to which it is called supreme or greater, it would not be conceived as either supreme or greater, yet it would not, therefore, be less good, or suffer detriment to its essential greatness in any degree. And this truth is clearly seen from the fact that this Nature exists through no other than itself, whatever there be that is good or great. If, then, the supreme Nature can be so conceived of as not supreme, that still it shall be in no wise greater or less than when it is conceived of as the highest of all beings, it is manifest that the term supreme, taken by itself, does not describe that Being which is altogether greater and better than whatever is not what it is. But, what these considerations show regarding the term supreme or highest is found to be true, in like manner, of other similar, relative expressions.

Passing over these relative predications, then, since none of them taken by itself represents the essence of anything, let our attention be turned to the discussion of other kinds of predication.

Now, certainly if one diligently considers separately whatever there is that is not of a relative nature, either it is such that, to be it is in general better than not to be it, or such that, in some cases, not to be it is better than to be it. But I here understand the phrases, to be it and not to be it, in the same way in which I understand to be true and not to be true, to be bodily and not to be bodily, and the like. Indeed, to be anything is, in general, better than not to be it; as to be wise is better than not to be so; that is, it is better to be wise than not to be wise. For, though one who

is just, but not wise, is apparently a better man than one who is wise, but not just, yet, taken by itself, it is not better not to be wise than to be wise. For, everything that is not wise, simply in so far as it is not wise, is less than what is wise, since everything that is not wise would be better if it were wise. In the same way, to be true is altogether better than not to be so, that is, better than not to be true; and just is better than not just; and to live than not to live.

But, in some cases, not to be a certain thing is better than to be it, as not to be gold may be better than to be gold. For it is better for man not to be gold, than to be gold; although it might be better for something to be gold, than not to be gold—lead, for instance. For though both, namely, man and lead are not gold, man is something as much better than gold, as he would be of inferior nature, were he gold; while lead is something as much more base than gold, as it would be more precious, were it gold.

But, from the fact that the supreme Nature may be so conceived of as not supreme, that *supreme* is neither in general better than *not supreme*, nor *not supreme* better, n any case, than *supreme*—from this fact it is evident that there are many relative expressions which are by no means included in this classification. Whether, however, any are so included, I refrain from inquiring; since it is sufficient, for my purpose, that undoubtedly none of these, taken by itself, describes the substance of the supreme Nature.

Since, then, it is true of whatever else there is, that, if it is taken independently, to be it is better than not to be it; as it is impious to suppose that the substance of the supreme Nature is anything, than which what is not it is in any way better, it must be true that this substance is whatever is, in general, better than what is not it. For, it alone is that, than which there is nothing better at all, and which is better than all things, which are not what it is.

It is not a material body, then, or any of those things which the bodily senses discern. For, than all these there is something better, which is not what they themselves are. For, the rational mind, as to which no bodily sense can perceive what, or of what character, or how great, it is—the less this rational mind would be if it were any of those things that are in the scope of the bodily senses, the greater it is than any of these. For by no means should this supreme Being be said to be any of those things to which something, which they themselves are not, is superior; and it should by all means, as our reasoning shows, be said to be any of those things to which everything, which is not what they themselves are, is inferior.

Hence, this Being must be living, wise, powerful, and all-powerful, true, just, blessed, eternal, and whatever, in like manner, is absolutely better than what is not it. Why, then, should we make any further inquiry as to what that supreme Nature is, if it is manifest which of all things it is, and which it is not?

CHAPTER XVI.

For this Being it is the same to be just that it is to be justice; and so with regard to attributes that can be expressed in the same way: and none of these shows of what character, or how great, but what this Being is.

But perhaps, when this Being is called just, or great, or anything like these, it is not shown what it is, but of what character, or how great it is. For every such term seems to be used with reference to quantity or magnitude; because everything that is just is so through justness, and so with other like cases, in the same way. Hence, the supreme Nature itself is not just, except through justness.

It seems, then, that by participation in this quality, that is, justness, the supremely good Substance is called just. But, if this is so, it is just through another, and not through itself. But this is contrary to the truth already established, that it is good, or great, or whatever it is at all, through itself and not through another. So, if it is not just, except through justness, and cannot be just, except through itself, what can be more clear than that this Nature is itself justness? And, when it is said to be just through justness, it is the same as saying that it is just through itself. And, when it is said to be just through itself, nothing else is understood than that it is just through justness. Hence, if it is inquired what the supreme Nature, which is in question, is in itself, what truer answer can be given, than Justness?

We must observe, then, how we are to understand the statement, that the Nature which is itself justness is just. For, since a man cannot be justness, but can possess justness, we do not conceive of a just man as *being* justness, but as possessing justness. Since, on the other hand, it cannot properly be said of the supreme Nature that it possesses justness, but that it is justness, when it is called just it is properly conceived of as being justness, but not as possessing justness. Hence, if, when it is said to be justness, it is not said of what character it is, but *what* it is, it follows that, when it is called just, it is not said of what character it is, but what it is.

Therefore, seeing that it is the same to say of the supreme Being, that it is just and that it is justness; and, when it is said that it is justness, it is nothing else than saying that it is just; it makes no difference whether it is said to be justness or to be just. Hence, when one is asked regarding the supreme Nature, what it is, the answer, *Just*, is not less fitting than the answer, *Justness*. Moreover, what we see to have been proved in the case of justness, the intellect is compelled to acknowledge as true of all attributes which are similarly predicated of this supreme Nature. Whatever such attribute is predicated of it, then, it is shown, not of what character, or how great, but *what* it is.

But it is obvious that whatever good thing the supreme Nature is, it is in the highest degree. It is, therefore, supreme Being, supreme Justness, supreme Wisdom, supreme Truth, supreme Goodness, supreme Greatness, supreme Beauty, supreme Immortality, supreme Incorruptibility, supreme Immutability, supreme Blessedness, supreme Eternity, supreme Power, supreme Unity; which is nothing else than supremely being, supremely living, etc.

CHAPTER XVII.

It is simple in such a way that all things that can be said of its essence are one and the same in it: and nothing can be said of its substance except in terms of *what it is*.

Is it to be inferred, then, that if the supreme Nature is so many goods, it will therefore be compounded of more goods than one? Or is it true, rather, that there are not more goods than one, but a single good

described by many names? For, everything which is composite requires for its subsistence the things of which it is compounded, and, indeed, owes to them the fact of its existence, because, whatever it is, it is through these things; and they are not what they are through it, and therefore it is not at all supreme. If, then, that Nature is compounded of more goods than one, all these facts that are true of every composite must be applicable to it. But this impious falsehood the whole cogency of the truth that was shown above refutes and overthrows, through a clear argument.

Since, then, that Nature is by no means composite, and yet is by all means those so many goods, necessarily all these are not more than one, but are one. Any one of them is, therefore, the same as all, whether taken all at once or separately. Therefore, just as whatever is attributed to the essence of the supreme Substance is one; so this substance is whatever it is essentially in one way, and by virtue of one consideration. For, when a man is said to be a material body, and rational, and human, these three things are not said in one way, or in virtue of one consideration. For, in accordance with one fact, he is a material body; and in accordance with another, rational; and no one of these, taken by itself, is the whole of what man is.

That supreme Being, however, is by no means anything in such a way that it is not this same thing, according to another way, or another consideration; because, whatever it is essentially in any way, this is all of what it is. Therefore, nothing that is truly said of the supreme Being is accepted in terms of quality or quantity, but only in terms of *what* it is. For, whatever it is in terms of either quality or quantity

would constitute still another element, in terms of what it is; hence, it would not be simple, but composite.

CHAPTER XVIII.

It is without beginning and without end.

FROM what time, then, has this so simple Nature which creates and animates all things existed, or until what time is it to exist? Or rather, let us ask neither from what time, nor to what time, it exists; but is it without beginning and without end? For, if it has a beginning, it has this either from or through itself, or from or through another, or from or through nothing.

But it is certain, according to truths already made plain, that in no wise does it derive existence from another, or from nothing; or exist through another, or through nothing. In no wise, therefore, has it had inception through or from another, or through or from nothing.

Moreover, it cannot have inception from or through itself, although it exists from and through itself. For it so exists from and through itself, that by no means is there one essence which exists from and through itself, and another through which, and from which, it exists. But, whatever begins to exist from or through something, is by no means identical with that from or through which it begins to exist. Therefore, the supreme Nature does not begin through or from, itself.

Seeing, then, that it has a beginning neither through nor from itself, and neither through nor from nothing, it assuredly has no beginning at all. But neither will it have an end. For, if it is to have end, it is not supremely immortal and supremely incorruptible. But we have proved that it is supremely immortal and supremely incorruptible. Therefore, it will not have an end.

Furthermore, if it is to have an end, it will perish either willingly or against its will. But certainly that is not a simple, unmixed good, at whose will the supreme good perishes. But this Being is itself the true and simple, unmixed good. Therefore, that very Being, which is certainly the supreme good, will not die of its own will. If, however, it is to perish against its will, it is not supremely powerful, or all-powerful. But cogent reasoning has asserted it to be powerful and all-powerful. Therefore, it will not die against its will. Hence, if neither with nor against its will the supreme Nature is to have an end, in no way will it have an end.

Again, if the supreme nature has an end or a beginning, it is not true eternity, which it has been irrefutably proved to be above.

Then, let him who can conceive of a time when this began to be true, or when it was not true, namely, that something was destined to be: or when this shall cease to be true, and shall not be true, namely, that something has existed. But, if neither of these suppositions is conceivable, and both these facts cannot exist without truth, it is impossible even to conceive that truth has either beginning or end. And then, if truth had a beginning, or shall have an end; before it began it was true that truth did not exist, and after it shall be ended it will be true that truth will not exist. Yet, anything that is true cannot exist without truth. Therefore, truth existed before truth existed, and truth will exist after truth shall be ended, which is a most contradictory conclusion. Whether, then,

truth is said to have, or understood not to have, beginning or end, it cannot be limited by any beginning or end. Hence, the same follows as regards the supreme Nature, since it is itself the supreme Truth.

CHAPTER XIX.

In what sense nothing existed before or will exist after this Being.

But here we are again confronted by the term nothing, and whatever our reasoning thus far, with the concordant attestation of truth and necessity, has concluded nothing to be. For, if the propositions duly set forth above have been confirmed by the fortification of logically necessary truth, not anything existed before the supreme Being, nor will anything exist after it. Hence, nothing existed before, and nothing will exist after, it. For, either something or nothing must have preceded it; and either something or nothing must be destined to follow it.

But, he who says that nothing existed before it appears to make this statement, "that there was before it a time when nothing existed, and that there will be after it a time when nothing will exist." Therefore, when nothing existed, that Being did not exist, and when nothing shall exist, that Being will not exist. How is it, then, that it does not take inception from nothing or how is it that it will not come to nothing?—if that Being did not yet exist, when nothing already existed; and the same Being shall no longer exist, when nothing shall still exist. Of what avail is so weighty a mass of arguments, if this *nothing* so easily demolishes their structure? For, if it is established that the supreme Being succeeds *nothing*,¹ which

1 Nothing is here treated as an entity, supposed actually to precede the supreme Being in existence. The fallacy involved is shown below.—*Tr*.

precedes it, and yields its place to *nothing*, which follows it, whatever has been posited as true above is necessarily unsettled by empty nothing.

But, rather ought this *nothing* to be resisted, lest so many structures of cogent reasoning be stormed by *nothing*; and the supreme good, which has been sought and found by the light of truth, be lost for *nothing*. Let it rather be declared, then, that nothing did not exist before the supreme Being, and that nothing will not exist after it, rather than that, when a place is given before or after it to nothing, that Being which through itself brought into existence what was nothing, should be reduced through nothing to nothing.

For this one assertion, namely, that nothing existed before the supreme Being, carries two meanings. For, one sense of this statement is that, before the supreme Being, there was a time when nothing was. But another understanding of the same statement is that, before the supreme Being, not anything existed. Just as, supposing I should say, "Nothing has taught me to fly," I could explain this assertion either in this way, that nothing, as an entity in itself, which signifies *not anything*, has taught me actually to fly which would be false; or in this way, that not anything has taught me to fly, which would be true.

The former interpretation, therefore, which is followed by the inconsistency discussed above, is rejected by all reasoning as false. But there remains the other interpretation, which unites in perfect consistency with the foregoing arguments, and which, from the force of their whole correlation, must be true.

Hence, the statement that nothing existed before that Being must be received in the latter sense. Nor

should it be so explained, that it shall be understood that there was any time when that Being did not exist, and nothing did exist; but, so that it shall be understood that, before that Being, there was not anything. The same sort of double signification is found in the statement that nothing will exist after that Being.

If, then, this interpretation of the term *nothing*, that has been given, is carefully analysed, most truly neither something nor nothing preceded or will follow the supreme Being, and the conclusion is reached, that nothing existed before or will exist after it. Yet, the solidity of the truths already established is in no wise impaired by the emptiness of *nothing*.

CHAPTER XX.

It exists in every place and at every time.

But, although it has been concluded above that this creative Nature exists everywhere, and in all things, and through all; and from the fact that it neither began, nor will cease to be, it follows that it always has been, and is, and will be; yet, I perceive a certain secret murmur of contradiction which compels me to inquire more carefully where and when that Nature exists.

The supreme Being, then, exists either everywhere and always, or merely at some place and time, or nowhere and never: or, as I express it, either in every place and at every time, or finitely, in some place and at some time, or in no place and at no time.

But what can be more obviously contradictory, than that what exists most really and supremely exists nowhere and never? It is, therefore, false that it ex-

72

ists nowhere and never. Again, since there is no good, nor anything at all without it; if this Being itself exists nowhere or never, then nowhere or never is there any good, and nowhere and never is there anything at all. But there is no need to state that this is false. Hence, the former proposition is also false, that that Being exists nowhere and never.

It therefore exists finitely, at some time and place. or everywhere and always. But, if it exists finitely. at some place or time, there and then only, where and when it exists, can anything exist. Where and when it does not exist, moreover, there is no existence at all, because, without it, nothing exists. Whence it will follow, that there is some place and time where and when nothing at all exists. But seeing that this is false-for place and time themselves are existing things-the supreme Nature cannot exist finitely, at some place or time. But, if it is said that it of itself exists finitely, at some place and time, but that, through its power, it is wherever and whenever anything is, this is not true. For, since it is manifest that its power is nothing else than itself, by no means does its power exist without it.

Since, then, it does not exist finitely, at some place or time, it must exist everywhere and always, that is, in every place and at every time.

CHAPTER XXI.

It exists in no place or time.

But, if this is true, either it exists in every place and at every time, or else only a part of it so exists, the other part transcending every place and time.

But, if in part it exists, and in part does not exist,

in every place and at every time, it has parts; which is false. It does not, therefore, exist everywhere and always in part.

But how does it exist as a whole, everywhere and always? For, either it is to be understood that it exists as a whole at once, in all places or at all times, and by parts in individual places and times; or, that it exists as a whole, in individual places and times as well.

But, if it exists by parts in individual places or times, it is not exempt from composition and division of parts; which has been found to be in a high degree alien to the supreme Nature. Hence, it does not so exist, as a whole, in all places and at all times that it exists by parts in individual places and times.

We are confronted, then, by the former alternative, that is, how the supreme Nature can exist, as a whole, in every individual place and time. This is doubtless impossible, unless it either exists at once or at different times in individual places or times. But, since the law of place and the law of time, the investigation of which it has hitherto been possible to prosecute in a single discussion, because they advanced on exactly the same lines, here separate one from another and seem to avoid debate, as if by evasion in diverse directions, let each be investigated independently in discussion directed on itself alone.

First, then, let us see whether the supreme Nature can exist, as a whole, in individual places, either at once in all, or at different times, in different places. Then, let us make the same inquiry regarding the times at which it can exist.

If, then, it exists as a whole in each individual place, then, for each individual place there is an individual whole. For, just as place is so distinguished from place that there are individual places, so that which exists as a whole, in one place, is so distinct from that which exists as a whole at the same time, in another place, that there are individual wholes. For, of what exists as a whole, in any place, there is no part that does not exist in that place. And that of which there is no part that does not exist in a given place, is no part of what exists at the same time outside this place.

What exists as a whole, then, in any place, is no part of what exists at the same time outside that place. But, of that of which no part exists outside any given place, no part exists, at the same time, in another place. How, then, can what exists as a whole, in any place, exist simultaneously, as a whole, in another place, if no part of it can at that time exist in another place?

Since, then, one whole cannot exist as a whole in different places at the same time, it follows that, for individual places, there are individual wholes, if anything is to exist as a whole in different individual places at once. Hence, if the supreme Nature exists as a whole, at one time, in every individual place, there are as many supreme Natures as there can be individual places; which it would be irrational to believe. Therefore, it does not exist, as a whole, at one time in individual places.

If, however, at different times it exists, as a whole, in individual places, then, when it is in one place, there is in the meantime no good and no existence in other places, since without it absolutely nothing exists. But the absurdity of this supposition is proved by the existence of places themselves, which are not nothing, but something. Therefore, the supreme Nature does not exist, as a whole, in individual places at different times.

But, if neither at the same time nor at different times does it exist, as a whole, in individual places, it is evident that it does not at all exist, as a whole, in each individual place. We must now examine, then, whether this supreme Nature exists, as a whole, at individual times, either simultaneously or at distinct times for individual times.

But, how can anything exist, as a whole, simultaneously, at individual times, if these times are not themselves simultaneous? But, if this Being exists, as a whole, separately and at distinct times for individual times, just as a man exists as a whole yesterday, to-day, and to-morrrow; it is properly said that it was and is and will be. Its age, then, which is no other than its eternity, does not exist, as a whole, simultaneously, but it is distributed in parts according to the parts of time.

But its eternity is nothing else than itself. The supreme Being, then, will be divided into parts, according to the divisions of time. For, if its age is prolonged through periods of time, it has with this time present, past, and future. But what else is its age than its duration of existence, than its eternity? Since, then, its eternity is nothing else than its essence, as considerations set forth above irrefutably prove; if its eternity has past, present, and future, its essence also has, in consequence, past, present, and future.

But what is past is not present or future; and what is present is not past or future; and what is future is not past or present. How, then, shall that proposition be valid, which was proved with clear and logical cogency above, namely, that that supreme Nature is in no wise composite, but is supremely simple, supremely immutable?—how shall this be so, if that Nature is one thing, at one time, and another, at another, and has parts distributed according to times? Or rather, if these earlier propositions are true, how can these latter be possible? By no means, then, is past or future attributable to the creative Being, either its age or its eternity. For why has it not a present, if it truly *is*? But *was* means past, and *will be* future. Therefore that Being never was, nor will be. Hence, it does not exist at distinct times, just as it does not exist, as a whole, simultaneously in different individual times.

If, then, as our discussion has proved, it neither so exists, as a whole, in all places or times that it exists, as a whole, at one time in all, or by parts in individual places and times; nor so that it exists, as a whole, in individual times and places, it is manifest that it does not in any way exist, as a whole, in every time or place.

And, since, in like manner, it has been demonstrated that it neither so exists in every time or place, that a part exists in every, and a part transcends every, place and time, it is impossible that it exists everywhere and always.

For, in no way can it be conceived to exist everywhere and always, except either as a whole or in part. But if it does not at all exist everywhere and always, it will exist either finitely in some place or time, or in none. But it has already been proved, that it cannot exist finitely, in any place or time. In no place or time, that is, nowhere and never does it exist. For it cannot exist, except in every or in some place or time.

But, on the other hand, since it is irrefutably established, not only that it exists through itself, and without beginning and without end, but that without it nothing anywhere or ever exists, it must exist everywhere and always.

CHAPTER XXII.

How it exists in every place and time, and in none.

How, then, shall these propositions, that are so necessary according to our exposition, and so necessary according to our proof, be reconciled? Perhaps the supreme Nature exists in place and time in some such way, that it is not prevented from so existing simultaneously, as a whole, in different places or times, that there are not more wholes than one; and that its age, which does not exist, except as true eternity, is not distributed among past, present, and future.

For, to this law of space and time, nothing seems to be subject, except the beings which so exist in space or time that they do not transcend extent of space or duration of time. Hence, though of beings of this class it is with all truth asserted that one and the same whole cannot exist simultaneously, as a whole, in different places or times; in the case of those beings which are not of this class, no such conclusion is necessarily reached.

For it seems to be rightly said, that place is predicable only of objects whose magnitude place contains by including it, and includes by containing it; and that time is predicable only of objects whose dura-

78

tion time ends by measuring it, and measures by ending it. Hence, to any being, to whose spatial extent or duration no bound can be set, either by space or time, no place or time is properly attributed. For, seeing that place does not act upon it as place, nor time as time, it is not irrational to say, that no place is its place, and no time its time.

But, what evidently has no place or time is doubtless by no means compelled to submit to the law of place or time. No law of place or time, then, in any way governs any nature, which no place or time limits by some kind of restraint. But what rational consideration can by any course of reasoning fail to reach the conclusion, that the Substance which creates and is supreme among all beings, which must be alien to, and free from, the nature and law of all things which itself created from nothing, is limited by no restraint of space or time; since, more truly, its power, which is nothing else than its essence, contains and includes under itself all these things which it created?

Is it not impudently foolish, too, to say either, that space circumscribes the magnitude of truth, or, that time measures its duration—truth, which regards no greatness or smallness of spatial or temporal extent at all?

Seeing, then, that this is the condition of place or time; that only whatever is limited by their bounds neither escapes the law of parts—such as place follows, according to magnitude, or such as time submits to, according to duration—nor can in any way be contained, as a whole, simultaneously by different places or times; but whatever is in no wise confined by the restraint of place or time, is not compelled by any law of places or times to multiplicity of parts,

nor is it prevented from being present, as a whole and simultaneously, in more places or times than one seeing, I say, that this is the condition governing place or time, no doubt the supreme Substance, which is encompassed by no restraint of place or time, is bound by none of their laws.

Hence, since inevitable necessity requires that the supreme Being, as a whole, be lacking to no place or time, and no law of place or time prevents it from being simultaneously in every place or time; it must be simultaneously present in every individual place or time. For, because it is present in one place, it is not therefore prevented from being present at the same time, and in like manner in this, or that other, place or time.

Nor, because it was, or is, or shall be, has any part of its eternity therefore vanished from the present, with the past, which no longer is; nor does it pass with the present, which is, for an instant; nor is it to come with the future, which is not yet.

For, by no means is that Being compelled or forbidden by a law of space or time to exist, or not to exist, at any place or time—the Being which, in no wise, includes its own existence in space or time. For, when the supreme Being is said to exist in space or time, although the form of expression regarding it, and regarding local and temporal natures, is the same, because of the usage of language, yet the sense is different, because of the unlikeness of the objects of discussion. For in the latter case the same expression has two meanings, namely: (1) that these objects are present in those places and times in which they are said to be, and (2) that they are contained by these places and times themselves.

80

But in the case of the supreme Being, the first sense only is intended, namely, that it is present; not that it is also contained. If the usage of language permitted, it would, therefore, seem to be more fittingly said, that it exists with place or time, than that it exists in place or time. For the statement that a thing exists in another implies that it is contained, more than does the statement that it exists with another.

In no place or time, then, is this Being properly said to exist, since it is contained by no other at all. And yet it may be said, after a manner of its own, to be in every place or time, since whatever else exists is sustained by its presence, lest it lapse into nothingness. It exists in every place and time, because it is absent from none; and it exists in none, because it has no place or time, and has not taken to itself distinctions of place or time, neither here nor there, nor anywhere, nor then, nor now, nor at any time; nor does it exist in terms of this fleeting present, in which we live, nor has it existed, nor will it exist, in terms of past or future, since these are restricted to things finite and mutable, which it is not.

And yet, these properties of time and place can, in some sort, be ascribed to it, since it is just as truly present in all finite and mutable beings as if it were circumscribed by the same places, and suffered change by the same times.

We have sufficient evidence, then, to dispel the contradiction that threatened us; as to how the highest Being of all exists, everywhere and always, and nowhere and never, that is, in every place and time, and in no place or time, according to the consistent truth of different senses of the terms employed.

CHAPTER XXIII.

How it is better conceived to exist everywhere than in every place

But, since it is plain that this supreme Nature is not more truly in all places than in all existing things, not as if it were contained by them, but as containing all, by permeating all, why should it not be said to be everywhere, in this sense, that it may be understood rather to be in all existing things, than merely in all places, since this sense is supported by the truth of the fact, and is not forbidden by the proper signification of the word of place?

For we often quite properly apply terms of place to objects which are not places; as, when I say that the understanding is *there* in the soul, *where* rationality is. For, though *there* and *where* are adverbs of place, yet, by no local limitation, does the mind contain anything, nor is either rationality or understanding contained.

Hence, as regards the truth of the matter, the supreme Nature is more appropriately said to be everywhere, in this sense, that it is in all existing things, than in this sense, namely that it is merely in all places. And since, as the reasons set forth above show, it cannot exist otherwise, it must so be in all existing things, that it is one and the same perfect whole in every individual thing simultaneously.

CHAPTER XXIV

How it is better understood to exist always than at every time.

It is also evident that this supreme Substance is without beginning and without end; that it has neither

past, nor future, nor the temporal, that is, transient present in which we live; since its age, or eternity, which is nothing else than itself, is immutable and without parts. Is not, therefore, the term which seems to mean *all time* more properly understood, when applied to this Substance, to signify eternity, which is never unlike itself, rather than a changing succession of times, which is ever in some sort unlike itself?

Hence, if this Being is said to exist always; since, for it, it is the same to exist and to live, no better sense can be attached to this statement, than that it exists or lives eternally, that is, it possesses interminable life, as a perfect whole at once. For its eternity apparently is an interminable life, existing at once as a perfect whole.

For, since it has already been shown that this Substance is nothing else than its own life and its own eternity, is in no wise terminable, and does not exist, except as at once and perfectly whole, what else is true eternity, which is consistent with the nature of that Substance alone, than an interminable life, existing as at once and perfectly whole?

For this truth is, at any rate, clearly perceived from the single fact that true eternity belongs only to that substance which alone, as we have proved, was not created, but is the creator, since true eternity is conceived to be free from the limitations of beginning and end; and this is proved to be consistent with the nature of no created being, from the very fact that all such have been created from nothing.

CHAPTER XXV.

It cannot suffer change by any accidents.¹

But does not this Being, which has been shown to exist as in every way substantially identical with itself, sometimes exist as different from itself, at any rate, accidentally? But how is it supremely immutable, if it can, I will not say, be, but, be conceived of, as variable by virtue of accidents? And, on the other hand, does it not partake of accident, since even this very fact that it is greater than all other natures and that it is unlike them seems to be an accident in its case (*illi accidere*)? But what is the inconsistency between susceptibility to certain facts, called *accidents*, and natural immutability, if from the undergoing of these accidents the substance undergoes no change?

For, of all the facts, called accidents, some are understood not to be present or absent without some variation in the subject of the accident—all colors, for instance—while others are known not to effect any change in a thing either by occurring or not occurring —certain relations, for instance. For it is certain that I am neither older nor younger than a man who is not yet born, nor equal to him, nor like him. But I shall be able to sustain and to lose all these relations toward him, as soon as he shall have been born, according as he shall grow, or undergo change through divers qualities.

It is made clear, then, that of all those facts, called accidents, a part bring some degree of mutability in their train, while a part do not impair at all the im-

1 Accidents, as Anselm uses the term, are facts external to the essence of a being, which may yet be conceived to produce changes in a mutable being.

mutability of that in whose case they occur. Hence, although the supreme Nature in its simplicity has never undergone such accidents as cause mutation, yet it does not disdain occasional expression in terms of those accidents which are in no wise inconsistent with supreme immutability; and yet there is no accident respecting its essence, whence it would be conceived of, as itself variable.

Whence this conclusion, also, may be reached, that it is susceptible of no accident; since, just as those accidents, which effect some change by their occurrence or non-occurrence, are by virtue of this very effect of theirs regarded as being true *accidents*, so those facts, which lack a like effect, are found to be improperly called accidents. Therefore, this Essence is always, in every way, substantially identical with itself; and it is never in any way different from itself, even accidentally. But, however it may be as to the proper signification of the term *accident*, this is undoubtedly true, that of the supremely immutable Nature no statement can be made, whence it shall be conceived of as mutable.

CHAPTER XXVI.

How this Being is said to be substance: it transcends all substance and is individually whatever it is.

Bur, if what we have ascertained concerning the simplicity of this Nature is established, how is it substance? For, though every substance is susceptible of admixture of difference, or, at any rate, susceptible of mutation by accidents, the immutable purity of this Being is inaccessible to admixture or mutation, in any form.

ANSELM.

How, then, shall it be maintained that it is a substance of any kind, except as it is called *substance* for *being*, and so transcends. as it is above, every substance? For, as great as is the difference between that Being, which is through itself whatever it is, and which creates every other being from nothing, and a being, which is made whatever it is through another, from nothing; so much does the supreme Substance differ from these beings, which are not what it is. And, since it alone, of all natures, derives from itself, without the help of another nature, whatever existence it has, is it not whatever it is individually and apart from association with its creatures?

Hence, if it ever shares any name with other beings, doubtless a very different signification of that name is to be understood in its case.

CHAPTER XXVII.

It is not included among substances as commonly treated yet it is a substance and an indivisible spirit.

It is, therefore, evident that in any ordinary treatment of substance, this Substance cannot be included, from sharing in whose essence every nature is excluded. Indeed, since every substance is treated either as universal, i. e., as essentially common to more than one substance, as being a man is common to individual men; or as individual, having a universal essence in common with others, as individual men have in common with individual men the fact that they are men; does any one conceive that, in the treatment of other substances, that supreme Nature is included, which neither divides itself into more substances than one, nor unites with any other, by virtue of a common essence?

Yet, seeing that it not only most certainly exists, but exists in the highest degree of all things; and since the essence of anything is usually called its substance, doubtless if any worthy name can be given it, there is no objection to our calling it *substance*.

is known, and of these, spirit is more worthy than And since no worthier essence than spirit and body

And since no worthier essence than spirit and body is known, and of these, spirit is more worthy than body, it must certainly be maintained that this Being is spirit and not body. But, seeing that one spirit has not any parts, and there cannot be more spirits than one of this kind, it must, by all means, be an indivisible spirit. For since, as is shown above, it is neither compounded of parts, nor can be conceived of as mutable, through any differences or accidents, it is impossible that it is divisible by any form of division.

CHAPTER XXVIII.

This Spirit exists simply, and created beings are not comparable with him.

IT seems to follow, then, from the preceding considerations, that the Spirit which exists in so wonderfully singular and so singularly wonderful a way of its own is in some sort unique; while other beings which seem to be comparable with it are not so.

For, by diligent attention it will be seen that that Spirit alone exists simply, and perfectly, and absolutely; while all other beings are almost non-existent, and hardly exist at all. For, seeing that of this Spirit, because of its immutable eternity, it can in no wise be said, in terms of any alteration, that it was or will be, but simply that it is; it is not now, by mutation, anything which it either was not at any time, or will not be in the future. Nor does it fail to be now what it was, or will be, at any time; but, whatever it is, it is, once for all, and simultaneously, and interminably. Seeing, I say, that its existence is of this character, it is rightly said itself to exist simply, and absolutely, and perfectly.

But since, on the other hand, all other beings, in accordance with some cause, have at some time been, or will be, by mutation, what they are not now; or are what they were not, or will not be, at some time; and, since this former existence of theirs is no longer a fact; and that future existence is not yet a fact; and their existence in a transient, and most brief, and scarcely existing, present is hardly a fact—since, then, they exist in such mutability, it is not unreasonably denied that they exist simply, and perfectly, and absolutely; and it is asserted that they are almost nonexistent, that they scarcely exist at all.

Again, since all beings, which are other than this Spirit himself, have come from non-existence to existence, not through themselves, but through another; and, since they return from existence to non-existence, so far as their own power is concerned, unless they are sustained through another being, is it consistent with their nature to exist simply, or perfectly, or absolutely, and not rather to be almost non-existent

And since the existence of this ineffable Spirit alone can in no way be conceived to have taken inception from non-existence, or to be capable of sustaining any deficiency rising from what is in nonexistence; and since, whatever he is himself, he is not through another than himself, that is, than what he is himself, ought not his existence alone to be conceived of as simple, and perfect, and absolute? But what is thus simply, and on every ground, solely perfect, simple, and absolute, this may very certainly be justly said to be in some sort unique. And, on the other hand, whatever is known to exist through a higher cause, and neither simply, nor perfectly, nor absolutely, but scarcely to exist, or to be almost non-existent—this assuredly may be rightly said to be in some sort non-existent.

According to this course of reasoning, then, the creative Spirit alone exists, and all creatures are nonexistent; yet, they are not wholly non-existent, because, through that Spirit which alone exists absolutely, they have been made something from nothing.

CHAPTER XXIX.

His expression is identical with himself, and consubstantial with him, since there are not two spirits, but one.

But now, having considered these questions regarding the properties of the supreme Nature, which have occurred to me in following the guidance of reason to the present point, I think it reasonable to examine this Spirit's expression (*locutio*), through which all things were created.

For, though all that has been ascertained regarding this expression above has the inflexible strength of reason, I am especially compelled to a more careful discussion of this expression by the fact that it is proved to be identical with the supreme Spirit himself. For, if this Spirit created nothing except through himself, and whatever was created by him was created through that expression, how shall that expression be anything else than what the Spirit himself is?

Furthermore, the facts already discovered declare

ANSELM.

irrefutably that nothing at all ever could, or can, exist, except the creative Spirit and its creatures. But it is impossible that the expression of this Spirit is included among created beings; for every created being was created through that expression; but that expression could not be created through itself. For nothing can be created through itself, since every creature exists later than that through which it is created, and nothing exists later than itself.

The alternative remaining is, then, that this expression of the supreme Spirit, since it cannot be a creature, is no other than the supreme Spirit. Therefore, this expression itself can be conceived of as nothing else than the intelligence (*intelligentia*) of this Spirit, by which he conceives of (*intelligit*) all things. For, to him, what is expressing anything, according to this kind of expression, but conceiving of it? For he does not, like man, ever fail to express what he conceives.

If, then, the supremely simple Nature is nothing else than what its intelligence is, just as it is identical with its wisdom, necessarily, in the same way, it is nothing else than what its expression is. But, since it is already manifest that the supreme Spirit is one only, and altogether indivisible, this his expression must be so consubstantial with him, that they are not two spirits, but one.

CHAPTER XXX.

This expression does not consist of more words than one, but is one Word.

WHY, then, should I have any further doubt regarding that question which I dismissed above as doubtful, namely, whether this expression consists of

90

more words than one, or of one? For, if it is so consubstantial with the supreme Nature that they are not two spirits, but one; assuredly, just as the latter is supremely simple, so is the former. It therefore does not consist of more words than one, but is one Word, through which all things were created.

CHAPTER XXXI.

This Word itself is not the likeness of created beings, but the reality of their being, while created beings are a kind of likeness of reality.—What natures are greater and more excellent than others.

But here, it seems to me, there arises a question that is not easy to answer, and yet must not be left in any ambiguity. For all words of that sort by which we express any objects in our mind, that is, conceive of them, are likenesses and images of the objects to which they correspond; and every likeness or image is more or less true, according as it more or less closely imitates the object of which it is the likeness.

What, then, is to be our position regarding the Word by which all things are expressed, and through which all were created? Will it be, or will it not be, the likeness of the things that have been created through itself? For, if it is itself the true likeness of mutable things, it is not consubstantial with supreme immutability; which is false. But, if it is not altogether true, and is merely a sort of likeness of mutable things, then the Word of supreme Truth is not altogether true; which is absurd. But if it has no likeness to mutable things, how were they created after its example?

But perhaps nothing of this ambiguity will remain if—as the reality of a man is said to be the living man, but the likeness or image of a man in his picture —so the reality of being is conceived of as in the Word, whose essence exists so supremely that in a certain sense it alone exists; while in these things which, in comparison with that Essence, are in some sort non-existent, and yet were made something through, and according to, that Word, a kind of imitation of that supreme Essence is found.

For, in this way the Word of supreme Truth, which is also itself supreme Truth, will experience neither gain nor loss, according as it is more or less like its creatures. But the necessary inference will rather be, that every created being exists in so much the greater degree, or is so much the more excellent, the more like it is to what exists supremely, and is supremely great.

For on this account, perhaps,—nay, not perhaps, but certainly,—does every mind judge natures in any way alive to excel those that are not alive, the sentient to excel the non-sentient, the rational the irrational. For, since the supreme Nature, after a certain unique manner of its own, not only exists, but lives, and is sentient and rational, it is clear that, of all existing beings, that which is in some way alive is more like this supreme Nature, than that which is not alive at all; and what, in any way, even by a corporeal sense, cognises anything, is more like this Nature than what is not sentient at all; and what is rational, more than what is incapable of reasoning.

But it is clear, for a like reason, that certain natures exist in a greater or less degree than others. For, just as that is more excellent by nature which, through its natural essence, is nearer to the most excellent Being, so certainly that nature exists in a greater degree, whose essence is more like the supreme Essence. And I think that this can easily be ascertained as follows. If we should conceive any substance that is alive, and sentient, and rational, to be deprived of its reason, then of its sentience, then of its life, and finally of the bare existence that remains, who would fail to understand that the substance that is thus destroyed, little by little, is gradually brought to smaller and smaller degrees of existence, and at last to non-existence? But the attributes which, taken each by itself, reduce an essence to less and less degrees of existence, if assumed in order, lead it to greater and greater degrees.

It is evident, then, that a living substance exists in a greater degree than one that is not living, a sentient than a non-sentient, and a rational than a nonrational. So, there is no doubt that every substance exists in a greater degree, and is more excellent, according as it is more like that substance which exists supremely and is supremely excellent.

It is sufficiently clear, then, that in the Word, through which all things were created, is not their likeness, but their true and simple essence; while, in the things created, there is not a simple and absolute essence, but an imperfect imitation of that true Essence. Hence, it necessarily follows, that this Word is not more nor less true, according to its likeness to the things created, but every created nature has a higher essence and dignity, the more it is seen to approach that Word.

ANSELM

CHAPTER XXXII.

The supreme Spirit expresses himself by a coeternal Word.

But since this is true, how can what is simple Truth be the Word corresponding to those objects, of which it is not the likeness? Since every word by which an object is thus mentally expressed is the likeness of that object, if this is not the word corresponding to the objects that have been created through it, how shall we be sure that it is the Word? For every word is a word corresponding to some object. Therefore, if there were no creature, there would be no word.

Are we to conclude, then, that if there were no creature, that Word would not exist at all, which is the supreme self-sufficient Essence? Or, would the supreme Being itself, perhaps, which is the Word, still be the eternal Being, but not the Word, if nothing were ever created through that Being? For, to what has not been, and is not, and will not be, there can be no word corresponding.

But, according to this reasoning, if there were never any being but the supreme Spirit, there would be no word at all in him. If there were no word in him, he would express nothing to himself; if he expressed nothing to himself, since, for him, expressing anything is the same with understanding or conceiving of it (*intelligere*), he would not understand or conceive of anything; if he understood or conceived of nothing, then the supreme Wisdom, which is nothing else than this Spirit, would understand or conceive of nothing; which is most absurd. What is to be inferred? For, if it conceived of nothing, how would it be the supreme Wisdom? Or, if there were in no wise anything but it, of what would it conceive? Would it not conceive of itself? But how can it be even imagined that the supreme Wisdom, at any time does not conceive of itself; since a rational mind can remember not only itself, but that supreme Wisdom, and conceive of that Wisdom and of itself? For, if the human mind could have no memory or concept of that Wisdom or of itself, it would not distinguish itself at all from irrational creatures, and that Wisdom from the whole created world, in silent meditation by itself, as my mind does now.

Hence, that Spirit, supreme as he is eternal, is thus eternally mindful of himself, and conceives of himself after the likeness of a rational mind; nay, not after the likeness of anything; but in the first place that Spirit, and the rational mind after its likeness. But, if he conceives of himself eternally, he expresses himself eternally. If he expresses himself eternally, his Word is eternally with him. Whether, therefore, it be thought of in connection with no other existing being, or with other existing beings, the Word of that Spirit must be coeternal with him.

CHAPTER XXXIII.

He utters himself and what he creates by a single consubstantial Word.

But here, in my inquiry concerning the Word, by which the Creator expresses all that he creates, is suggested the word by which he, who creates all, expresses himself. Does he express himself, then, by one word, and what he creates by another; or does

ANSELM.

he rather express whatever he creates by the same word whereby he expresses himself?

For this Word also, by which he expresses himself, must be identical with himself, as is evidently true of the Word by which he expresses his creatures. For since, even if nothing but that supreme Spirit ever existed, urgent reason would still require the existence of that word by which he expresses himself, what is more true than that his Word is nothing else than what he himself is? Therefore, if he expresses himself and what he creates, by a Word consubstantial with himself, it is manifest that of the Word by which he expresses himself, and of the Word by which he expresses the created world, the substance is one.

How, then, if the substance is one, are there two words? But, perhaps, identity of substance does not compel us to admit a single Word. For the Creator himself, who speaks in these words, has the same substance with them, and yet is not the Word. But, undoubtedly the word by which the supreme Wisdom expresses itself may most fitly be called its Word on the former ground, namely, that it contains the perfect likeness of that Wisdom.

For, on no ground can it be denied that when a rational mind conceives of itself in meditation the image of itself arises in its thought, or rather the thought of the mind is itself its image, after its likeness, as if formed from its impression. For, whatever object the mind, either through representation of the body or through reason, desires to conceive of truly, it at least attempts to express its likeness, so far as it is able, in the mental concept itself. And the more truly it succeeds in this, the more truly does it think of the object itself; and, indeed, this fact is observed more

96

clearly when it thinks of something else which it is not, and especially when it thinks of a material body. For, when I think of a man I know, in his absence, the vision of my thought forms such an image as I have acquired in memory through my ocular vision and this image is the word corresponding to the man I express by thinking of him.

The rational mind, then, when it conceives of itself in thought, has with itself its image born of itself that is, its thought in its likeness, as if formed from its impression, although it cannot, except in thought alone, separate itself from its image, which image is its word.

Who, then, can deny that the supreme Wisdom, when it conceives of itself by expressing itself, begets a likeness of itself consubstantial with it, namely, its Word? And this Word, although of a subject so uniquely important nothing can be said with sufficient propriety, may still not inappropriately be called the image of that Wisdom, its representation, just as it is called his likeness.

But the Word by which the Creator expresses the created world is not at all, in the same way, a word corresponding to the created world, since it is not this world's likeness, but its elementary essence. It therefore follows, that he does not express the created world itself by a word corresponding to the created world. To what, then, does the word belong, whereby he expresses it, if he does not express it by a word belonging to itself? For what he expresses, he expresses by a word, and a word must belong to something, that is, it is the likeness of something. But if he expresses nothing but himself or his created world he can express nothing, except by a word corresponding to himself or to something else.

So, if he expresses nothing by a word belonging to the created world, whatever he expresses, he expresses by the Word corresponding to himself. By one and the same Word, then, he expresses himself and whatever he has made.

CHAPTER XXXIV.

How he can express the created world by his Word.

But how can objects so different as the creative and the created being be expressed by one Word, especially since that Word itself is coeternal with him who expresses them, while the created world is not coeternal with him? Perhaps, because he himself is supreme Wisdom and supreme Reason, in which are all things that have been created; just as a work which is made after one of the arts, not only when it is made, but before it is made, and after it is destroyed, is always in respect of the art itself nothing else than what that art is.

Hence, when the supreme Spirit expresses himself, he expresses all created beings. For, both before they were created, and now that they have been created, and after they are decayed or changed in any way, they are ever in him not what they are in themselves, but what this Spirit himself is. For, in themselves they are mutable beings, created according to immutable reason; while in him is the true first being, and the first reality of existence, the more like unto which those beings are in any way, the more really and excellently do they exist. Thus, it may reasonably be declared that, when the supreme Spirit ex-

98

presses himself, he also expresses whatever has been created by one and the same Word.

CHAPTER XXXV.

Whatever has been created is in his Word and knowledge, life and truth.

But, since it is established that his word is consubstantial with him, and perfectly like him, it necessarily follows that all things that exist in him exist also, and in the same way, in his Word. Whatever has been created, then, whether alive or not alive, or howsoever it exists in itself, is very life and truth in him.

But, since knowing is the same to the supreme Spirit as conceiving or expressing, he must know all things that he knows in the same way in which he expresses or conceives of them. Therefore, just as all things are in his Word life and truth, so are they in his knowledge.

CHAPTER XXXVI.

In how incomprehensible a way he expresses or knows the objects created by him.

HENCE, it may be most clearly comprehended that how this Spirit expresses, or how he knows the created world, cannot be comprehended by human knowledge. For none can doubt that created substances exist far differently in themselves than in our knowledge. For, in themselves they exist by virtue of their own being; while in our knowledge is not their being, but their likeness.

We conclude, then, that they exist more truly in themselves than in our knowledge, in the same degree in which they exist more truly anywhere by virtue of their own being, than by virtue of their likeness. Therefore, since this is also an established truth, that every created substance exists more truly in the Word, that is, in the intelligence of the Creator, than it does in itself, in the same degree in which the creative being exists more truly than the created; how can the human mind comprehend of what kind is that expression and that knowledge, which is so much higher and truer than created substances; if our knowledge is as far surpassed by those substances as their likeness is removed from their being?

CHAPTER XXXVII.

Whatever his relation to his creatures, this relation his Word also sustains: yet both do not simultaneously sustain this relation as more than one being.

But since it has already been clearly demonstrated that the supreme Spirit created all things through his Word, did not the Word itself also create all things? For, since it is consubstantial with him, it must be the supreme essence of that of which it is the Word. But there is no supreme Essence, except one, which is the only creator and the only beginning of all things which have been created. For this Essence, through no other than itself, alone created all things from nothing. Hence, whatever the supreme Spirit creates, the same his Word also creates, and in the same way.

Whatever relation, then, the supreme Spirit bears to what he creates, this relation his Word also bears, and in the same way. And yet, both do not bear it simultaneously, as more than one, since there are not more supreme creative essences than one. Therefore,

just as he is the creator and the beginning of the world, so is his Word also; and yet there are not two, but one creator and one beginning.

CHAPTER XXXVIII.

It cannot be explained why they are two, although they must be so.

Our careful attention is therefore demanded by a peculiarity which, though most unusual in other beings, seems to belong to the supreme Spirit and his Word. For, it is certain that in each of these separately and in both simultaneously, whatever they are so exists that it is separately perfected in both, and yet does not admit plurality in the two. For although, taken separately, he is perfectly supreme Truth and Creator, and his Word is supreme Truth and Creator; yet both at once are not two truths or two creators.

But although this is true, yet it is most remarkably clear that neither he, whose is the Word, can be his own Word, nor can the Word be he, whose Word it is, although in so far as regards either what they are substantially, or what relation they bear to the created world, they ever preserve an indivisible unity. But in respect of the fact that he does not derive existence from that Word, but that Word from him, they admit an ineffable plurality, ineffable, certainly, for although necessity requires that they be two, it can in no wise be explained why they are two.

For although they may perhaps be called two equals, or some other mutual relation may in like manner be attributed to them, yet if it were to be asked what it is in these very relative expressions with reference to which they are used, it cannot be expressed plurally, as one speaks of two equal lines, or two like men. For, neither are there two equal spirits nor two equal creators, nor is there any dual expression which indicates either their essence or their relation to the created world; and there is no dual expression which designates the peculiar relation of the one to the other, since there are neither two words nor two images.

For the Word, by virtue of the fact that it is a word or image, bears a relation to the other, because it is Word and image only as it is the Word and image of something; and so peculiar are these attributes to the one that they are by no means predicable of the other. For he, whose is the Word and image, is neither image nor Word. It is, therefore, evident that it cannot be explained why they are two, the supreme Spirit and the Word, although by certain properties of each they are required to be two. For it is the property of the one to derive existence from the other, and the property of that other that the first derives existence from him.

CHAPTER XXXIX.

This Word derives existence from the supreme Spirit by birth.

AND this truth, it seems, can be expressed in no more familiar terms than when it is said to be the property of the one, to be born of the other; and of the other, that the first is born of him. For it is now clearly proved, that the Word of the supreme Spirit does not derive existence from him, as do those beings which have been created by him; but as Creator from Creator, supreme Being from supreme Being. And, to dispose of this comparison with all brevity, it is one and the same being, which derives existence from one and the same being, and on such terms, that it in no wise derives existence, except from that being.

Since it is evident, then, that the Word of the supreme Spirit so derives existence from him alone, that it is completely analogous to the offspring of a parent; and that it does not derive existence from him, as if it were created by him, doubtless no more fitting supposition can be entertained regarding its origin, than that it derives existence from the supreme Spirit by birth (*nascendo*).

For, innumerable objects are unhesitatingly said to be born of those things from which they derive existence, although they possess no such likeness to those things of which they are said to be born, as offspring to a parent.—We say, for instance, that the hair is born of the head, or the fruit of the tree, although the hair does not resemble the head, nor the fruit the tree.

If, then, many objects of this sort are without absurdity said to be born, so much the more fittingly may the Word of the supreme Spirit be said to derive existence from him by birth, the more perfect the resemblance it bears to him, like a child's to its parent, through deriving existence from him.

CHAPTER XL.

He is most truly a parent, and that Word his offspring.

But if it is most properly said to be born, and is so like him of whom it is born, why should it be esteemed *like*, as a child is like his parent? why should it not rather be declared, that the Spirit is more truly a parent, and the Word his offspring, the more he alone is sufficient to effect this birth, and the more what is born expresses his likeness? For, among other beings which we know bear the relations of parent and child, none so begets as to be solely and without accessory, sufficient to the generation of offspring; and none is so begotten that without any admixture of unlikeness, it shows complete likeness to its parent.

If, then, the Word of the supreme Spirit so derives its complete existence from the being of that Spirit himself alone, and is so uniquely like him, that no child ever so completely derives existence from its parent, and none is so like its parent, certainly the relation of parent and offspring can be ascribed to no beings so consistently as to the supreme Spirit and his Word. Hence, it is his property to be most truly parent, and its to be most truly his offspring.

CHAPTER XLI.

He most truly begets, and it is most truly begotten.

Bur it will be impossible to establish this proposition, unless, in equal degree, he most truly begets, and it is most truly begotten. As the former supposition is evidently true, so the latter is necessarily most certain. Hence, it belongs to the supreme Spirit most truly to beget, and to his Word to be most truly begotten.

CHAPTER XLII.

It is the property of the one to be most truly progenitor and Father, and of the other to be the begotten and Son.

I should certainly be glad, and perhaps able, now to reach the conclusion, that he is most truly the Fa-

ther, while this Word is most truly his Son. But I think that even this question should not be neglected: whether it is more fitting to call them Father and Son, than mother and daughter, since in them there is no distinction of sex.

For, if it is consistent with the nature of the one to be the Father, and of his offspring to be the Son, because both are Spirit (*Spiritus*, masculine); why is it not, with equal reason, consistent with the nature of the one to be the mother, and the other the daughter, since both are truth and wisdom (veritas et sapientia, feminine)?

Or, is it because in these natures that have a difference of sex, it belongs to the superior sex to be father or son, and to the inferior to be mother or daughter? And this is certainly a natural fact in most instances, but in some the contrary is true, as among certain kinds of birds, among which the female is always larger and stronger, while the male is smaller and weaker.

At any rate, it is more consistent to call the supreme Spirit father than mother, for this reason, that the first and principal cause of offspring is always in the father. For, if the maternal cause is ever in some way preceded by the paternal, it is exceedingly inconsistent that the name *mother* should be attached to that parent with which, for the generation of offspring, no other cause is associated, and which no other precedes. It is, therefore, most true that the supreme Spirit is Father of his offspring. But, if the son is always more like the father than is the daughter, while nothing is more like the supreme Father than his offspring; then it is most true that this offspring is not Aughter, but a Son.

ANSELM.

Hence, just as it is the property of the one most truly to beget, and of the other to be begotten, so it is the property of the one to be most truly progenitor, and of the other to be most truly begotten. And as the one is most truly the parent, and the other his offspring, so the one is most truly Father, and the other most truly Son.

CHAPTER XLIII.

Consideration of the common attributes of both and the individual properties of each.

Now that so many and so important properties of each have been discovered, whereby a strange plurality, as ineffable as it is inevitable, is proved to exist in the supreme unity, I think it most interesting to reflect, again and again, upon so unfathomable a mystery.

For observe: although it is so impossible that he who begets, and he who is begotten, are the same, and that parent and offspring are the same—so impossible that necessarily one must be the progenitor and the other the begotten, and one the Father, the other the Son; yet, here it is so necessary that he who begets and he who is begotten shall be the same, and also that parent and offspring shall be the same, that the progenitor cannot be any other than what the begotten is, nor the Father any other than the Son.

And although the one is one, and the other another, so that it is altogether evident that they are two; yet that which the one and the other are is in such a way one and the same, that it is a most obscure mystery why they are two. For, in such a way is one the Father and the other the Son, that when I speak of both I perceive that I have spoken of two;

106

and yet so identical is that which both Father and Son are, that I do not understand why they are two of whom I have spoken.

For, although the Father separately is the perfectly supreme Spirit, and the Son separately is the perfectly supreme Spirit, yet, so are the Spirit-Father and the Spirit-Son one and the same being, that the Father and the Son are not two spirits, but one Spirit. For, just as to separate properties of separate beings, plurality is not attributed, since they are not properties of two things, so, what is common to both preserves an indivisible unity, although it belongs, as a whole, to them taken separately.

For, as there are not two fathers or two sons, but one Father and one Son, since separate properties belong to separate beings, so there are not two spirits, but one Spirit; although it belongs both to the Father, taken separately, and to the Son, taken separately, to be the perfect Spirit. For so opposite are their relations, that the one never assumes the property of the other; so harmonious are they in nature, that the one ever contains the essence of the other. For they are so diverse by virtue of the fact that the one is the Father and the other the Son, that the Father is never called the Son, nor the Son the Father; and they are so identical, by virtue of their substance, that the essence of the Son is ever in the Father, and the essence of the Father in the Son.

CHAPTER XLIV.

How one is the essence of the other.

HENCE, even if one is called the essence of the other, there is no departure from truth; but the su-

ANSELM.

preme simplicity and unity of their common nature is thus honored. For, not as one conceives of a man's wisdom, through which man is wise, though he cannot be wise through himself, can we thus understand the statement that the Father is essence of the Son, and the Son the essence of the Father. We cannot understand that the Son is existent through the Father, and the Father through the Son, as if the one could not be existent except through the other, just as a man cannot be wise except through wisdom.

For, as the supreme Wisdom is ever wise through itself, so the supreme Essence ever exists through itself. But, the perfectly supreme Essence is the Father, and the perfectly supreme Essence is the Son. Hence, the perfect Father and the perfect Son exist, each through himself, just as each is wise through himself.

For the Son is not the less perfect essence or wisdom because he is an essence born of the essence of the Father, and a wisdom born of the wisdom of the Father; but he would be a less perfect essence or wisdom if he did not exist through himself, and were not wise through himself.

For, there is no inconsistency between the subsistence of the Son through himself, and his deriving existence from his Father. For, as the Father has essence, and wisdom, and life in himself; so that not through another's, but through his own, essence he exists; through his own wisdom he is wise; through his own life he lives; so, by generation, he grants to his Son the possession of essence, and wisdom, and life in himself, so that not through an extraneous essence, wisdom, and life, but through his own, he subsists, is wise, and lives; otherwise, the existence of

108

Father and Son will not be the same, nor will the Son be equal to the Father. But it has already been clearly proved how false this supposition is.

Hence, there is no inconsistency between the subsistence of the Son through himself, and his deriving existence from the Father, since he must have from the Father this very power of subsisting through himself. For, if a wise man should teach me his wisdom, which I formerly lacked, he might without impropriety be said to teach me by this very wisdom of his. But, although my wisdom would derive its existence and the fact of its being from his wisdom, yet when my wisdom once existed, it would be no other essence than its own, nor would it be wise except through itself.

Much more, then, the eternal Father's eternal Son, who so derives existence from the Father that they are not two essences, subsists, is wise, and lives through himself. Hence, it is inconceivable that the Father should be the essence of the Son, or the Son the essence of the Father, on the ground that the one could not subsist through itself, but must subsist through the other. But in order to indicate how they share in an essence supremely simple and supremely one, it may consistently be said, and conceived, that the one is so identical with the other that the one possesses the essence of the other.

On these grounds, then, since there is obviously no difference between possessing an essence and being an essence, just as the one possesses the essence of the other, so the one is the essence of the other, that is, the one has the same existence with the other.

CHAPTER XLV.

The Son may more appropriately be called the essence of the Father, than the Father the essence of the Son: and in like manner the Son is the virtue, wisdom, etc., of the Father.

AND although, for reasons we have noted, this is true, it is much more proper to call the Son the essence of the Father than the Father the essence of the Son. For, since the Father has his being from none other than himself, it is not wholly appropriate to say that he has the being of another than himself; while, since the Son has his being from the Father, and has the same essence with his Father, he may most appropriately be said to have the essence of his Father.

Hence, seeing that neither has an essence, except by *being* an essence; as the Son is more appropriately conceived to have the essence of the Father than the Father to have the essence of the Son, so the Son may more fitly be called the essence of the Father than the Father the essence of the son. For this single explanation proves, with sufficiently emphatic brevity, that the Son not only has the same essence with the Father, but has this very essence from the Father; so that, to assert that the Son is the essence of the Father is the same as to assert that the Son is not a different essence from the essence of the Father nay, from the Father-essence.

In like manner, therefore, the Son is the virtue of the Father, and his wisdom, and justice, and whatever is consistently attributed to the essence of the supreme Spirit.

CHAPTER XI.VI.

How some of these truths which are thus expounded may also be conceived of in another way.

YET, some of these truths, which may be thus expounded and conceived of, are apparently capable of another interpretation as well, not inconsistent with this same assertion. For it is proved that the Son is the true Word, that is, the perfect intelligence, conceiving of the whole substance of the Father, or perfect cognition of that substance, and knowledge of it, and wisdom regarding it; that is, it understands, and conceives of, the very essence of the Father, and cog nises it, and knows it, and is wise (sapit) regarding it.

If, then, in this sense, the Son is called the intelligence of the Father, and wisdom concerning him, and knowledge and cognition of him, and acquaintance with him; since the Son understands and conceives of the Father, is wise concerning him, knows and is acquainted with him, there is no departure from truth.

Most properly, too, may the Son be called the truth of the Father, not only in the sense that the truth of the Son is the same with that of the Father, as we have already seen; but in this sense, also, that in him no imperfect imitation shall be conceived of, but the complete truth of the substance of the Father since he is no other than what the Father is.

CHAPTER XLVII.

The Son is the intelligence of intelligence and the Truth of truth

But if the very substance of the Father is intelligence, and knowledge, and wisdom, and truth, it is

ANSELM.

consequently inferred that as the Son is the intelligence, and knowledge, and wisdom, and truth, of the paternal substance, so he is the intelligence of intelligence, the knowledge of knowledge, the wisdom of wisdom, and the truth of truth.

CHAPTER XLVIII.

How the Son is the intelligence or wisdom of memory or the memory of the Father and of memory.

But what is to be our notion of memory? Is the Son to be regarded as the intelligence conceiving of memory, or as the memory of the Father, or as the memory of memory? Indeed, since it cannot be denied that the supreme Wisdom remembers itself, nothing can be more consistent than to regard the Father as memory, just as the Son is the Word; because the Word is apparently born of memory, a fact that is more clearly seen in the case of the human mind.

For, since the human mind is not always thinking of itself, though it ever remembers itself, it is clear that, when it thinks of itself, the word corresponding to it is born of memory. Hence, it appears that, if it always thought of itself, its word would be always born of memory. For, to think of an object of which we have remembrance, this is to express it mentally; while the word corresponding to the object is the thought itself, formed after the likeness of that object from memory.

Hence, it may be clearly apprehended in the supreme Wisdom, which always thinks of itself, just as it remembers itself, that, of the eternal remembrance of it, its coeternal Word is born. Therefore, as the Word is properly conceived of as the child, the mem-

ory most appropriately takes the name of parent. If, then, the child which is born of the supreme Spirit alone is the child of his memory, there can be no more logical conclusion than that his memory is himself. For not in respect of the fact that he remembers himself does he exist in his own memory, like ideas that exist in the human memory, without being the memory itself; but he so remembers himself that he is his own memory.

It therefore follows that, just as the Son is the intelligence or wisdom of the Father, so he is that of the memory of the Father. But, regarding whatever the Son has wisdom or understanding, this he likewise remembers. The Son is, therefore, the memory of the Father, and the memory of memory, that is, the memory that remembers the Father, who is memory, just as he is the wisdom of the Father, and the wisdom of wisdom, that is, the wisdom wise regarding the wisdom of the Father; and the Son is indeed memory, born of memory, as he is wisdom, born of wisdom, while the Father is memory and wisdom born of none.

CHAPTER XLIX.

The supreme Spirit loves himself.

But, while I am here considering with interest the individual properties and the common attributes of Father and Son, I find none in them more pleasurable to contemplate than the feeling of mutual love. For how absurd it would be to deny that the supreme Spirit loves himself, just as he remembers himself, and conceives of himself! since even the rational human mind is convinced that it can love both itself and him, because it can remember itself and him, and can conceive of itself and of him; for idle and almost useless is the memory and conception of any object, unless, so far as reason requires, the object itself is loved or condemned. The supreme Spirit, then, loves himself, just as he remembers himself and conceives of himself.

CHAPTER L.

The same love proceeds equally from Father and Son.

It is, at any rate, clear to the rational man that he does not remember himself or conceive of himself because he loves himself, but he loves himself because he remembers himself and conceives of himself; and that he could not love himself if he did not remember and conceive of himself. For no object is loved without remembrance or conception of it; while many things are retained in memory and conceived of that are not loved.

It is evident, then, that the love of the supreme Spirit proceeds from the fact that he remember himself and conceives of himself (se intelligit). But if, by the memory of the supreme Spirit, we understand the Father, and by his intelligence by which he conceives of anything, the Son, it is manifest that the love of the supreme Spirit proceeds equally from Father and Son.

CHAPTER LI.

Each loves himself and the other with equal love.

But if the supreme Spirit loves himself, no doubt the Father loves himself, the Son loves himself, and the one the other; since the Father separately is the supreme Spirit, and the Son separately is the su-

preme Spirit, and both at once one Spirit. And, since each equally remembers himself and the other, and conceives equally of himself and the other; and since what is loved, or loves in the Father, or in the Son, is altogether the same, necessarily each loves himself and the other with an equal love.

CHAPTER LII.

This love is as great as the supreme Spirit himself.

How great, then, is this love of the supreme Spirit, common as it is to Father and Son! But, if he loves himself as much as he remembers and conceives of himself; and, moreover, remembers and conceives of himself in as great a degree as that in which his essence exists, since otherwise it cannot exist; undoubtedly his love is as great as he himself is.

CHAPTER LIII.

This love is identical with the supreme Spirit, and yet it is itself with the Father and the Son one spirit.

But what can be equal to the supreme Spirit, except the supreme Spirit? That love is, then, the supreme Spirit. Hence, if no creature, that is, if nothing other than the supreme Spirit, the Father and the Son, ever existed; nevertheless, Father and Son would love themselves and one another.

It therefore follows that this love is nothing else than what the Father and the Son are, which is the supreme Being. But, since there cannot be more than one supreme Being, what inference can be more necessary than that Father and Son and the love of both are one supreme Being? Therefore, this love is supreme Wisdom, supreme Truth, the supreme Good, and whatsoever can be attributed to the substance of the supreme Spirit.

CHAPTER LIV.

It proceeds as a whole from the Father, and as a whole from the Son, and yet does not exist except as one love.

It should be carefully considered whether there are two loves, one proceeding from the Father, the other from the Son; or one, not proceeding as a whole from one, but in part from the Father, in part from the Son; or neither more than one, nor one proceeding in part from each separately, but one proceeding as a whole from each separately, and likewise as a whole from the two at once.

But the solution of such a question can, without doubt, be apprehended from the fact that this love proceeds not from that in which Father and Son are more than one, but from that in which they are one. For, not from their relations, which are more than one, but from their essence itself, which does not admit of plurality, do Father and Son equally produce so great a good.

Therefore, as the Father separately is the supreme Spirit, and the Son separately is the supreme Spirit, and Father and Son at once are not two, but one Spirit; so from the Father separately the love of the supreme Spirit emanates as a whole, and from the Son as a whole, and at once from Father and Son, not as two, but as one and the same whole.

CHAPTER LV.

This love is not their Son.

SINCE this love, then, has its being equally from Father and Son, and is so like both that it is in no wise unlike them, but is altogether identical with them; is it to be regarded as their Son or offspring? But, as the Word, so soon as it is examined, declares itself to be the offspring of him from whom it derives existence, by displaying a manifold likeness to its parent; so love plainly denies that it sustains such a relation, since, so long as it is conceived to proceed from Father and Son, it does not at once show to one who contemplates it so evident a likeness to him from whom it derives existence, although deliberate reasoning teaches us that it is altogether identical with Father and Son.

Therefore, if it is their offspring, either one of them is its father and the other its mother, or each is its father, or mother,—suppositions which apparently contradict all truth. For, since it proceeds in precisely the same way from the Father as from the Son, regard for truth does not allow the relations of Father and Son to it to be described by different words; therefore, the one is not its father, the other its mother. But that there are two beings which, taken separately, bear each the perfect relation of father or mother, differing in no respect, to some one being of this no existing nature allows proof by any example.

Hence, both, that is, Father and Son, are not father and mother of the love emanating from them. It

ANSELM.

therefore is apparently most inconsistent with truth that their identical love should be their son or offspring.

CHAPTER LVI.

Only the Father begets and is unbegotten; only the Son is begotten; only love neither begotten nor unbegotten.

STILL, it is apparent that this love can neither be said, in accordance with the usage of common speech, to be unbegotten, nor can it so properly be said to be begotten, as the Word is said to be begotten. For we often say of a thing that it is begotten of that from which it derives existence, as when we say that light or heat is begotten of fire, or any effect of its cause.

On this ground, then, love, proceeding from the supreme Spirit, cannot be declared to be wholly unbegotten, but it cannot so properly be said to be begotten as can the Word; since the Word is the most true offspring and most true Son, while it is manifest that love is by no means offspring or son.

He alone, therefore, may, or rather should, be called begetter and unbegotten, whose is the Word; since he alone is Father and parent, and in no wise derives existence from another; and the Word alone should be called begotten, which alone is Son and offspring. But only the love of both is neither begotten nor unbegotten, because it is neither son nor offspring, and yet does in some sort derive existence from another.

CHAPTER LVII.

This love is uncreated and creator, as are Father and Son; and yet it is with them not three, but one uncreated and creative being. And it may be called the Spirit of Father and Son.

Bur, since this love separately is the supreme Being, as are Father and Son, and yet at once Father and Son, and the love of both are not more than one, but one supreme Being, which alone was created by none, and created all things through no other than itself; since this is true, necessarily, as the Father separately, and the Son separately, are each uncreated and creator, so, too, love separately is uncreated and creator, and yet all three at once are not more than one, but one uncreated and creative being.

None, therefore, makes or begets or creates the Father, but the Father alone begets, but does not create, the Son; while Father and Son alike do not create or beget, but somehow, if such an expression may be used, breathe their love: for, although the supremely immutable Being does not breathe after our fashion, yet the truth that this Being sends forth this, its love, which proceeds from it, not by departing from it, but by deriving existence from it, can perhaps be no better expressed than by saying that this Being breathes its love.

But, if this expression is admissible, as the Word of the supreme Being is its Son, so its love may fittingly enough be called its breath (*Spiritus*). So that, though it is itself essentially spirit, as are Father and Son, they are not regarded as the spirits of anything, since neither is the Father born of any other nor the Son of the Father. as it were, by *breathing*; while that love is regarded as the Breath or Spirit of both, since from both breathing in their transcendent way it mysteriously proceeds.

And this love, too, it seems, from the fact that there is community of being between Father and Son, may, not unreasonably, take, as it were its own, some name which is common to Father and Son; if there is any exigency demanding that it should have a name proper to itself. And, indeed, if this love is actually designated by the name Spirit, as by its own name, since this name equally describes the Father and the Son: it will be useful to this effect also, that through this name it shall be signified that this love is identical with Father and Son, although it has its being from them.

CHAPTER LVIII.

As the Son is the essence or wisdom of the Father in the sense that he has the same essence or wisdom that the Father has: so likewise the Spirit is the essence and wisdom etc. of Father and Son.

ALSO, just as the Son is the substance and wisdom and virtue of the Father, in the sense that he has the same essence and wisdom and virtue with the Father; so it may be conceived that the Spirit of both is the essence or wisdom or virtue of Father and Son, since it has altogether the same essence, wisdom, and virtue with these.

CHAPTER LIX.

The Father and the Son and their Spirit exist equally the one in the other.

It is a most interesting consideration that the Father, and the Son, and the Spirit of both, exist in one

120

another with such equality that no one of them surpasses another. For, not only is each in such a way the perfectly supreme Being that, nevertheless, all three at once exist only as one supreme Being, but the same truth is no less capable of proof when each is taken separately.

For the Father exists as a whole in the Son, and in the Spirit common to them; and the Son in the Father, and in the Spirit; and the Spirit in the Father, and in the Son; for the memory of the supreme Being exists, as a whole, in its intelligence and in its love, and the intelligence in its memory and love, and the love in its memory and intelligence. For the supreme Spirit conceives of (*intelligit*) its memory as a whole, and loves it, and remembers its intelligence as a whole, and loves it as a whole, and remembers its love as a whole, and conceives of it as a whole.

But we mean by the memory, the Father; by the intelligence, the Son; by the love, the Spirit of both. In such equality, therefore, do Father and Son and Spirit embrace one another, and exist in one another, that none of them can be proved to surpass another or to exist without it.

CHAPTER LX.

To none of these is another necessary that he may remember, conceive, or love : since each taken by himself is memory and intelligence and love and all that is necessarily inherent in the supreme Being.

Bur, while this discussion engages our attention, I think that this truth, which occurs to me as I reflect, ought to be most carefully commended to memory. The Father must be so conceived of as memory, the Son as intelligence, and the Spirit as love, that it

shall also be understood that the Father does not need the Son, or the Spirit common to them, nor the Son the Father, or the same Spirit, nor the Spirit the Father, or the Son: as if the Father were able, through his own power, only to remember, but to conceive only through the Son, and to love only through the Spirit of himself and his son; and the Son could only conceive or understand (*intelligere*) through himself, but remembered through the Father, and loved through his Spirit; and this Spirit were able through himself alone only to love, while the Father remembers for him, and the Son conceives or understands (*intelligit*) for him.

For, since among these three each one taken separately is so perfectly the supreme Being and the supreme Wisdom that through himself he remembers and conceives and loves, it must be that none of these three needs another, in order either to remember or to conceive or to love. For, each taken separately is essentially memory and intelligence and love, and all that is necessarily inherent in the supreme Being.

CHAPTER LXI.

Yet there are not three, but one Father and one Son and one Spirit.

AND here I see a question arises. For, if the Father is intelligence and love as well as memory, and the Son is memory and love as well as intelligence, and the Spirit is no less memory and intelligence than love; how is it that the Father is not a Son and a Spirit of some being? and why is not the Son the Father and the Spirit of some being? and why is not this Spirit the Father of some being, and the Son of

some being? For it was understood, that the Father was memory, the Son intelligence, and the Spirit love.

But this question is easily answered, if we consider the truths already disclosed in our discussion. For the Father, even though he is intelligence and love, is not for that reason the Son or the Spirit of any being; since he is not intelligence, begotten of any, or love, proceeding from any, but whatever he is, he is only the *begetter*, and is he from whom the other proceeds.

The Son also, even though by his own power he remembers and loves, is not, for that reason, the Father or the Spirit of any; since he is not memory as begetter, or love as proceeding from another after the likeness of his Spirit, but whatever being he has he is only *begotten* and is he from whom the Spirit proceeds.

The Spirit, too, is not necessarily Father or Son, because his own memory and intelligence are sufficient to him; since he is not memory as begetter, or intelligence as begotten, but he alone, whatever he is, proceeds or emanates.

What, then, forbids the conclusion that in the supreme Being there is only one Father, one Son, one Spirit, and not three Fathers or Sons or Spirits?

CHAPTER LXII.

How it seems that of these three more sons than one are born.

But perhaps the following observation will prove inconsistent with this assertion. It should not be doubted that the Father and the Son and their Spirit each expresses himself and the other two, just as each conceives of, and understands, himself and the other two. But, if this is true, are there not in the supreme Being as many words as there are expressive beings, and as many words as there are beings who are expressed?

For, if more men than one give expression to some one object in thought, apparently there are as many words corresponding to that object as there are thinkers; since the word corresponding to it exists in the thoughts of each separately. Again, if one man thinks of more objects than one, there are as many words in the mind of the thinker as there are objects thought of.

But in the thought of a man, when he thinks of anything outside his own mind, the word corresponding to the object thought of is not born of the object itself, since that is absent from the view of thought, but of some likeness or image of the object which exists in the memory of the thinker, or which is perhaps called to mind through a corporeal sense from the present object itself.

But in the supreme Being, Father and Son and their Spirit are always so present to one another—for each one, as we have already seen, exists in the others no less than in himself—that, when they express one another, the one that is expressed seems to beget his own word, just as when he is expressed by himself. How is it, then, that the Son and the Spirit of the Son and of the Father beget nothing, if each begets his own word, when he is expressed by himself or by another? Apparently as many words as can be proved to be born of the supreme Substance, so many Sons, according to our former reasoning, must there be begotten of this substance, and so many spirits proceeding from it.

CHAPTER LXIII.

How among them there is only one Son of one Father, that is, one Word, and that from the Father alone.

On these grounds, therefore, there apparently are in that Being, not only many fathers and sons and beings proceeding from it, but other necessary attributes as well; or else Father and Son and their Spirit, of whom it is already certain that they truly exist, are not three expressive beings, although each taken separately is expressive, nor are there more beings than one expressed, when each one expresses himself and the other two.

For, just as it is an inherent property of the supreme Wisdom to know and conceive, so it is assuredly natural to eternal and immutable knowledge and intelligence ever to regard as present what it knows and conceives of. For, to such a supreme Spirit expressing and beholding through conception, as it were, are the same, just as the expression of our human mind is nothing but the intuition of the thinker.

But reasons already considered have shown most convincingly that whatever is essentially inherent in the supreme Nature is perfectly consistent with the nature of the Father and the Son and their Spirit taken separately; and that, nevertheless, this, if attributed to the three at once, does not admit of plurality. Now, it is established that as knowledge and intelligence are attributes of his being, so his knowing and conceiving is nothing else than his expression, that is, his ever beholding as present what he knows and conceives of. Necessarily, therefore, just as the Father separately, and the Son separately, and their

Spirit separately, is a knowing and conceiving being, and yet the three at once are not more knowing and conceiving beings than one, but one knowing and one conceiving being: so, each taken separately is expressive, and yet there are not three expressive beings at once, but one expressive being.

Hence, this fact may also be clearly recognised, that when these three are expressed, either by themselves or by another, there are not more beings than one expressed. For what is therein expressed except their being? If, then, that Being is one and only one, then what is expressed is one and only one; therefore, if it is in them one and only one which expresses, and one which is expressed-for it is one wisdom which expresses and one substance which is expressed -it follows that there are not more words than one. but one alone. Hence, although each one expresses himself and all express one another. nevertheless there cannot be in the supreme Being another Word than that already shown to be born of him whose is the Word, so that it may be called his true image and his Son.

And in this truth I find a strange and inexplicable factor. For observe: although it is manifest that each one, that is, Father and Son, and the Spirit of Father and Son equally expresses himself and both the others, and that there is one Word alone among them; yet it appears that this Word itself can in no wise be called the Word of all three, but only of one.

For it has been proved that it is the image and Son of him whose Word it is. And it is plain that it cannot properly be called either the image or son of itself, or of the Spirit proceeding from it. For, neither of itself nor of a being proceeding from it, is it born,

nor does it in its existence imitate itself or a being proceeding from itself. For it does not imitate itself, or take on a like existence to itself, because imitation and likeness are impossible where only one being is concerned, but require plurality of beings; while it does not imitate the spirit, nor does it exist in his likeness, because it has not its existence from that Spirit, but the Spirit from it. It is to be concluded that this sole Word corresponds to him alone, from whom it has existence by generation, and after whose complete likeness it exists.

One Father, then, and not more than one Father; one Son, and not more than one Son; one Spirit proceeding from them, and not more than one such Spirit, exist in the supreme Being. And, although there are three, so that the Father is never the Son or the Spirit proceeding from them, nor the Son at any time the Father or the Spirit, nor the Spirit of Father and Son ever the Father or the Son; and each separately is so perfect that he is self-sufficient, needing neither of the others: yet what they are is in such a way one that just as it cannot be attributed to them taken separately as plural, so neither can it be attributed to them as plural, when the three are taken at once. And though each one expresses himself and all express one another, yet there are not among them more words than one, but one; and this Word corresponds not to each separately, nor to all together, but to one alone.

CHAPTER LXIV

Though this truth is inexplicable, it demands belief.

IT seems to me that the mystery of so sublime a subject transcends all the vision of the human intel-

lect. And for that reason I think it best to refram from the attempt to explain how this thing is. For it is my opinion that one who is investigating an incomprehensible object ought to be satisfied if his reasoning shall have brought him far enough to recognise that this object most certainly exists; nor ought assured belief to be the less readily given to these truths which are declared to be such by cogent proofs, and without the contradiction of any other reason, if, because of the incomprehensibility of their own natural sublimity, they do not admit of explanation.

But what is so incomprehensible, so ineffable, as that which is above all things? Hence, if these truths, which have thus far been debated in connection with the supreme Being, have been declared on cogent grounds, even though they cannot be so examined by the human intellect as to be capable of explanation in words, their assured certainty is not therefore shaken. For, if a consideration, such as that above, rationally comprehends that it is incomprehensible in what way supreme Wisdom knows its creatures, of which we necessarily know so many; who shall explain how it knows and expresses itself, of which nothing or scarcely anything can be known by man? Hence, if it is not by virtue of the self-expression of this Wisdom that the Father begets and the Son is begotten. who shall tell his generation?

CHAPTER LXV.

How real truth may be reached in the discussion of an ineffable subject.

But again, if such is the character of its ineffability,—nay, since it is such,—how shall whatever con-

128

clusion our discussion has reached regarding it in terms of Father, Son, and emanating Spirit be valid? For, if it has been explained on true grounds, how is it ineffable? Or, if it is ineffable, how can it be such as our discussion has shown? Or, could it be explained to a certain extent, and therefore nothing would disprove the truth of our argument; but since it could not be comprehended at all, for that reason it would be ineffable?

But how shall we meet the truth that has already been established in this very discussion, namely, that the supreme Being is so above and beyond every other nature that, whenever any statement is made concerning it in words which are also applicable to other natures, the sense of these words in this case is by no means that in which they are applied to other natures.

For what sense have I conceived of, in all these words that I have thought of, except the common and familiar sense? If, then, the familiar sense of words is alien to that Being, whatever I have inferred to be attributable to it is not its property. How, then, has any truth concerning the supreme Being been discovered, if what has been discovered is so alien to that Being? What is to be inferred?

Or, has there in some sort been some truth discovered regarding this incomprehensible object, and in some sort has nothing been proved regarding it? For often we speak of things which we do not express with precision as they are; but by another expression we indicate what we are unwilling or unable to express with precision, as when we speak in riddles. And often we see a thing, not precisely as it is in itself, but through a likeness or image, as when we

look upon a face in a mirror. And in this way, we often express and yet do not express, see and yet do not see, one and the same object; we express and see it through another; we do not express it, and do not see it by virtue of its own proper nature,

On these grounds, then, it appears that there is nothing to disprove the truth of our discussion thus far, concerning the supreme Nature, and yet this Nature itself remains not the less ineffable, if we believe that it has never been expressed according to the peculiar nature of its own being, but somehow described through another.

For whatever terms seem applicable to that Nature do not reveal it to me in its proper character, but rather intimate it through some likeness. For, when I think of the meanings of these terms, I more naturally conceive in my mind of what I see in created objects, than of what I conceive to transcend all human understanding. For it is something much less, nay, something far different, that their meaning suggests to my mind, than that the conception of which my mind itself attempts to achieve through this shadowy signification.

For, neither is the term *wisdom* sufficient to reveal to me that Being, through which all things were created from nothing and are preserved from nothingness; nor is the term *essence* capable of expressing to me that Being which, through its unique elevation, is far above all things, and through its peculiar natural character greatly transcends all things.

In this way, then, is that Nature ineffable, because it is incapable of description in words or by any other means; and, at the same time, an inference regarding it, which can be reached by the instruction of reason

130

or in some other way, as it were in a riddle, is not therefore necessarily false.

CHAPTER LXVI.

Through the rational mind is the nearest approach to the supreme-Being.

SINCE it is clear, then, that nothing can be ascertained concerning this Nature in terms of its own peculiar character, but only in terms of something else, it is certain that a nearer approach toward knowledge of it is made through that which approaches it more nearly through likeness. For the more like to it anything among created beings is proved to be, the more excellent must that created being be by nature. Hence, this being, through its greater likeness, assists. the investigating mind in the approach to supreme Truth; and through its more excellent created essence, teaches the more correctly what opinion the mind itself ought to form regarding the Creator. So, undoubtedly, a greater knowledge of the creative Being is attained, the more nearly the creature through which the investigation is made approaches that Being. For that every being, in so far as it exists, is like the supreme Being, reasons already considered do not permit us to doubt.

It is evident, then, that as the rational mind alone, among all created beings, is capable of rising to the investigation of this Being, so it is not the less this same rational mind alone, through which the mind itself can most successfully achieve the discovery of this same Being. For it has already been acknowledged that this approaches it most nearly, through likeness of natural essence. What is more obvious, then, than that the more earnestly the rational mind devotes it-

self to learning its own nature, the more effectively does it rise to the knowledge of that Being; and the more carelessly it contemplates itself, the farther does it descend from the contemplation of that Being?

CHAPTER LXVII.

The mind itself is the mirror and image of that Being.

THEREFORE, the mind may most fitly be said to be its own mirror wherein it contemplates, so to speak, the image of what it cannot see face to face. For, if the mind itself alone among all created beings is capable of remembering and conceiving of and loving itself, I do not see why it should be denied that it is the true image of that being which, through its memory and intelligence and love, is united in an ineffable Trinity. Or, at any rate, it proves itself to be the more truly the image of that Being by its power of remembering, conceiving of, and loving, that Being. For, the greater and the more like that Being it is, the more truly it is recognised to be its image.

But, it is utterly inconceivable that any rational creature can have been naturally endowed with any power so excellent and so like the supreme Wisdom as this power of remembering, and conceiving of, and loving, the best and greatest of all beings. Hence, no faculty has been bestowed on any creature that is so truly the image of the Creator.

CHAPTER LXVIII.

The rational creature was created in order that it might love this Being.

It seems to follow, then, that the rational creature ought to devote itself to nothing so earnestly as to the

expression, through voluntary performance, of this image which is impressed on it through a natural potency. For, not only does it owe its very existence to its creator; but the fact that it is known to have no power so important as that of remembering, and conceiving of, and loving, the supreme good, proves that it ought to wish nothing else so especially.

For who can deny that whatever within the scope of one's power is better, ought to prevail with the will? For, to the rational nature rationality is the same with the ability to distinguish the just from the not-just, the true from the not-true, the good from the not-good, the greater good from the lesser; but this power is altogether useless to it, and superfluous, unless what it distinguishes it loves or condemns, in accordance with the judgment of true discernment.

From this, then, it seems clear enough that every rational being exists for this purpose, that according as, on the grounds of discernment, it judges a thing to be more or less good, or not good, so it may love that thing in greater or less degree, or reject it.

It is, therefore, most obvious that the rational creature was created for this purpose, that it might love the supreme Being above all other goods, as this Being is itself the supreme good; nay, that it might love nothing except it, unless because of it; since that Being is good through itself, and nothing else is good except through it.

But the rational being cannot love this Being, unless it has devoted itself to remembering and conceiving of it. It is clear, then, that the rational creature ought to devote its whole ability and will to remembering, and conceiving of, and loving, the supreme

good, for which end it recognises that it has its very existence.

CHAPTER LXIX.

The soul that ever loves this Essence lives at some time in true blessedness.

But there is no doubt that the human soul is a rational creature. Hence, it must have been created for this end, that it might love the supreme Being. It must, therefore, have been created either for this end, that it might love that Being eternally; or for this, that at some time it might either voluntarily, or by violence, lose this love.

But it is impious to suppose that the supreme Wisdom created it for this end, that at some time, either it should despise so great a good, or, though wishing to keep it, should lose it by some violence. We infer, then, that it was created for this end, that it might love the supreme Being eternally. But this it cannot do unless it lives forever. It was so created, then, that it lives forever, if it forever wills to do that for which it was created.

Hence, it is most incompatible with the nature of the supremely good, supremely wise, and omnipotent Creator, that what he has made to exist that it might love him, he should make not to exist, so long as it truly loves him; and that what he voluntarily gave to a non-loving being that it might ever love, he should take away, or permit to be taken away, from the loving being, so that necessarily it should not love; especially since it should by no means be doubted that he himself loves every nature that loves him. Hence, it is manifest that the human soul is never deprived of its life, if it forever devotes itself to loving the supreme life.

How, then, shall it live? For is long life so important a matter, if it is not secure from the invasion of troubles? For whoever, while he lives, is either through fear or through actual suffering subject to troubles, or is deceived by a false security, does he not live in misery? But, if any one lives in freedom from these troubles, he lives in blessedness. But it is most absurd to suppose that any nature that forever loves him, who is supremely good and omnipotent, forever lives in misery. So, it is plain, that the human soul is of such a character that, if it diligently observes that end for which it exists, it at some time lives in blessedness, truly secure from death itself and from every other trouble.

CHAPTER LXX.

This Being gives itself in return to the creature that loves it, that that creature may be eternally blessed.

THEREFORE it cannot be made to appear true that he who is most just and most powerful makes no return to the being that loves him perseveringly, to which although it neither existed nor loved him, he gave existence that it might be able to be a loving being. For, if he makes no return to the loving soul, the most just does not distinguish between the soul that loves, and the soul that despises what ought to be supremely loved, nor does he love the soul that loves him; or else it does not avail to be loved by him; all of which suppositions are inconsistent with his nature; hence he does make a return to every soul that perseveres in loving him.

But what is this return? For, if he gave to what was nothing, a rational being, that it might be a loving soul, what shall he give to the loving soul, if it does not cease to love? If what waits upon love is so great, how great is the recompense given to love? And if the sustainer of love is such as we declare, of what character is the profit? For, if the rational creature, which is useless to itself without this love, is with it preëminent among all creatures, assuredly nothing can be the reward of love except what is preëminent among all natures.

For this same good, which demands such love toward itself, also requires that it be desired by the loving soul. For, who can love justice, truth, blessedness, incorruptibility, in such a way as not to wish to enjoy them? What return, then, shall the supreme Goodness make to the being that loves and desires it, except itself? For, whatever else it grants, it does not give in return, since all such bestowals neither compensate the love, nor console the loving being, nor satisfy the soul that desires this supreme Being.

Or, if it wishes to be loved and desired, so as to make some other return than its love, it wishes to be loved and desired, not for its own sake, but for the sake of another; and does not wish to be loved itself but wishes another to be loved; which it is impious to suppose.

So, it is most true that every rational soul, if, as it should, it earnestly devotes itself through love to longing for supreme blessedness, shall at some time receive that blessedness to enjoy, that what it now sees as *through a glass* and *in a riddle*, it may then see *face to face*. But it is most foolish to doubt whether it enjoys that blessedness eternally; since,

in the enjoyment of that blessedness, it will be impossible to turn the soul aside by any fear, or to deceive it by false security; nor, having once experienced the need of that blessedness, will it be able not to love it; nor will that blessedness desert the soul that loves it; nor shall there be anything powerful enough to separate them against their will. Hence, the soul that has once begun to enjoy supreme Blessedness will be eternally blessed.

CHAPTER LXXI.

The soul that despises this being will be eternally miserable.

FROM this it may be inferred, as a certain consequence, that the soul which despises the love of the supreme good will incur eternal misery. It might be said that it would be justly punished for such contempt if it *lost* existence or life, since it does not employ itself to the end for which it was created. But reason in no wise admits such a belief, namely, that after such great guilt it is condemned to be what it was before all its guilt.

For, before it existed, it could neither be guilty nor feel a penalty. If, then, the soul despising that end for which it was created, dies so as to feel nothing, or so as to be nothing at all, its condition will be the same when in the greatest guilt and when without all guilt; and the supremely wise Justice will not distinguish between what is capable of no good and wills no evil, and what is capable of the greatest good and wills the greatest evil.

But it is plain enough that this is a contradiction. Therefore, nothing can be more logical, and nothing ought to be believed more confidently than that the

soul of man is so constituted that, if it scorns loving the supreme Being, it suffers eternal misery; that just as the loving soul shall rejoice in an eternal reward, so the soul despising that Being shall suffer eternal punishment; and as the former shall feel an immutable sufficiency, so the latter shall feel an inconsolable need.

CHAPTER LXXII.

Every human soul is immortal. And it is either forever miserable, or at some time truly blessed.

But if the soul is mortal, of course the loving soul is not eternally blessed, nor the soul that scorns this. Being eternally miserable. Whether, therefore, it loves or scorns that for the love of which it was created, it must be immortal. But if there are some rational souls which are to be judged as neither loving nor scorning, such as the souls of infants seem to be, what opinion shall be held regarding these? Are they mortal or immortal? But undoubtedly all human souls are of the same nature. Hence, since it is established that some are immortal, every human soul must be immortal. But since every living being is either never, or at some time, truly secure from all trouble; necessarily, also, every human soul is either ever miserable, or at some time truly blessed.

CHAPTER LXXIII.

No soul is unjustly deprived of the supreme good, and every effort must be directed toward that good.

But, which souls are unhesitatingly to be judged as so loving that for the love of which they were created, that they deserve to enjoy it at some time, and

which as so scorning it, that they deserve ever to stand in need of it; or how and on what ground those which it seems impossible to call either loving or scorning are assigned to either eternal blessedness or misery,—of all this I think it certainly most difficult or even impossible for any mortal to reach an understanding through discussion. But that no being is unjustly deprived by the supremely great and supremely good Creator of that good for which it was created, we ought most assuredly to believe. And toward this good every man ought to strive, by loving and desiring it with all his heart, and all his soul, and all his mind.

CHAPTER LXXIV.

The supreme Being is to be hoped for.

But the human soul will by no means be able to train itself in this purpose, if it despairs of being able to reach what it aims at. Hence, devotion to effort is not more profitable to it than hope of attainment is necessary.

CHAPTER LXXV.

We must believe in this Being, that is, by believing we must reach out for it.

But what does not believe cannot love or hope. It is, therefore, profitable to this human soul to believe the supreme Being and those things without which that Being cannot be loved, that, by believing, the soul may reach out for it. And this truth can be more briefly and fitly indicated, I think, if instead of saying, "strive for" the supreme Being, we say, "believe *in*" the supreme Being.

For, if one says that he believes in it. he apparently shows clearly enough both that, through the faith which he professes, he strives for the supreme. Being, and that he believes those things which are proper to this aim. For it seems that either he who does not believe what is proper to striving for that Being, or he who does not strive for that Being, through what he believes, does not believe in it. And, perhaps, it is indifferent whether we say, "believe in it," or "direct belief to it," just as by believing to strive for it and toward it are the same, except that whoever shall have come to it by striving for (tendendoin) it, will not remain without, but within it. And this is indicated more distinctly and familiarly if we say, "striving for" (in) it, than if we say, "toward" (ad) it.

On this ground, therefore, I think it may more fitly be said that we should believe *in* it, than that we should direct belief t_0 it.

CHAPTER LXXVL

We should believe in Father and Son and in their Spirit equally, and in each separately, and in the three at once.

WE should believe, then, equally in the Father and in the Son and in their Spirit, and in each separately, and in the three at once, since the Father separately, and the Son separately, and their Spirit separately is the supreme Being, and at once Father and Son with their Spirit are one and the same supreme Being, in which alone every man ought to believe; because it is the sole end which in every thought and act he ought to strive for. Hence, it is manifest that as none is able to strive for that Being, except he be-

lieve in it; so to believe it avails none, except he strive for it.

CHAPTER LXXVII.

What is living, and what dead faith.

HENCE, with however great confidence so important a truth is believed, the faith will be useless and, as it were, dead, unless it is strong and living through love. For, that the faith which is accompanied by sufficient love is by no means idle, if an opportunity of operation offers, but rather exercises itself in an abundance of works, as it could not do without love. may be proved from this fact alone, that, since it loves the supreme Justice, it can scorn nothing that is just, it can approve nothing that is unjust. Therefore, seeing that the fact of its operation shows that life, without which it could not operate, is inherent in it; it is not absurd to say that operative faith is alive, because it has the life of love without which it could not operate ; and that idle faith is not living, because it lacks that life of love, with which it would not be idle.

Hence, if not only he who has lost his sight is called blind, but also he who ought to have sight and has it not, why cannot, in like manner, *faith without love* be called *dead*; not because it has lost its life, that is, love; but because it has not the life which it ought always to have? As that faith, then, which operates through love is recognised as living, so that which is idle, through contempt, is proved to be dead. It may, therefore, be said with sufficient fitness that living faith believes *in* that *in* which we ought to believe; while dead faith merely believes that whic.. ought to be believed.

CHAPTER LXXVIII.

The supreme Being may in some sort be called Three.

AND so it is evidently expedient for every man to believe in a certain ineffable trinal unity, and in one Trinity; one and a unity because of its one essence, but trinal and a trinity because of its three—what? For, although I can speak of a Trinity because of Father and Son and the Spirit of both, who are three; yet I cannot, in one word, show why they are three; as if I should call this Being a Trinity because of its three persons, just as I would call it a unity because of its one substance.

For three persons are not to be supposed, because all persons which are more than one so subsist separately from one another, that there must be as many substances as there are persons, a fact that is recognised in the case of more men than one, when there are as many persons as there are individual substances. Hence, in the supreme Being, just as there are not more substances than one, so there are not more persons than one.

So, if one wishes to express to any why they are three, he will say that they are Father and Son and the Spirit of both, unless perchance, compelled by the lack of a precisely appropriate term, he shall choose some one of those terms which cannot be applied in a plural sense to the supreme Being, in order to indicate what cannot be expressed in any fitting language; as if he should say, for instance, that this wonderful Trinity is one essence or nature, and three persons or substances.

For, these two terms are more appropriately chosen to describe plurality in the supreme Being, because the word *person* is applied only to an individual, rational nature; and the word substance is ordinarily applied to individual beings, which especially subsist in plurality. For individual beings are especially exposed to, that is, are *subject* to, accidents, and for this reason they more properly receive the name *sub-stance*. Now, it is already manifest that the supreme Being, which is subject to no accidents, cannot properly be called a substance, except as the word *substance* is used in the same sense with the word *Essence*. Hence, on this ground, namely, of necessity, that supreme and one Trinity or trinal unity may justly be called one Essence and three Persons or three Substances.

CHAPTER LXXIX.

This Essence itself is God, who alone is lord and ruler of all.

It appears, then—nay, it is unhesitatingly declared that what is called God is not nothing; and that to this supreme Essence the name *God* is properly given. For every one who says that a God exists, whether one or more than one, conceives of him only as of some substance which he believes to be above every nature that is not God, and that he is to be worshipped of men because of his preëminent majesty, and to be appeased for man's own sake because of some imminent necessity.

But what should be so worshipped in accordance with its majesty, and what should be so appeased in behalf of any object, as the supremely good and supremely powerful Spirit, who is Lord of all and who rules all? For, as it is established that through the

supreme Good and its supremely wise omnipotence all things were created and live, it is most inconsistent to suppose that the Spirit himself does not rule the beings created by him, or that beings he created are governed by another less powerful or less good, or by no reason at all, but by the confused flow of events alone. For it is he alone through whom it is well with every creature, and without whom it is well with none, and *from whom*, and *through whom*, and *im whom*, are all things.

Therefore, since he himself alone is not only the beneficent Creator, but the most powerful lord, and most wise ruler of all; it is clear that it is he alone whom every other nature, according to its whole ability, ought to worship in love, and to love in worship; from whom all happiness is to be hoped for; with whom refuge from adversity is to be sought; to whom supplication for all things is to be offered. Truly, therefore, he is not only God, but the only God, ineffably Three and One.

144

APPENDIX.

IN BEHALF OF THE FOOL.

AN AMSWER TO THE ARGUMENT OF ANSELM IN THE PROSLOGIUM. BY GAUNILON, A MONK OF MARMOUTIER.

1. If one doubts or denies the existence of a being of such a nature that nothing greater than it can be conceived, he receives this answer:

The existence of this being is proved, in the first place, by the fact that he himself, in his doubt or denial regarding this being, already has it in his understanding; for in hearing it spoken of he understands what is spoken of. It is proved, therefore, by the fact that what he understands must exist not only in his understanding, but in reality also.

And the proof of this is as follows.—It is a greater thing to exist both in the understanding and in reality than to be in the understanding alone. And if this being is in the understanding alone, whatever has even in the past existed in reality will be greater than this being. And so that which was greater than all beings will be less than some being, and will not be greater than all: which is a manifest contradiction.

And hence, that which is greater than all, already proved to be in the understanding, must exist not only in the understanding, but also in reality: for otherwise it will not be greater than all other beings. 2. The fool might make this reply:

This being is said to be in my understanding already, only because I understand what is said. Now could it not with equal justice be said that I have in my understanding all manner of unreal objects, having absolutely no existence in themselves, because I understand these things if one speaks of them, whatever they may be?

Unless indeed it is shown that this being is of such a character that it cannot be held in concept like all unreal objects, or objects whose existence is uncertain: and hence I am not able to conceive of it when I hear of it, or to hold it in concept; but I must understand it and have it in my understanding; because, it seems, I cannot conceive of it in any other way than by understanding it, that is, by comprehending in my knowledge its existence in reality.

But if this is the case, in the first place there will be no distinction between what has precedence in time—namely, the having of an object in the understanding—and what is subsequent in time—namely, the understanding that an object exists; as in the example of the picture, which exists first in the mind of the painter, and afterwards in his work.

Moreover, the following assertion can hardly be accepted: that this being, when it is spoken of and heard of, cannot be conceived not to exist in the way in which even God can be conceived not to exist. For if this is impossible, what was the object of this argument against one who doubts or denies the existence of such a being?

Finally, that this being so exists that it cannot be perceived by an understanding convinced of its own indubitable existence, unless this being is afterwards

APPENDIX.

conceived of—this should be proved to me by an indisputable argument, but not by that which you have advanced: namely, that what I understand, when I hear it, already is in my understanding. For thus in my understanding, as I still think, could be all sorts of things whose existence is uncertain, or which do not exist at all, if some one whose words I should understand mentioned them. And so much the more if I should be deceived, as often happens, and believe in them: though I do not yet believe in the being whose existence you would prove.

3. Hence, your example of the painter who already has in his understanding what he is to paint cannot agree with this argument. For the picture, before it is made, is contained in the artificer's art itself; and any such thing, existing in the art of an artificer, is nothing but a part of his understanding itself. A joiner, St. Augustine says, when he is about to make a box in fact, first has it in his art. The box which is made in fact is not life; but the box which exists in his art is life. For the artificer's soul lives, in which all these things are, before they are produced. Why, then, are these things life in the living soul of the artificer, unless because they are nothing else than the knowledge or understanding of the soul itself?

With the exception, however, of those facts which are known to pertain to the mental nature, whatever, on being heard and thought out by the understanding, is perceived to be real, undoubtedly that real object is one thing, and the understanding itself, by which the object is grasped, is another. Hence, even if it were true that there is a being than which a greater is inconceivable: yet to this being, when heard of and understood, the not yet created picture in the mind of the painter is not analogous.

4. Let us notice also the point touched on above, with regard to this being which is greater than all which can be conceived, and which, it is said, can be none other than God himself. I, so far as actual knowledge of the object, either from its specific or general character, is concerned, am as little able to conceive of this being when I hear of it, or to have it in my understanding, as I am to conceive of or understand God himself: whom, indeed, for this very reason I can conceive not to exist. For I do not know that reality itself which God is, nor can I form a conjecture of that reality from some other like reality. For you yourself assert that that reality is such that there can be nothing else like it.

For, suppose that I should hear something said of a man absolutely unknown to me, of whose very existence I was unaware. Through that special or general knowledge by which I know what man is, or what men are, I could conceive of him also, according to the reality itself, which man is. And yet it would be possible, if the person who told me of him deceived me, that the man himself, of whom I conceived, did not exist; since that reality according to which I conceived of him, though a no less indisputable fact, was not that man, but any man.

Hence, I am not able, in the way in which I should have this unreal being in concept or in understanding, to have that being of which you speak in concept or in understanding, when I hear the word *God* or the words, *a being greater than all other beings*. For I can conceive of the man according to a fact that is real and familiar to me: but of God, or a being greater than all others, I could not conceive at all, except merely according to the word. And an object can hardly or never be conceived according to the word alone.

For when it is so conceived, it is not so much the word itself (which is, indeed, a real thing—that is, the sound of the letters and syllables) as the signification of the word, when heard, that is conceived. But it is not conceived as by one who knows what is generally signified by the word; by whom, that is, it is conceived according to a reality and in true conception alone. It is conceived as by a man who does not know the object, and conceives of it only in accordance with the movement of his mind produced by hearing the word, the mind attempting to image for itself the signification of the word that is heard. And it would be surprising if in the reality of fact it could ever attain to this.

Thus, it appears, and in no other way, this being is also in my understanding, when I hear and understand a person who says that there is a being greater than all conceivable beings. So much for the assertion that this supreme nature already is in my understanding.

5. But that this being must exist, not only in the understanding but also in reality, is thus proved to me:

If it did not so exist, whatever exists in reality would be greater than it. And so the being which has been already proved to exist in my understanding, will not be greater than all other beings.

I still answer: if it should be said that a being which cannot be even conceived in terms of any fact, is in the understanding, I do not deny that this being is, accordingly, in my understanding. But since through this fact it can in no wise attain to real existence also, I do not yet concede to it that existence at all, until some certain proof of it shall be given.

For he who says that this being exists, because otherwise the being which is greater than all will not be greater than all, does not attend strictly enough to what he is saying. For I do not yet say, no, I even deny or doubt that this being is greater than any real object. Nor do I concede to it any other existence than this (if it should be called existence) which it has when the mind, according to a word merely heard, tries to form the image of an object absolutely unknown to it.

How, then, is the veritable existence of that being proved to me from the assumption, by hypothesis, that it is greater than all other beings? For I should still deny this, or doubt your demonstration of it, to this extent, that I should not admit that this being is in my understanding and concept even in the way in which many objects whose real existence is uncertain and doubtful, are in my understanding and concept. For it should be proved first that this being itself really exists somewhere; and then, from the fact that it is greater than all, we shall not hesitate to infer that it also subsists in itself.

6. For example: it is said that somewhere in the ocean is an island, which, because of the difficulty, or rather the impossibility, of discovering what does not exist, is called the lost island. And they say that this island has an inestimable wealth of all manner of riches and delicacies in greater abundance than is told of the Islands of the Blest; and that having no owner or inhabitant, it is more excellent than all other coun-

tries, which are inhabited by mankind, in the abundance with which it is stored.

Now if some one should tell me that there is such an island, I should easily understand his words, in which there is no difficulty. But suppose that he went on to say, as if by a logical inference: "You can no longer doubt that this island which is more excellent than all lands exists somewhere, since you have no doubt that it is in your understanding. And since it is more excellent not to be in the understanding alone, but to exist both in the understanding and in reality, for this reason it must exist. For if it does not exist, any land which really exists will be more excellent than it; and so the island already understood by you to be more excellent will not be more excellent."

If a man should try to prove to me by such reasoning that this island truly exists, and that its existence should no longer be doubted, either I should believe that he was jesting, or I know not which I ought to regard as the greater fool: myself, supposing that I should allow this proof; or him, if he should suppose that he had established with any certainty the existence of this island. For he ought to show first that the hypothetical excellence of this island exists as a real and indubitable fact, and in no wise as any unreal object, or one whose existence is uncertain, in my understanding.

7. This, in the mean time, is the answer the fool could make to the arguments urged against him. When he is assured in the first place that this being is so great that its non-existence is not even conceivable, and that this in turn is proved on no other ground than the fact that otherwise it will not be greater than all things, the fool may make the same answer, mid say:

When did I say that any such being exists in reality, that is, a being greater than all others?—that on this ground it should be proved to me that it also exists in reality to such a degree that it cannot even be conceived not to exist? Whereas in the first place it should be in some way proved that a nature which is higher, that is, greater and better, than all other natures, exists; in order that from this we may then be able to prove all attributes which necessarily the being that is greater and better than all possesses.

Moreover, it is said that the non-existence of this being is inconceivable. It might better be said, perhaps, that its non-existence, or the possibility of its non-existence, is unintelligible. For according to the true meaning of the word, unreal objects are unintelligible. Yet their existence is conceivable in the way in which the fool conceived of the non-existence of God. I am most certainly aware of my own existence: but I know, nevertheless, that my non-existence is possible. As to that supreme being, moreover, which God is, I understand without any doubt both his existence, and the impossibility of his non-existence. Whether, however, so long as I am most positively aware of my existence, I can conceive of my non-existence, I am not sure. But if I can, why can I not conceive of the non-existence of whatever else I know with the same certainty? If, however, I cannot. God will not be the only being of which it can be said. it is impossible to conceive of his non-existence.

8. The other parts of this book are argued with such truth, such brilliancy, such grandeur; and are so replete with usefulness, so fragrant with a certain

152

APPENDIX.

perfume of devout and holy feeling, that though there are matters in the beginning which, however rightly sensed, are weakly presented, the rest of the work should not be rejected on this account. The rather ought these earlier matters to be reasoned more cogently, and the whole to be received with great respect and honor.

ANSELM'S APOLOGETIC.

IN REPLY TO GAUNILON'S ANSWER IN BEHALF OF THE FOOL.

It was a fool against whom the argument of my Proslogium was directed. Seeing, however, that the author of these objections is by no means a fool, and is a Catholic, speaking in behalf of the fool, I think it sufficient that I answer the Catholic.

CHAPTER I.

A general refutation of Gaunilon's argument. It is shown that a being than which a greater cannot be conceived exists in reality.

You say—whosoever you may be, who say that a fool is capable of making these statements—that a being than which a greater cannot be conceived is not in the understanding in any other sense than that in which a being that is altogether inconceivable in terms of reality, is in the understanding. You say that the inference that this being exists in reality, from the fact that it is in the understanding, is no more just than the inference that a lost island most certainly exists, from the fact that when it is described the hearer does not doubt that it is in his understanding.

But I say: if a being than which a greater is inconceivable is not understood or conceived, and is not in the understanding or in concept, certainly either God is not a being than which a greater is inconceivable, or else he is not understood or conceived, and is not in the understanding or in concept. But I call on your faith and conscience to attest that this is most false. Hence, that than which a greater cannot be conceived is truly understood and conceived, and is in the understanding and in concept. Therefore either the grounds on which you try to controvert me are not true, or else the inference which you think to base logically on those grounds is not justified.

But you hold, moreover, that supposing that a being than which a greater cannot be conceived is understood, it does not follow that this being is in the understanding; nor, if it is in the understanding, does it therefore exist in reality.

In answer to this, I maintain positively: if that being can be even conceived to be, it must exist in reality. For that than which a greater is inconceivable cannot be conceived except as without beginning. But whatever can be conceived to exist, and does not exist, can be conceived to exist through a beginning. Hence what can be conceived to exist, but does not exist, is not the being than which a greater cannot be conceived. Therefore, if such a being can be conceived to exist, necessarily it does exist.

Furthermore: if it can be conceived at all, it must exist. For no one who denies or doubts the existence of a being than which a greater is inconceivable, denies or doubts that if it did exist, its non-existence, either in reality or in the understanding, would be impossible. For otherwise it would not be a being

APPENDIX.

than which a greater cannot be conceived. But as to whatever can be conceived, but does not exist—if there were such a being, its non-existence, either in reality or in the understanding, would be possible. Therefore if a being than which a greater is inconceivable can be even conceived, it cannot be nonexistent.

But let us suppose that it does not exist, even if it can be conceived. Whatever can be conceived, but does not exist, if it existed, would not be a being than which a greater is inconceivable. If, then, there were a being a greater than which is inconceivable, it would not be a being than which a greater is inconceivable: which is most absurd. Hence, it is false to deny that a being than which a greater cannot be conceived exists, if it can be even conceived; much the more, therefore, if it can be understood or can be in the understanding.

Moreover, I will venture to make this assertion: without doubt, whatever at any place or at any time does not exist—even if it does exist at some place or at some time—can be conceived to exist nowhere and never, as at some place and at some time it does not exist. For what did not exist yesterday, and exists to-day, as it is understood not to have existed yesterday, so it can be apprehended by the intelligence that it never exists. And what is not here, and is elsewhere, can be conceived to be nowhere, just as it is not here. So with regard to an object of which the individual parts do not exist at the same places or times: all its parts and therefore its very whole can be conceived to exist nowhere or never.

For, although time is said to exist always, and the world everywhere, yet time does not as a whole exist

always, nor the world as a whole everywhere. And as individual parts of time do not exist when others exist, so they can be conceived never to exist. And so it can be apprehended by the intelligence that individual parts of the world exist nowhere, as they do not exist where other parts exist. Moreover, what is composed of parts can be dissolved in concept, and be non-existent. Therefore, whatever at any place or at any time does not exist as a whole, even if it is existent, can be conceived not to exist.

But that than which a greater cannot be conceived, if it exists, cannot be conceived not to exist. Otherwise, it is not a being than which a greater cannot be conceived: which is inconsistent. By no means, then, does it at any place or at any time fail to exist as a whole: but it exists as a whole everywhere and always.

Do you believe that this being can in some way be conceived or understood, or that the being with regard to which these things are understood can be in concept or in the understanding? For if it cannot, these things cannot be understood with reference to it. But if you say that it is not understood and that it is not in the understanding, because it is not thoroughly understood; you should say that a man who cannot face the direct rays of the sun does not see the light of day, which is none other than the sunlight. Assuredly a being than which a greater cannot be conceived exists, and is in the understanding, at least to this extent—that these statements regarding it are understood.

CHAPTER II.

The argument is continued. It is shown that a being than which a greater is inconceivable can be conceived, and also, in so far, exists.

I HAVE said, then, in the argument which you dispute, that when the fool hears mentioned a being than which a greater is inconceivable, he understands what he hears. Certainly a man who does not understand when a familiar language is spoken, has no understanding at all, or a very dull one. Moreover, I have said that if this being is understood, it is in the understanding. Is that in no understanding which has been proved necessarily to exist in the reality of fact?

But you will say that although it is in the understanding, it does not follow that it is understood. But observe that the fact of its being understood does necessitate its being in the understanding. For as what is conceived, is conceived by conception, and what is conceived by conception, as it is conceived, so is in conception; so what is understood, is understood by understanding, and what is understood by understanding, as it is understood, so is in the understanding. What can be more clear than this?

After this, I have said that if it is even in the understanding alone, it can be conceived also to exist in reality, which is greater. If, then, it is in the understanding alone, obviously the very being than which a greater cannot be conceived is one than which a greater can be conceived. What is more logical? For if it exists even in the understanding alone, can it not be conceived also to exist in reality? And if it can be so conceived, does not he who conceives of this conceive of a thing greater than that being, if it exists

ANSELM.

in the understanding alone? What more consistent inference, then, can be made than this: that if a being than which a greater cannot be conceived is in the understanding alone, it is not that than which a greater cannot be conceived?

But, assuredly, in no understanding is a being than which a greater is conceivable a being than which a greater is inconceivable. Does it not follow, then, that if a being than which a greater cannot be conceived is in any understanding, it does not exist in the understanding alone? For if it is in the understanding alone, it is a being than which a greater can be conceived, which is inconsistent with the hypothesis.

CHAPTER III.

A criticism of Gaunilon's example, in which he tries to show that in this way the real existence of a lost island might be inferred from the fact of its being conceived.

But, you say, it is as if one should suppose an island in the ocean, which surpasses all lands in its fertility, and which, because of the difficulty, or rather the impossibility, of discovering what does not exist, is called a lost island; and should say that there can be no doubt that this island truly exists in reality, for this reason, that one who hears it described easily understands what he hears.

Now I promise confidently that if any man shall devise anything existing either in reality or in concept alone (except that than which a greater cannot be conceived) to which he can adapt the sequence of my reasoning, I will discover that thing, and will give him his lost island, not to be lost again.

But it now appears that this being than which a greater is inconceivable cannot be conceived not to

APPENDIX.

be, because it exists on so assured a ground of truth; for otherwise it would not exist at all.

Hence, if any one says that he conceives this being not to exist, I say that at the time when he conceives of this either he conceives of a being than which a greater is inconceivable, or he does not conceive at all. If he does not conceive, he does not conceive of the non-existence of that of which he does not conceive. But if he does conceive, he certainly conceives of a being which cannot be even conceived not to exist. For if it could be conceived not to exist, it could be conceived to have a beginning and an end. But this is impossible.

He, then, who conceives of this being conceives of a being which cannot be even conceived not to exist; but he who conceives of this being does not conceive that it does not exist; else he conceives what is inconceivable. The non-existence, then, of that than which a greater cannot be conceived is inconceivable.

CHAPTER IV.

The difference between the possibility of conceiving of non-existence, and understanding non-existence.

You say, moreover, that whereas I assert that this supreme being cannot be *conceived* not to exist, it might better be said that its non-existence, or even the possibility of its non-existence, cannot be *understood*.

But it was more proper to say, it cannot be conceived. For if I had said that the object itself cannot be understood not to exist, possibly you yourself, who say that in accordance with the true meaning of the term what is unreal cannot be understood, would offer the objection that nothing which is can be understood not to be, for the non-existence of what exists is unreal: hence God would not be the only being of which it could be said, it is impossible to understand its non-existence. For thus one of those beings which most certainly exist can be understood not to exist in the same way in which certain other real objects can be understood not to exist.

But this objection, assuredly, cannot be urged against the term *conception*, if one considers the matter well. For although no objects which exist can be understood not to exist, yet all objects, except that which exists in the highest degree, can be conceived not to exist. For all those objects, and those alone, can be conceived not to exist, which have a beginning or end or composition of parts: also, as I have already said, whatever at any place or at any time does not exist as a whole.

That being alone, on the other hand, cannot be conceived not to exist, in which any conception discovers neither beginning nor end nor composition of parts, and which any conception finds always and everywhere as a whole.

Be assured, then, that you can conceive of your own non-existence, although you are most certain that you exist. I am surprised that you should have admitted that you are ignorant of this. For we conceive of the non-existence of many objects which we know to exist, and of the existence of many which we know not to exist; not by forming the opinion that they so exist, but by imagining that they exist as we conceive of them.

And indeed, we can conceive of the non-existence of an object, although we know it to exist, because at the same time we can conceive of the former and know the latter. And we cannot conceive of the nonexistence of an object, so long as we know it to exist, because we cannot conceive at the same time of existence and non-existence.

If, then, one will thus distinguish these two senses of this statement, he will understand that nothing, so long as it is known to exist, can be conceived not to exist; and that whatever exists, except that being than which a greater cannot be conceived, can be conceived not to exist, even when it is known to exist.

So, then, of God alone it can be said that it is impossible to conceive of his non-existence; and yet many objects, so long as they exist, in one sense cannot be conceived not to exist. But in what sense God is to be conceived not to exist, I think has been shown clearly enough in my book.

CHAPTER V.

A particular discussion of certain statements of Gaunilon's. In the first place, he misquoted the argument which he undertook to refute.

THE nature of the other objections which you, in behalf of the fool, urge against me it is easy, even for a man of small wisdom, to detect; and I had therefore thought it unnecessary to show this. But since I hear that some readers of these objections think they have some weight against me, I will discuss them briefly.

In the first place, you often repeat that I assert that what is greater than all other beings is in the understanding; and if it is in the understanding, it exists also in reality, for otherwise the being which is greater than all would not be greater than all.

Nowhere in all my writings is such a demonstration found. For the real existence of a being which is said to be greater than all other beings cannot be demonstrated in the same way with the real existence of one that is said to be a being than which a greater cannot be conceived.

If it should be said that a being than which a greater cannot be conceived has no real existence, or that it is possible that it does not exist, or even that it can be conceived not to exist, such an assertion can be easily refuted. For the non-existence of what does not exist is possible, and that whose non-existence is possible can be conceived not to exist. But whatever can be conceived not to exist, if it exists, is not a being than which a greater cannot be conceived; but if it does not exist, it would not, even if it existed, be a being than which a greater cannot be conceived. But it cannot be said that a being than which a greater is inconceivable, if it exists, is not a being than which a greater is inconceivable; or that if it existed, it would not be a being than which a greater is inconceivable.

It is evident, then, that neither is it non-existent, nor is it possible that it does not exist, nor can it be conceived not to exist. For otherwise, if it exists, it is not that which it is said to be in the hypothesis; and if it existed, it would not be what it is said to be in the hypothesis.

But this, it appears, cannot be so easily proved of a being which is said to be greater than all other beings. For it is not so evident that what can be conceived not to exist is not greater than all existing beings, as it is evident that it is not a being than which a greater cannot be conceived. Nor is it so indubitable that if a being greater than all other beings exists, it is no other than the being than which a greater cannot be conceived; or that if it were such a being, some other might not be this being in like manner; as it is certain with regard to a being which is hypothetically posited as one than which a greater cannot be conceived.

For consider : if one should say that there is a being greater than all other beings, and that this being can nevertheless be conceived not to exist; and that a being greater than this, although it does not exist, can be conceived to exist: can it be so clearly inferred in this case that this being is therefore not a being greater than all other existing beings, as it would be most positively affirmed in the other case, that the being under discussion is not, therefore, a being than which a greater cannot be conceived?

For the former conclusion requires another premise than the predication, greater than all other beings. In my argument, on the other hand, there is no need of any other than this very predication, a being than which a greater cannot be conceived.

If the same proof cannot be applied when the being in question is predicated to be greater than all others, which can be applied when it is predicated to be a being than which a greater cannot be conceived, you have unjustly censured me for saying what I did not say; since such a predication differs so greatly from that which I actually made. If, on the other hand, the other argument is valid, you ought not to blame me so for having said what can be proved.

Whether this can be proved, however, he will easily decide who recognises that this being than which a greater cannot be conceived is demonstrable. For by no means can this being than which a greater cannot be conceived be understood as any other than that which alone is greater than all. Hence, just as

ANSELM.

that than which a greater cannot be conceived is understood, and is in the understanding, and for that reason is asserted to exist in the reality of fact: so what is said to be greater than all other beings is understood and is in the understanding, and therefore it is necessarily inferred that it exists in reality.

You see, then, with how much justice you have compared me with your fool, who, on the sole ground that he understands what is described to him, would affirm that a lost island exists.

CHAPTER VI.

A discussion of Gaunilon's argument in his second chapter: that any unreal beings can be understood in the same way, and would, to that extent, exist.

ANOTHER of your objections is that any unreal beings, or beings whose existence is uncertain, can be understood and be in the understanding in the same way with that being which I discussed. I am surprised that you should have conceived this objection, for I was attempting to prove what was still uncertain, and contented myself at first with showing that this being is understood in any way, and is in the understanding. It was my intention to consider, on these grounds, whether this being is in the understanding alone, like an unreal object, or whether it also exists in fact, as a real being. For if unreal objects, or objects whose existence is uncertain, in this way are understood and are in the understanding, because, when they are spoken of, the hearer understands what the speaker means, there is no reason why that being of which I spoke should not be understood and be in the understanding.

How, moreover, can these two statements of yours

APPENDIX.

be reconciled: (1) the assertion that if a man should speak of any unreal objects, whatever they might be, you would understand, and (2) the assertion that on hearing of that being which does exist, and not in that way in which even unreal objects are held in concept, you would not say that you conceive of it or have it in concept; since, as you say, you cannot conceive of it in any other way than by understanding it, that is, by comprehending in your knowledge its real existence?

How, I ask, can these two things be reconciled: that unreal objects are understood, and that understanding an object is comprehending in knowledge its real existence? The contradiction does not concern me: do you see to it. But if unreal objects are also in some sort understood, and your definition is applicable, not to every understanding, but to a certain sort of understanding, I ought not to be blamed for saying that a being than which a greater cannot be conceived is understood and is in the understanding, even before I reached the certain conclusion that this being exists in reality.

CHAPTER VII.

In answer to another objection: that the supremely great being may be conceived not to exist, just as by the fool God is conceived not to exist.

AGAIN, you say that it can probably never be believed that this being, when it is spoken of and heard of, cannot be conceived not to exist in the same way in which even God may be conceived not to exist.

Such an objection could be answered by those who have attained but little skill in disputation and argument. For is it compatible with reason for a man to deny the existence of what he understands, because it is said to be that being whose existence he denies because he does not understand it? Or, if at some times its existence is denied, because only to a certain extent is it understood, and that which is not at all understood is the same to him: is not what is stiil undetermined more easily proved of a being which exists in some understanding than of one which exists is no understanding?

Hence it cannot be credible that any man denies the existence of a being than which a greater cannot be conceived, which, when he hears of it, he understands in a certain degree: it is incredible, I say, that any man denies the existence of this being because he denies the existence of God, the sensory perception of whom he in no wise conceives of.

Or if the existence of another object, because it is not at all understood, is denied, yet is not the existence of what is understood in some degree more easily proved than the existence of an object which is in no wise understood?

Not irrationally, then, has the hypothesis of a being a greater than which cannot be conceived been employed in controverting the fool, for the proof of the existence of God: since in some degree he would understand such a being, but in no wise could he understand God.

CHAPTER VIII.

The example of the picture, treated in Gaunilon's third chapter, is examined.—From what source a notion may be formed of the supremely great being, of which Gaunilon inquired in his fourth chapter.

MOREOVER, your so careful demonstration that the being than which a greater cannot be conceived is

APPENDIX.

not analogous to the not yet executed picture in the understanding of the painter, is quite unnecessary. It was not for this purpose that I suggested the preconceived picture. I had no thought of asserting that the being which I was discussing is of such a nature; but I wished to show that what is not understood to exist can be in the understanding.

Again, you say that when you hear of a being than which a greater is inconceivable, you cannot conceive of it in terms of any real object known to you either specifically or generally, nor have it in your understanding. For, you say, you neither know such a being in itself, nor can you form an idea of it from anything like it.

But obviously this is not true. For everything that is less good, in so far as it is good, is like the greater good. It is therefore evident to any rational mind, that by ascending from the lesser good to the greater, we can form a considerable notion of a being than which a greater is inconceivable.

For instance, who (even if he does not believe that what he conceives of exists in reality) supposing that there is some good which has a beginning and an end, does not conceive that a good is much better, which, if it begins, does not cease to be? And that as the second good is better than the first, so that good which has neither beginning nor end, though it is ever passing from the past through the present to the future, is better than the second? And that far better than this is a being—whether any being of such a nature exists or not—which in no wise requires change or motion, nor is compelled to undergo change or motion?

Is this inconceivable, or is some being greater

than this conceivable? Or is not this to form a notion from objects than which a greater is conceivable, of the being than which a greater cannot be conceived? There is, then, a means of forming a notion of a being than which a greater is inconceivable.

So easily, then, can the fool who does not accept sacred authority be refuted, if he denies that a notion may be formed from other objects of a being than which a greater is inconceivable. But if any Catholic would deny this, let him remember that the invisible things of God, from the creation of the world, are clearly seen, being understood by the things that are made, even his eternal power and Godhead. (Romans i. 20.)

CHAPTER IX.

The possibility of understanding and conceiving of the supremely great being. The argument advanced against the fool is confirmed.

But even if it were true that a being than which a greater is inconceivable cannot be conceived or understood; yet it would not be untrue that a being than which a greater cannot be conceived is conceivable and intelligible. There is nothing to prevent one's saying *ineffable*, although what is said to be ineffable cannot be spoken of. *Inconceivable* is conceivable, although that to which the word *inconceivable* can be applied is not conceivable. So, when one says, *that than which nothing greater is conceivable*, undoubtedly what is heard is conceivable and intelligible, although that being itself, than which a greater is inconceivable, cannot be conceived or understood.

Or, though there is a man so foolish as to say that there is no being than which a greater is inconceivable, he will not be so shameless as to say that he

APPENDIX.

cannot understand or conceive of what he says. Or, if such a man is found, not only ought his words to be rejected, but he himself should be contemned.

Whoever, then, denies the existence of a being than which a greater cannot be conceived, at least understands and conceives of the denial which he makes. But this denial he cannot understand or conceive of without its component terms; and a term of this statement is a being than which a greater cannot be conceived. Whoever, then, makes this denial, understands and conceives of that than which a greater is inconceivable.

Moreover, it is evident that in the same way it is possible to conceive of and understand a being whose non-existence is impossible; but he who conceives of this conceives of a greater being than one whose nonexistence is possible. Hence, when a being than which a greater is inconceivable is conceived, if it is a being whose non-existence is possible that is conceived, it is not a being than which a greater cannot be conceived. But an object cannot be at once conceived and not conceived. Hence he who conceives of a being than which a greater is inconceivable, does not conceive of that whose non-existence is possible, but of that whose non-existence is impossible. Therefore, what he conceives of must exist; for anything whose non-existence is possible, is not that of which he conceives.

CHAPTER X.

The certainty of the foregoing argument.—The conclusion of the book.

I BELIEVE that I have shown by an argument which is not weak, but sufficiently cogent, that in my former book I proved the real existence of a being than which a greater cannot be conceived; and I believe that this argument cannot be invalidated by the validity of any objection. For so great force does the signification of this reasoning contain in itself, that this being which is the subject of discussion, is of necessity, from the very fact that it is understood or conceived, proved also to exist in reality, and to be whatever we should believe of the divine substance.

For we attribute to the divine substance anything of which it can be conceived that it is better to be than not to be that thing. For example: it is better to be eternal than not eternal; good, than not good; nay, goodness itself, than not goodness itself. But it cannot be that anything of this nature is not a property of the being than which a greater is inconceivable. Hence, the being than which a greater is inconceivable must be whatever snould be attributed to the divine essence.

I thank you for your kindness both in your blame and in your praise for my book. For since you have commended so generously those parts of it which seem to you worthy of acceptance, it is quite evident that you have criticised in no unkind spirit those parts of it which seemed to you weak.

CUR DEUS HOMO.

TABLE OF CONTENTS.

CUR DEUS HOMO.

BOOK FIRST.

		PAGE
Prefa	Ce	177
I.	The question on which the whole work rests	178
II.	How those things which are to be said should be re-	
	ceived	179
III.	Objections of infidels and replies of believers	
	How these things appear not decisive to infidels, and	
	merely like so many pictures	183
V.	How the redemption of man could not be effected by	
	any other being but God	184
VI.	How infidels find fault with us for saying that God has	
	redeemed us by his death, etc	185
VII.	How the devil had no justice on his side against man	187
VIII.	How, although the acts of Christ's condescension which	
	we speak of do not belong to his divinity, it yet seems	
	improper to infidels that these things should be said	
	of him even as a man, etc	190
IX.	How it was of his own accord that he died	192
X.	On the same topics	197
XI.	What it is to sin, and to make satisfaction for sin	201
	Whether it were proper for God to put away sins by	
	compassion alone, without any payment of debt	203
XIII.	How nothing less was to be endured, in the order of	
	things, than that the creature should take away the	
	honor due the Creator, etc	206
XIV.	How the honor of God exists in the punishment of the	
	wicked	207
XV.	Whether God suffers his honor to be violated even in	
		208

TABLE OF CONTENTS.

XVI.	The reason why the number of angels who fell must	AGE
	be made up from men	210
XVII.	How other angels cannot take the place of those who	
	fell	211
XVIII.	Whether there will be more holy men than evil an-	
	gels	212
XIX.	How man cannot be saved without satisfaction for sin	222
XX.	That satisfaction ought to be proportionate to guilt	225
XXI.	How great a burden sin is	228
XXII.	What contempt man brought upon God when he	
	allowed himself to be conquered by the devil	230
XXIII.	What man took from God by his sin	231
XXIV.	How, as long as man does not restore what he owes	
	God, he cannot be happy	233
XXV.	How man's salvation by Christ is necessarily possible	237

BOOK SECOND.

I.	How man was made holy by God, so as to be happy	
	in the enjoyment of God	239
II.	How man would never have died, unless he had	
	sinned	241
III.	How man will rise with the same body which he has	
	in this world	241
IV.	How God will complete, in respect to human nature,	
	what he has begun	242
V.	How, although the thing may be necessary, God may	
	not do it by a compulsory necessity	242
VI.	How no being, except the God-man, can make the	
	atonement by which man is saved	244
VII.	How necessary it is for the same being to be perfect	
	God and perfect man	245
VIII.	How it behooved God to take a man of the race of	
	Adam, and born of a woman	247
XIX.	How of necessity the Word only can unite in one per-	
v	son with man	250
А.	How this man dies not of debt; and in what sense he	
VT	can or cannot sin	-
	How Christ dies of his own power	255
лп.	How, though he share in our weakness, he is not	
	therefore miserable	259

TABLE OF CONTENTS.

	P	AGE
XIII.	How, along with our other weaknesses, he does not	
	partake of our ignorance	260
XIV.	How his death outweighs the number and greatness	
	of our sins	
	How his death removes even the sins of his murderers	263.
XVI.	How God took that man from a sinful substance, and	
	yet without sin; and of the salvation of Adam and	
	Eve	265
XVII.	How he did not die of necessity though he could not	
	be born, except as destined to suffer death	269
XVIIIa.	How with God there is neither necessity nor impos-	
	sibility	273
	How Christ's life is paid to God for the sins of men	
XIX.	How human salvation follows upon his death	283
XX.	How great and how just is God's compassion	286
	How it is impossible for the devil to be reconciled	286
XXII.	How the truth of the Old and New Testament is	
	shown in the things which have been said	287

ANSELM'S CUR DEUS HOMO.

PREFACE.

THE first part of this book was copied without my knowledge, before the work had been completed and revised. I have therefore been obliged to finish it as best I could, more hurriedly, and so more briefly. than I wished. For had an undisturbed and adequate period been allowed me for publishing it, I should have introduced and subjoined many things about which I have been silent. For it was while suffering under great anguish of heart (the origin and reason of which are known to God), that, at the entreaty of others, I began the book in England, and finished it when an exile in Capua. From the theme on which it was published I have called it Cur Deus Homo, and have divided it into two short books. The first contains the objections of infidels, who despise the Christian faith because they deem it contrary to reason; and also the reply of believers; and, in fine, leaving Christ out of view (as if nothing had ever been known of him), it proves, by absolute reasons, the impossibility that any man should be saved without him. Again, in the second book, likewise, as if nothing were known of Christ, it is moreover shown by plain reasoning and fact that human nature was ordained for this purpose, viz., that every man should enjoy a happy immortality, both in body and in soul; and

ANSELM.

that it was necessary that this design for which man was made should be fulfilled; but that it could not be fulfilled unless God became man, and unless all things were to take place which we hold with regard to Christ. I request all who may wish to copy this book to prefix this brief preface, with the heads of the whole work, at its commencement; so that, into whosesoever hands it may fall, as he looks on the face of it, there may be nothing in the whole body of the work which shall escape his notice.

BOOK FIRST.

CHAPTER I.

The question on which the whole work rests.

I HAVE been often and most earnestly requested by many, both personally and by letter, that I would hand down in writing the proofs of a certain doctrine of our faith, which I am accustomed to give to inquirers; for they say that these proofs gratify them, and are considered sufficient. This they ask, not for the sake of attaining to faith by means of reason, but that they may be gladdened by understanding and meditating on those things which they believe; and that, as far as possible, they may be always ready to convince any one who demands of them a reason of that hope which is in us. And this question, both infidels are accustomed to bring up against us, ridiculing Christian simplicity as absurd; and many believers ponder it in their hearts; for what cause or necessity. in sooth, God became man, and by his own death, as we believe and affirm, restored life to the world ; when

he might have done this, by means of some other being, angelic or human, or merely by his will. Not only the learned, but also many unlearned persons interest themselves in this inquiry and seek for its solution. Therefore, since many desire to consider this subject, and, though it seem very difficult in the investigation, it is yet plain to all in the solution, and attractive for the value and beauty of the reasoning; although what ought to be sufficient has been said by the holy fathers and their successors, yet I will take pains to disclose to inquirers what God has seen fit to lay open to me. And since investigations, which are carried on by question and answer, are thus made more plain to many, and especially to less quick minds, and on that account are more gratifying, I will take to argue with me one of those persons who agitate this subject; one, who among the rest impels me more earnestly to it, so that in this way Boso may question and Anselm reply.

CHAPTER II.

How those things which are to be said should be received.

Boso. As the right order requires us to believe the deep things of Christian faith before we undertake to discuss them by reason; so to my mind it appears a neglect if, after we are established in the faith, we do not seek to understand what we believe. Therefore, since I thus consider myself to hold the faith of our redemption, by the prevenient grace of God, so that, even were I unable in any way to understand what I believe, still nothing could shake my constancy; I desire that you should discover to me, what, as you know, many besides myself ask, for what necessity

ANSELM.

and cause God, who is omnipotent, should have assumed the littleness and weakness of human nature for the sake of its renewal?

Anselm. You ask of me a thing which is above me, and therefore I tremble to take in hand subjects too lofty for me, lest, when some one may have thought or even seen that I do not satisfy him, he will rather believe that I am in error with regard to the substance of the truth, than that my intellect is not able to grasp it.

Boso. You ought not so much to fear this, because you should call to mind, on the other hand, that it often happens in the discussion of some question that God opens what before lay concealed; and that you should hope for the grace of God, because if you liberally impart those things which you have freely received, you will be worthy to receive higher things to which you have not yet attained.

Anselm. There is also another thing on account of which I think this subject can hardly, or not at all, be discussed between us comprehensively; since, for this purpose, there is required a knowledge of Power and Necessity and Will and certain other subjects which are so related to one another that none of them can be fully examined without the rest; and so the discussion of these topics requires a separate labor, which, though not very easy, in my opinion, is by no means useless; for ignorance of these subjects makes certain things difficult, which by acquaintance with them become easy.

Boso. You can speak so briefly with regard to these things, each in its place, that we may both have all that is requisite for the present object, and what remains to be said we can put off to another time.

Anselm. This also much disinclines me from your request, not only that the subject is important, but as it is of a form fair above the sons of men, so is it of a wisdom fair above the intellect of men. On this account, I fear, lest, as I am wont to be incensed against sorry artists, when I see our Lord himself painted in an unseemly figure; so also it may fall out with me if I should undertake to exhibit so rich a theme in rough and vulgar diction.

Boso. Even this ought not to deter you, because, as you allow any one to talk better if he can, so you preclude none from writing more elegantly if your language does not please him. But, to cut you off from all excuses, you are not to fulfil this request of mine for the learned but for me, and those asking the same thing with me.

Anselm. Since I observe your earnestness and that of those who desire this thing with you, out of love and pious zeal, I will try to the best of my ability (with the assistance of God and your prayers, which, when making this request, you have often promised me), not so much to make plain what you inquire about, as to inquire with you. But I wish all that I say to be received with this understanding, that, if I shall have said anything which higher authority does not corroborate, though I appear to demonstrate it by argument, yet it is not to be received with any further confidence, than as so appearing to me for the time, until God in some way make a clearer revelation to me. But if I am in any measure able to set your inquiry at rest, it should be concluded that a wiser than I will be able to do this more fully; nay, we must understand that for all that a man can say or

know still deeper grounds of so great a truth lie concealed.

Boso. Suffer me, therefore, to make use of the words of infidels; for it is proper for us when we seek to investigate the reasonableness of our faith to propose the objections of those who are wholly unwilling to submit to the same faith, without the support of reason. For although they appeal to reason because they do not believe, but we, on the other hand, because we do believe; nevertheless, the thing sought is one and the same. And if you bring up anything in reply which sacred authority seems to oppose, let it be mine to urge this inconsistency until you disprove it.

Anselm. Speak on according to your pleasure.

CHAPTER III.

Objections of infidels and replies of believers.

Boso. Infidels ridiculing our simplicity charge upon us that we do injustice and dishonor to God when we affirm that he descended into the womb of a virgin, that he was born of woman, that he grew on the nourishment of milk and the food of men; and, passing over many other things which seem incompatible with Deity, that he endured fatigue, hunger, thirst, stripes and crucifixion among thieves.

Anselm. We do no injustice or dishonor to God, but give him thanks with all the heart, praising and proclaiming the ineffable height of his compassion. For the more astonishing a thing it is and beyond expectation, that he has restored us from so great and deserved ills in which we were, to so great and unmerited blessings which we had forfeited; by so much

the more has he shown his more exceeding love and tenderness towards us. For did they but carefully consider how fitly in this way human redemption is secured, they would not ridicule our simplicity. but would rather join with us in praising the wise beneficence of God. For, as death came upon the human race by the disobedience of man, it was fitting that by man's obedience life should be restored. And, as sin, the cause of our condemnation, had its origin from a woman, so ought the author of our righteousness and salvation to be born of a woman. And so also was it proper that the devil, who, being man's tempter, had conquered him in eating of the tree, should be vanquished by man in the suffering of the tree which man bore. Many other things also, if we carefully examine them, give a certain indescribable beauty to our redemption as thus procured.

CHAPTER IV.

How these things appear not decisive to infidels, and merely like so many pictures.

Boso. These things must be admitted to be beautiful, and like so many pictures; but, if they have no solid foundation, they do not appear sufficient to infidels, as reasons why we ought to believe that God wished to suffer the things which we speak of. For when one wishes to make a picture, he selects something substantial to paint it upon, so that his picture may remain. For no one paints in water or in air, because no traces of the picture remain in them. Wherefore, when we hold up to infidels these harmonious proportions which you speak of as so many pictures of the real thing, since they do not think this

ANSELM.

belief of ours a reality, but only a fiction, they consider us, as it were, to be painting upon a cloud. Therefore the rational existence of the truth must first be shown, I mean, the necessity, which proves that God ought to or could have condescended to those things which we affirm. Afterwards, to make the body of the truth, so to speak, shine forth more clearly, these harmonious proportions, like pictures of the body, must be described.

Anselm. Does not the reason why God ought to do the things we speak of seem absolute enough when we consider that the human race, that work of his so very precious, was wholly ruined, and that it was not seemly that the purpose which God had made concerning man should fall to the ground; and, moreover, that this purpose could not be carried into effect unless the human race were delivered by their Creator himself?

CHAPTER V.

How the redemption of man could not be effected by any other being but God.

Boso. If this deliverance were said to be effected somehow by any other being than God (whether it were an angelic or a human being), the mind of man would receive it far more patiently. For God could have made some man without sin, not of a sinful substance, and not a descendant of any man, but just as he made Adam, and by this man it should seem that the work we speak of could have been done.

Anselm. Do you not perceive that, if any other being should rescue man from eternal death, man would rightly be adjudged as the servant of that being? Now if this be so, he would in no wise be restored to that

CUR DEUS HOMO.

dignity which would have been his had he never sinned. For he, who was to be through eternity only the servant of God and an equal with the holy angels, would now be the servant of a being who was not God, and whom the angels did not serve.

CHAPTER VI.

How infidels find fault with us for saying that God has redeemed us by his death, and thus has shown his love towards us, and that he came to overcome the devil for us.

Boso. This they greatly wonder at, because we call this redemption a release. For, say they, in what custody or imprisonment, or under whose power were you held, that God could not free you from it, without purchasing your redemption by so many sufferings, and finally by his own blood? And when we tell them that he freed us from our sins. and from his own wrath, and from hell, and from the power of the devil, whom he came to vanguish for us, because we were unable to do it, and that he purchased for us the kingdom of heaven; and that, by doing all these things, he manifested the greatness of his love towards us: they answer: If you say that God, who, as you believe, created the universe by a word, could not do all these things by a simple command, you contradict yourselves, for you make him powerless. Or, if you grant that he could have done these things in some other way, but did not wish to, how can you vindicate his wisdom, when you assert that he desired, without any reason, to suffer things so unbecoming? For these things which you bring up are all regulated by his will; for the wrath of God is nothing but his desire to punish. If, then, he does not desire to punish

ANSELM.

the sins of men, man is free from his sins, and from the wrath of God, and from hell, and from the power of the devil, all which things are the sufferings of sin; and, what he had lost by reason of these sins, he now regains. For, in whose power is hell, or the devil? Or, whose is the kingdom of heaven, if it be not his who created all things? Whatever things, therefore, you dread or hope for, all lie subject to his will, whom nothing can oppose. If, then, God were unwilling to save the human race in any other way than that you mention, when he could have done it by his simple will, observe, to say the least, how you disparage his wisdom. For, if a man without motive should do, by severe toil, a thing which he could have done in some easy way, no one would consider him a wise man. As to your statement that God has shown in this way how much he loved you, there is no argument to support this, unless it be proved that he could not otherwise have saved man. For, if he could not have done it otherwise, then it was, indeed, necessary for him to manifest his love in this way. But now, when he could have saved man differently, why is it that, for the sake of displaying his love, he does and suffers the things which you enumerate? For does he not show good angels how much he loves them, though he suffer no such things as these for them? As to what you say of his coming to vanquish the devil for you, with what meaning dare you allege this? Is not the omnipotence of God everywhere enthroned? How is it, then, that God must needs come down from heaven to vanquish the devil? These are the objections with which infidels think they can withstand us.

CHAPTER VII.

How the devil had no justice on his side against man; and why it was, that he seemed to have had it, and why God could have freed man in this way.

MOREOVER, I do not see the force of that argument, which we are wont to make use of, that God, in order to save men, was bound, as it were, to try a contest with the devil in justice, before he did in strength, so that, when the devil should put to death that being in whom there was nothing worthy of death, and who was God, he should justly lose his power over sinners: and that, if it were not so, God would have used undue force against the devil, since the devil had a rightful ownership of man, for the devil had not seized man with violence, but man had freely surrendered to him. It is true that this might well enough be said, if the devil or man belonged to any other being than God, or were in the power of any but God. But since neither the devil nor man belong to any but God, and neither can exist without the exertion of Divine power, what cause ought God to try with his own creature (de suo, in suo), or what should he do but punish his servant, who had seduced his fellow-servant to desert their common Lord and come over to himself; who, a traitor, had taken to himself a fugitive; a thief, had taken to himself a fellow-thief, with what he had stolen from his Lord. For when one was stolen from his Lord by the persuasions of the other, both were thieves. For what could be more just than for God to do this? Or, should God, the judge of all, snatch man, thus held, out of the power of him who holds him so unrighteously, either for the

purpose of punishing him in some other way than by means of the devil, or of sparing him, what injustice would there be in this? For, though man deserved to be tormented by the devil, yet the devil tormented him unjustly. For man merited punishment, and there was no more suitable way for him to be punished than by that being to whom he had given his consent to sin. But the infliction of punishment was nothing meritorious in the devil; on the other hand, he was even more unrighteous in this, because he was not led to it by a love of justice, but urged on by a malicious impulse. For he did not do this at the command of God, but God's inconceivable wisdom, which happily controls even wickedness, permitted it. And, in my opinion, those who think that the devil has any right in holding man, are brought to this belief by seeing that man is justly exposed to the tormenting of the devil, and that God in justice permits this; and therefore they suppose that the devil rightly inflicts it. For the very same thing, from opposite points of view, is sometimes both just and unjust, and hence, by those who do not carefully inspect the matter, is deemed wholly just or wholly unjust. Suppose, for example, that one strikes an innocent person unjustly, and hence justly deserves to be beaten himself; if, however, the one who was beaten. though he ought not to avenge himself, yet does strike the person who beat him, then he does it unjustly. And hence this violence on the part of the man who returns the blow is unjust, because he ought not to avenge himself; but as far as he who received the blow is concerned, it is just, for since he gave a blow unjustly, he justly deserves to receive one in return. Therefore, from opposite views, the same action is

both just and unjust, for it may chance that one person shall consider it only just, and another only unjust. So also the devil is said to torment men justly. because God in justice permits this, and man in justice suffers it. But when man is said to suffer justly, it is not meant that his just suffering is inflicted by the hand of justice itself, but that he is punished by the just judgment of God. But if that written decree is brought up, which the Apostle says was made against us, and cancelled by the death of Christ; and if any one thinks that it was intended by this decree that the devil, as if under the writing of a sort of compact, should justly demand sin and the punishment of sin. of man, before Christ suffered, as a debt for the first sin to which he tempted man, so that in this way he seems to prove his right over man, I do not by any means think that it is to be so understood. For that writing is not of the devil, because it is called the writing of a decree of the devil, but of God. For by the just judgment of God it was decreed, and, as it were, confirmed by writing, that, since man had sinned. he should not henceforth of himself have the power to avoid sin or the punishment of sin; for the spirit is out-going and not returning (est enim spiritus vadens et non rediens); and he who sins ought not to escape with impunity, unless pity spare the sinner. and deliver and restore him. Wherefore we ought not to believe that, on account of this writing, there can be found any justice on the part of the devil in his tormenting man. In fine, as there is never any injustice in a good angel, so in an evil angel there can be no justice at all. There was no reason, therefore. as respects the devil, why God should not make use of his own power against him for the liberation of man.

CHAPTER VIII.

How, although the acts of Christ's condescension which we speak of do not belong to his divinity, it yet seems improper to infidels that these things should be said of him even as a man; and why it appears to them that this man did not suffer death of his own will.

Anselm. The will of God ought to be a sufficient reason for us, when he does anything, though we cannot see why he does it. For the will of God is never irrational.

Boso. That is very true, if it be granted that God does wish the thing in question; but many will never allow that God does wish anything if it be inconsistent with reason.

Anselm. What do you find inconsistent with reason, in our confessing that God desired those things which make up our belief with regard to his incarnation?

Boso. This in brief: that the Most High should stoop to things so lowly, that the Almighty should do a thing with such toil.

Anselm. They who speak thus do not understand our belief. For we affirm that the Divine nature is beyond doubt impassible, and that God cannot at all be brought down from his exaltation, nor toil in anything which he wishes to effect. But we say that the Lord Jesus Christ is very God and very man, one person in two natures, and two natures in one person. When, therefore, we speak of God as enduring any humiliation or infirmity, we do not refer to the majesty of that nature, which cannot suffer; but to the feebleness of the human constitution which he assumed. And so there remains no ground of objection against our faith. For in this way we intend no debasement of the Divine nature, but we teach that one person is both Divine and human. In the incarnation of God there is no lowering of the Deity; but the nature of man we believe to be exalted.

Boso. Be it so; let nothing be referred to the Divine nature, which is spoken of Christ after the manner of human weakness; but how will it ever be made out a just or reasonable thing that God should treat or suffer to be treated in such a manner, that man whom the Father called his beloved Son in whom he was well pleased, and whom the Son made himself? For what justice is there in his suffering death for the sinner, who was the most just of all men? What man, if he condemned the innocent to free the guilty, would not himself be judged worthy of condemnation? And so the matter seems to return to the same incongruity which is mentioned above. For if he could not save sinners in any other way than by condemning the just, where is his omnipotence? If, however, he could, but did not wish to, how shall we sustain his wisdom and justice?

Anselm. God the Father did not treat that man as you seem to suppose, nor put to death the innocent for the guilty. For the Father did not compel him to suffer death, or even allow him to be slain, against his will, but of his own accord he endured death for the salvation of men.

Boso. Though it were not against his will, since he agreed to the will of the Father; yet the Father seems to have bound him, as it were, by his injunction. For it is said that Christ "humbled himself, being made obedient to the Father even unto death,

and that the death of the cross. For which cause God also hath highly exalted him;" and that "he learned obedience from the things which he suffered;" and that God spared not his own Son, but gave him up for us all." And likewise the Son says: "I came not to do my own will, but the will of him that sent me." And when about to suffer, he says; "As the Father hath given me commandment, so I do." Again: "The cup which the Father hath given me, shall I not drink it?" And, at another time : "Father, if it be possible, let this cup pass from me; nevertheless, not as I will, but as thou wilt." And again : "Father, if this cup may not pass from me except I drink it, thy will be done." In all these passages it would rather appear that Christ endured death by the constraint of obedience, than by the inclination of his own free will.

CHAPTER IX.

How it was of his own accord that he died, and what this means: "he was made obedient even unto death;" and: "for which cause God hath highly exalted him;" and: "I came not to do my own will;" and: "he spared not his own Son;" and: "not as I will, but as thou wilt."

Anselm. It seems to me that you do not rightly understand the difference between what he did at the demand of obedience, and what he suffered, not demanded by obedience, but inflicted on him, because he kept his obedience perfect.

Boso. I need to have you explain it more clearly.

Anselm. Why did the Jews persecute him even unto death?

Boso. For nothing else, but that, in word and in life, he invariably maintained truth and justice

Anselm. I believe that God demands this of every rational being, and every being owes this in obedience to God.

Boso. We ought to acknowledge this.

Anselm. That man, therefore, owed this obedience to God the Father, humanity to Deity; and the Father claimed it from him.

Boso. There is no doubt of this.

Anselm. Now you see what he did, under the demand of obedience.

Boso. Very true, and I see also what infliction he endured, because he stood firm in obedience. For death was inflicted on him for his perseverance in obedience and he endured it; but I do not understand how it is that obedience did not demand this.

Anselm. Ought man to suffer death, if he had never sinned, or should God demand this of him?

Boso. It is on this account that we believe that man would not have been subject to death, and that God would not have exacted this of him; but I should like to hear the reason of the thing from you.

Anselm. You acknowledge that the intelligent creature was made holy, and for this purpose, viz., to be happy in the enjoyment of God.

Boso. Yes.

Anselm. You surely will not think it proper for God to make his creature miserable without fault, when he had created him holy that he might enjoy a state of blessedness. For it would be a miserable thing for man to die against his will.

Boso. It is plain that, if man had not sinned, God ought not to compel him to die.

Anselm. God did not, therefore, compel Christ to die; but he suffered death of his own will, not yielding up his life as an act of obedience, but on account of his obedience in maintaining holiness; for he held out so firmly in this obedience that he met death on account of it. It may, indeed be said, that the Father commanded him to die, when he enjoined that upon him on account of which he met death. It was in this sense, then, that "as the Father gave him the commandment, so he did, and the cup which He gave to him, he drank: and he was made obedient to the Father, even unto death ;" and thus "he learned obedience from the things which he suffered," that is, how far obedience should be maintained. Now the word "didicit," which is used, can be understood in two ways. For either "didicit" is written for this: he caused others to learn; or it is used, because he did learn by experience what he had an understanding of before. Again, when the Apostle had said: "he humbled himself, being made obedient even unto death, and that the death of the cross," he added: "wherefore God also hath exalted him and given him a name, which is above every name." And this is similar to what David said: "he drank of the brook in the way, therefore did he lift up the head." For it is not meant that he could not have attained his exaltation in any other way but by obedience unto death; nor is it meant that his exaltation was conferred on him, only as a reward of his obedience (for he himself said before he suffered, that all things had been committed to him by the Father, and that all things belonging to the Father were his); but the expression is used because he had agreed with the Father and the Holy Spirit, that there was no other way to reveal to the world the height of his omnipotence, than by his death. For if a thing do not take place,

except on condition of something else, it is not improperly said to occur by reason of that thing. For if we intend to do a thing, but mean to do something else first by means of which it may be done; when the first thing which we wish to do is done, if the result is such as we intended, it is properly said to be on account of the other; since that is now done which caused the delay; for it had been determined that the first thing should not be done without the other. If. for instance, I propose to cross a river only in a boat, though I can cross it in a boat or on horseback, and suppose that I delay crossing because the boat is gone; but if afterwards I cross, when the boat has returned, it may be properly said of me: the boat was ready, and therefore he crossed. And we not only use this form of expression, when it is by means of a thing which we desire should take place first, but also when we intend to do something else, not by means of that thing, but only after it. For if one delays taking food because he has not to-day attended the celebration of mass; when that has been done which he wished to do first, it is not improper to say to him: now take food, for you have now done that for which you delayed taking food. Far less, therefore, is the language strange, when Christ is said to be exalted on this account, because he endured death; for it was through this, and after this, that he determined to accomplish his exaltation. This may be understood also in the same way as that passage in which it is said that our Lord increased in wisdom, and in favor with God; not that this was really the case, but that he deported himself as if it were so. For he was exalted after his death, as if it were really on account of that. Moreover, that saying of his: "I

came not to do mine own will, but the will of him that sent me," is precisely like that other saying: "My doctrine is not mine;" for what one does not have of himself, but of God, he ought not to call his own, but God's. Now no one has the truth which he teaches, or a holy will, of himself, but of God. Christ. therefore, came not to do his own will, but that of the Father; for his holy will was not derived from his humanity, but from his divinity. For that sentence: "God spared not his own Son, but gave him up for us all," means nothing more than that he did not rescue him. For there are found in the Bible many things like this. Again, when he says: "Father, if it be passible, let this cup pass from me; nevertheless not as I will, but as thou wilt;" and "If this cup may not pass from me, except I drink it, thy will be done;" he signifies by his own will the natural desire of safety, in accordance with which human nature shrank from the anguish of death. But he speaks of the will of the Father, not because the Father preferred the death of the Son to his life; but because the Father was not willing to rescue the human race. unless man were to do even as great a thing as was signified in the death of Christ. Since reason did not demand of another what he could not do, therefore, the Son says that he desires his own death. For he preferred to suffer, rather than that the human race should be lost; as if he were to say to the Father: "Since thou dost not desire the reconciliation of the world to take place in any other way, in this respect, I see that thou desirest my death ; let thy will, therefore, be done, that is, let my death take place, so that the world may be reconciled to thee." For we often say that one desires a thing, because he does not

choose something else, the choice of which would preclude the existence of that which he is said to desire; for instance, when we say that he who does not choose to close the window through which the draft is admitted which puts out the light, wishes the light to be extinguished. So the Father desired the death of the Son, because he was not willing that the world should be saved in any other way, except by man's doing so great a thing as that which I have mentioned. And this, since none other could accomplish it, availed as much with the Son, who so earnestly desired the salvation of man, as if the Father had commanded him to die; and, therefore, "as the Father gave him commandment, so he did, and the cup which the Father gave to him he drank, being obedient even unto death."

CHAPTER X.

Likewise on the same topics; and how otherwise they can be correctly explained.

It is also a fair interpretation that it was by that same holy will by which the son wished to die for the salvation of the world, that the Father gave him commandment (yet not by compulsion), and the cup of suffering, and spared him not, but gave him up for us and desired his death; and that the Son himself was obedient even unto death, and learned obedience from the things which he suffered. For as with regard to that will which led him to a holy life, he did not have it as a human being of himself, but of the Father; so also that will by which he desired to die for the accomplishment of so great good, he could not have had but from the Father of lights, from

ANSELM.

whom is every good and perfect gift. And as the Father is said to draw by imparting an inclination, so there is nothing improper in asserting that he moves man. For as the Son says of the Father: "No man cometh to me except the Father draw him," he might as well have said, except he move him. In like manner, also, could he have declared : "No man layeth down his life for my sake, except the Father move or draw him." For since a man is drawn or moved by his will to that which he invariably chooses, it is not improper to say that God draws or moves him when he gives him this will. And in this drawing or impelling it is not to be understood that there is any constraint, but a free and grateful clinging to the holy will which has been given. If then it cannot be denied that the Father drew or moved the Son to death by giving him that will; who does not see that, in the same manner, he gave him commandment to endure death of his own accord and to take the cup, which he freely drank. And if it is right to say that the Son spared not himself, but gave himself for us of his own will, who will deny that it is right to say that the Father, of whom he had this will, did not spare him but gave him up for us, and desired his death? In this way, also, by following the will received from the Father invariably, and of his own accord, the Son became obedient to Him, even unto death ; and learned obedience from the things which he suffered ; that is. he learned how great was the work to be accomplished by obedience. For this is real and sincere obedience when a rational being, not of compulsion, but freely, follows the will received from God. In other ways, also, we can properly explain the Father's desire that the Son should die, though these would appear sufficient. For as we say that he desires a thing who causes another to desire it; so, also, we say that he desires a thing who approves of the desire of another. though he does not cause that desire. Thus when we see a man who desires to endure pain with fortitude for the accomplishment of some good design; though we acknowledge that we wish to have him endure that pain, yet we do not choose, nor take pleasure in, his suffering, but in his choice. We are, also, accustomed to say that he who can prevent a thing but does not, desires the thing which he does not prevent. Since, therefore, the will of the Son pleased the Father, and he did not prevent him from choosing, or from fulfilling his choice, it is proper to say that he wished the Son to endure death so piously and for so great an object, though he was not pleased with his suffering. Moreover, he said that the cup must not pass from him, except he drank it, not because he could not have escaped death had he chosen to: but because, as has been said, the world could not otherwise be saved ; and it was his fixed choice to suffer death, rather than that the world should not be saved. It was for this reason, also, that he used those words, viz., to teach the human race that there was no other salvation for them but by his death; and not to show that he had no power at all to avoid death. For whatsoever things are said of him, similar to these which have been mentioned, they are all to be explained in accordance with the belief that he died, not by compulsion, but of free choice. For he was omnipotent, and it is said of him, when he was offered up, that he desired it. And he says himself: "I lay down my life that I may take it again; no man taketh it from me, but I lay it down of myself; I have power

to lay it down, and I have power to take it again." A man cannot, therefore, be properly said to have been driven to a thing which he does of his own power and will.

Boso. But this simple fact, that God allows him to be so treated, even if he were willing, does not seem becoming for such a Father in respect to such a Son.

Anselm. Yes, it is of all things most proper that such a Father should acquiesce with such a Son in his desire, if it be praiseworthy as relates to the honor of God, and useful for man's salvation, which would not otherwise be effected.

Boso. The question which still troubles us is, how the death of the Son can be proved reasonable and necessary. For otherwise, it does not seem that the Son ought to desire it, or the Father compel or permit it. For the question is, why God could not save man in some other way, and if so, why he wished to do it in this way? For it both seems unbecoming for God to have saved man in this way; and it is not clear how the death of the Son avails for the salvation of man. For it is a strange thing if God so delights in, or requires, the blood of the innocent, that he neither chooses, nor is able, to spare the guilty without the sacrifice of the innocent.

Anselm. Since, in this inquiry, you take the place of those who are unwilling to believe anything not previously proved by reason, I wish to have it understood between us that we do not admit anything in the least unbecoming to be ascribed to the Deity, and that we do not reject the *smallest* reason if it be not opposed by a greater. For as it is impossible to attribute anything in the least unbecoming to God; so any reason, however small, if not overbalanced by a greater, has the force of necessity.

Boso. In this matter, I accept nothing more willingly than that this agreement should be preserved between us in common.

Anselm. The question concerns only the incarnation of God, and those things which we believe with regard to his taking human nature.

Boso. It is so.

Anselm. Let us suppose, then, that the incarnation of God, and the things that we affirm of him as man, had never taken place; and be it agreed between us that man was made for happiness, which cannot be attained in this life, and that no being can ever arrive at happiness, save by freedom from sin, and that no man passes this life without sin. Let us take for granted, also, the other things, the belief of which is necessary for eternal salvation.

Boso. I grant it; for in these there is nothing which seems unbecoming or impossible for God.

Anselm. Therefore, in order that man may attain happiness, remission of sin is necessary.

Boso. We all hold this.

CHAPTER XI.

What it is to sin, and to make satisfaction for sin.

Anselm. We must needs inquire, therefore, in what manner God puts away men's sins; and, in order to do this more plainly, let us first consider what it is to sin, and what it is to make satisfaction for sin.

Boso. It is yours to explain and mine to listen.

Anselm. If man or angel always rendered to God his due, he would never sin. Boso. I cannot deny that.

Anselm. Therefore to sin is nothing else than not to render to God his due.

Boso. What is the debt which we owe to God?

Anselm. Every wish of a rational creature should be subject to the will of God.

Boso. Nothing is more true.

Anselm. This is the debt which man and angel owe to God, and no one who pays this debt commits sin; but every one who does not pay it sins. This is justice, or uprightness of will, which makes a being just. or upright in heart, that is, in will; and this is the sole and complete debt of honor which we owe to God, and which God requires of us. For it is such a. will only, when it can be exercised, that does works. pleasing to God: and when this will cannot be exercised, it is pleasing of itself alone, since without it no work is acceptable. He who does not render this honor which is due to God. robs God of his own and dishonors him; and this is sin. Moreover, so long as he does not restore what he has taken away, he remains in fault; and it will not suffice merely to restore what has been taken away, but, considering the contempt offered, he ought to restore more than he took away. For as one who imperils another's safety does not enough by merely restoring his safety, without making some compensation for the anguish incurred : so he who violates another's honor does not: enough by merely rendering honor again, but must, according to the extent of the injury done, make restoration in some way satisfactory to the person whom. he has dishonored. We must also observe that when any one pays what he has unjustly taken away, he ought to give something which could not have been.

CUR DEUS HOMO.

demanded of him, had he not stolen what belonged to another. So then, every one who sins ought to pay back the honor of which he has robbed God; and this is the satisfaction which every sinner owes to God.

Boso. Since we have determined to follow reason in all these things, I am unable to bring any objection against them, although you somewhat startle me.

CHAPTER XII.

Whether it were proper for God to put away sins by compassion alone, without any payment of debt.

Anselm. Let us return and consider whether it were proper for God to put away sins by compassion alone, without any payment of the honor taken from him.

Boso. I do not see why it is not proper.

Anselm. To remit sin in this manner is nothing else than not to punish; and since it is not right to cancel sin without compensation or punishment; if it be not punished, then is it passed by undischarged.

Boso. What you say is reasonable.

Anselm. It is not fitting for God to pass over anything in his kingdom undischarged.

Boso. If I wish to oppose this, I fear to sin.

Anselm. It is, therefore, not proper for God thus to pass over sin unpunished.

Boso. Thus it follows.

Anselm. There is also another thing which follows if sin be passed by unpunished, viz., that with God there will be no difference between the guilty and the not guilty; and this is unbecoming to God.

Boso. I cannot deny it.

Anselm. Observe this also. Every one knows that justice to man is regulated by law, so that, according to the requirements of law, the measure of award is bestowed by God.

Boso. This is our belief.

Anselm. But if sin is neither paid for nor punished, it is subject to no law.

Boso. I cannot conceive it to be otherwise.

Anselm. Injustice, therefore, if it is cancelled by compassion alone, is more free than justice, which seems very inconsistent. And to these is also added a further incongruity, viz., that it makes injustice like God. For as God is subject to no law, so neither is injustice.

Boso. I cannot withstand your reasoning. But when God commands us in every case to forgive those who trespass against us, it seems inconsistent to enjoin a thing upon us which it is not proper for him to do himself.

Anselm. There is no inconsistency in God's commanding us not to take upon ourselves what belongs to Him alone. For to execute vengeance belongs to none but Him who is Lord of all; for when the powers of the world rightly accomplish this end, God himself does it who appointed them for the purpose.

Boso. You have obviated the difficulty which I thought to exist; but there is another to which I would like to have your answer. For since God is so free as to be subject to no law, and to the judgment of no one, and is so merciful as that nothing more merciful can be conceived; and nothing is right or fit save as he wills; it seems a strange thing for us to say that he is wholly unwilling or unable to put away an injury done to himself, when we are wont to apply to him for indulgence with regard to those offences which we commit against others.

Anselm. What you say of God's liberty and choice and compassion is true; but we ought so to interpret these things as that they may not seem to interfere with His dignity. For there is no liberty except as regards what is best or fitting; nor should that be called mercy which does anything improper for the Divine character. Moreover, when it is said that what God wishes is just, and that what He does not wish is unjust, we must not understand that if God wished anything improper it would be just, simply because he wished it. For if God wishes to lie, we must not conclude that it is right to lie, but rather that he is not God. For no will can ever wish to lie, unless truth in it is impaired, nay, unless the will itself be impaired by forsaking truth. When, then, it is said: "If God wishes to lie," the meaning is simply this: "If the nature of God is such as that he wishes to lie:" and, therefore, it does not follow that falsehood is right, except it be understood in the same manner as when we speak of two impossible things: "If this be true, then that follows; because neither this nor that is true;" as if a man should say: "Supposing water to be dry, and fire to be moist;" for neither is the case. Therefore, with regard to these things, to speak the whole truth: If God desires a thing, it is right that he should desire that which involves no unfitness. For if God chooses that it should rain, it is right that it should rain; and if he desires that any man should die, then is it right that he should die. Wherefore, if it be not fitting for God to do anything unjustly, or out of course, it does not belong to his liberty or compassion or will to let the sinner go un-

ANSELM.

punished, who makes no return to God of what the sinner has defrauded him.

Boso. You remove from me every possible objection which I had thought of bringing against you.

Anselm. Yet observe why it is not fitting for God to do this.

Boso. I listen readily to whatever you say.

CHAPTER XIII.

How nothing less was to be endured, in the order of things, than that the creature should take away the honor due the Creator and not restore what he takes away.

Anselm. In the order of things, there is nothing less to be endured than that the creature should take away the honor due the Creator, and not restore what he has taken away.

Boso. Nothing is more plain than this.

Anselm. But there is no greater injustice suffered than that by which so great an evil must be endured.

Boso. This, also, is plain.

Anselm. I think, therefore, that you will not say that God ought to endure a thing than which no greater injustice is suffered, viz., that the creature should not restore to God what he has taken away.

Boso. No; I think it should be wholly denied.

Anselm. Again, if there is nothing greater or better than God, there is nothing more just than supreme justice, which maintains God's honor in the arrangement of things, and which is nothing else but God himself.

Boso. There is nothing clearer than this.

Anselm. Therefore God maintains nothing with more justice than the honor of his own dignity.

206

Boso. I must agree with you.

Anselm. Does it seem to you that he wholly preserves it, if he allows himself to be so defrauded of it as that he should neither receive satisfaction nor punish the one defrauding him.

Boso. I dare not say so.

Anselm. Therefore the honor taken away must be repaid, or punishment must follow; otherwise, either God will not be just to himself, or he will be weak in respect to both parties; and this it is impious even to think of.

Boso. I think that nothing more reasonable can be said.

CHAPTER XIV.

How the honor of God exists in the punishment of the wicked.

Boso. But I wish to hear from you whether the punishment of the sinner is an honor to God, or how it is an honor. For if the punishment of the sinner is not for God's honor when the sinner does not pay what he took away, but is punished, God loses his honor so that he cannot recover it. And this seems in contradiction to the things which have been said.

Anselm. It is impossible for God to lose his honor; for either the sinner pays his debt of his own accord, or, if he refuse, God takes it from him. For either man renders due submission to God of his own will, by avoiding sin or making payment, or else God subjects him to himself by torments, even against man's will, and thus shows that he is the Lord of man, though man refuses to acknowledge it of his own accord. And here we must observe that as man in sinning takes away what belongs to God, so God in punishing gets in return what pertains to man. For not

ANSELM.

only does that belong to a man which he has in present possession, but also that which it is in his power to have. Therefore, since man was so made as to be able to attain happiness by avoiding sin; if, on account of his sin, he is deprived of happiness and every good, he repays from his own inheritance what he has stolen, though he repay it against his will. For although God does not apply what he takes away to any object of his own, as man transfers the money which he has taken from another to his own use; yet what he takes away serves the purpose of his own honor, for this very reason, that it is taken away. For by this act he shows that the sinner and all that pertains to him are under his subjection.

CHAPTER XV.

Whether God suffers his honor to be violated even in the least degree.

Boso. What you say satisfies me. But there is still another point which I should like to have you answer. For if, as you make out, God ought to sustain his own honor, why does he allow it to be violated even in the least degree? For what is in any way made liable to injury is not entirely and perfectly preserved.

Anselm. Nothing can be added to or taken from the honor of God. For this honor which belongs to him is in no way subject to injury or change. But as the individual creature preserves, naturally or by reason, the condition belonging, and, as it were, allotted to him, he is said to obey and honor God; and to this, rational nature, which possesses intelligence, is especially bound. And when the being chooses what he ought, he honors God; not by bestowing anything upon him, but because he brings himself freely under God's will and disposal, and maintains his own condition in the universe, and the beauty of the universe itself, as far as in him lies. But when he does not choose what he ought, he dishonors God, as far as the being himself is concerned. because he does not submit himself freely to God's disposal. And he disturbs the order and beauty of the universe, as relates to himself, although he cannot injure nor tarnish the power and majesty of God. For if those things which are held together in the circuit of the heavens desire to be elsewhere than under the heavens, or to be further removed from the heavens, there is no place where they can be but under the heavens, nor can they fly from the heavens without also approaching them. For both whence and whither and in what way they go, they are still under the heavens; and if they are at a greater distance from one part of them, they are only so much nearer to the opposite part. And so, though man or evil angel refuse to submit to the Divine will and appointment, yet he cannot escape it; for if he wishes to fly from a will that commands, he falls into the power of a will that punishes. And if you ask whither he goes, it is only under the permission of that will; and even this wayward choice or action of his becomes subservient, under infinite wisdom, to the order and beauty of the universe before spoken of. For when it is understood that God brings good out of many forms of evil, then the satisfaction for sin freely given, or if this be not given, the exaction of punishment, hold their own place and orderly beauty in the same universe. For if Divine wisdom were not to insist upon these things, when wickedness tries to disturb the right appointment, there would be, in the very universe which God ought to control, an unseemliness springing from the violation of the beauty of arrangement, and God would appear to be deficient in his management. And these two things are not only unfitting, but consequently impossible; so that satisfaction or punishment must needs follow every sin.

Boso. You have relieved my objection.

Anselm. It is then plain that no one can honor or dishonor God, as he is in himself; but the creature, as far as he is concerned, appears to do this when he submits or opposes his will to the will of God.

Boso. I know of nothing which can be said against this.

Anselm. Let me add something to it.

Boso. Go on, until I am weary of listening.

CHAPTER XVI.

The reason why the number of angels who fell must be made up from men.

Anselm. It was proper that God should design to make up for the number of angels that fell, from human nature which he created without sin.

Boso. This is a part of our belief, but still I should like to have some reason for it.

Anselm. You mistake me, for we intended to discuss only the incarnation of the Deity, and here you are bringing in other questions.

Boso. Be not angry with me; "for the Lord loveth a cheerful giver;" and no one shows better how cheerfully he gives what he promises, than he who gives more than he promises; therefore, tell me freely what I ask.

Anselm. There is no question that intelligent na-

ture, which finds its happiness, both now and forever, in the contemplation of God, was foreseen by him in a certain reasonable and complete number, so that there would be an unfitness in its being either less or greater. For either God did not know in what number it was best to create rational beings, which is false; or, if he did know, then he appointed such a number as he perceived was most fitting. Wherefore, either the angels who fell were made so as to be within that number; or, since they were out of that number, they could not continue to exist, and so fell of necessity. But this last is an absurd idea.

Boso. The truth which you set forth is plain.

Anselm. Therefore, since they ought to be of that number, either their number should of necessity be made up, or else rational nature, which was foreseen as perfect in number, will remain incomplete. But this cannot be.

Boso. Doubtless, then, the number must be restored.

Anselm. But this restoration can only be made from human beings, since there is no other source.

CHAPTER XVII.

How other angels cannot take the place of those who fell.

Boso. Why could not they themselves be restored, or other angels substituted for them?

Anselm. When you shall see the difficulty of our restoration, you will understand the impossibility of theirs. But other angels cannot be substituted for them on this account (to pass over its apparent inconsistency with the completeness of the first creation), because they ought to be such as the former angels would have been, had they never sinned. But the first angels in that case would have persevered without ever witnessing the punishment of sin ; which, in respect to the others who were substituted for them after their fall, was impossible. For two beings who stand firm in truth are not equally deserving of praise. if one has never seen the punishment of sin, and the other forever witnesses its eternal reward. For it must not for a moment be supposed that good angels are upheld by the fall of evil angels, but by their own virtue. For, as they would have been condemned together, had the good sinned with the bad, so, had the unholy stood firm with the holy, they would have been likewise upheld. For, if, without the fall of a part, the rest could not be upheld, it would follow, either that none could ever be upheld, or else that it was necessary for some one to fall, in order by his punishment to uphold the rest; but either of these suppositions is absurd. Therefore, had all stood, all would have been upheld in the same manner as those who. stood; and this manner I explained, as well as I could, when treating of the reason why God did not bestow perseverance upon the devil.

Boso. You have proved that the evil angels must be restored from the human race; and from this reasoning it appears that the number of men chosen will not be less than that of fallen angels. But show, if you can, whether it will be greater.

CHAPTER XVIII.

Whether there will be more holy men than evil angels.

Anselm. If the angels, before any of them fell, existed in that perfect number of which we have spoken, then men were only made to supply the place of the lost angels; and it is plain that their number will not be greater. But if that number were not found in all the angels together, then both the loss and the original deficiency must be made up from men, and more men will be chosen than there were fallen angels. And so we shall say that men were made not only to restore the diminished number, but also to complete the imperfect number.

Boso. Which is the better theory, that angels were originally made perfect in number or that they were not?

Anselm. I will state my views.

Boso. I cannot ask more of you.

Anselm. If man was created after the fall of evil angels, as some understand the account in Genesis, I do not think that I can prove from this either of these suppositions positively. For it is possible, I think, that the angels should have been created perfect in number, and that afterwards man was created to complete theirn umber when it had been lessened; and it is also possible that they were not perfect in number, because God deferred completing the number, as he does even now, determining in his own time to create man. Wherefore, either God would only complete that which was not yet perfect, or, if it were also diminished, He would restore it. But if the whole creation took place at once, and those days in which Moses appears to describe a successive creation are not to be understood like such days as ours, I cannot see how angels could have been created perfect in number. Since, if it were so, it seems to me that some, either men or angels, would fall immediately, else in heaven's empire there would be more than the

ANSELM.

complete number required. If, therefore, all mings. were created at one and the same time, it should seem that angels, and the first two human beings. formed an incomplete number, so that, if no angel fell, the deficiency alone should be made up, but if any fell, the lost part should be restored; and that human nature, which had stood firm, though weaker than that of angels, might, as it were, justify God, and put the devil to silence, if he were to attribute his fall to weakness. And in case human nature fell, much more would it justify God against the devil, and even against. itself, because, though made far weaker and of a mortal race, yet, in the elect, it would rise from its weakness to an estate exalted above that from which the devil was fallen, as far as good angels, to whom it should be equal, were advanced after the overthrow of the evil, because they persevered. From these reasons. I am rather inclined to the belief that there was not, originally, that complete number of angels necessary to perfect the celestial state; since, supposing that man and angels were not created at the same time, this is possible; and it would follow of necessity, if they were created at the same time, which is the opinion of the majority, because we read : "He, who liveth forever, created all things at once." But if the perfection of the created universe is to be understood as consisting, not so much in the number of beings, as in the number of natures; it follows that human nature was either made to consummate this. perfection, or that it was superfluous, which we should. not dare affirm of the nature of the smallest reptile. Wherefore, then, it was made for itself, and not merely to restore the number of beings possessing another nature. From which it is plain that, even had noangel fallen, men would yet have had their place in the celestial kingdom. And hence it follows that there was not a perfect number of angels, even before a part fell; otherwise, of necessity some men or angels must fall, because it would be impossible that any should continue beyond the perfect number.

Boso. You have not labored in vain.

Anselm. There is, also, as I think, another reason which supports, in no small degree, the opinion that angels were not created perfect in number.

Boso. Let us hear it.

Anselm. Had a perfect number of angels been created, and had man been made only to fill the place of the lost angels, it is plain that, had not some angels fallen from their happiness, man would never have been exalted to it.

Boso. We are agreed.

Anselm. But if any one shall ask: "Since the elect rejoice as much over the fall of angels as over their own exaltation, because the one can never take place without the other; how can they be justified in this unholy joy, or how shall we say that angels are restored by the substitution of men, if they (the angels) would have remained free from this fault, had they not fallen, viz., from rejoicing over the fall of others?" We reply: Cannot men be made free from this fault? nay, how ought they to be happy with this fault? With what temerity, then, do we say that God neither wishes nor is able to make this substitution without this fault !

Boso. Is not the case similar to that of the Gentiles who were called unto faith, because the Jews rejected it?

Anselm. No; for had the Jews all believed, yet the

Gentiles would have been called; for "in every nation he that feareth God and worketh righteousness is accepted of him." But since the Jews despised the apostles, this was the immediate occasion of their turning to the Gentiles.

Boso. I see no way of opposing you.

Anselm. Whence does that joy which one has over another's fall seem to arise?

Boso. Whence, to be sure, but from the fact that each individual will be certain that, had not another fallen, he would never have attained the place where he now is?

Anselm. If, then, no one had this certainty, there would be no cause for one to rejoice over the doom of another.

Boso. So it appears.

Anselm. Think you that any one of them can have this certainty, if their number shall far exceed that of those who fell?

Boso. I certainly cannot think that any one would or ought to have it. For how can any one know whether he were created to restore the part diminished, or to make up that which was not yet complete in the number necessary to constitute the state? But all are sure that they were made with a view to the perfection of that kingdom.

Anselm. If, then, there shall be a larger number than that of the fallen angels, no one can or ought to know that he would not have attained this height but for another's fall.

Boso. That is true.

Anselm. No one, therefore, will have cause to rejoice over the perdition of another.

Boso. So it appears.

216

Anselm. Since, then, we see that if there are more men elected than the number of fallen angels, the incongruity will not follow which must follow if there are not more men elected; and since it is impossible that there should be anything incongruous in that celestial state, it becomes a necessary fact that angels were not made perfect in number, and that there will be more happy men than doomed angels.

Boso. I see not how this can be denied.

Anselm. I think that another reason can be brought to support this opinion.

Boso. You ought then to present it.

Anselm. We believe that the material substance of the world must be renewed, and that this will not take place until the number of the elect is accomplished, and that happy kingdom made perfect, and that after its completion there will be no change. Whence it may be reasoned that God planned to perfect both at the same time, in order that the inferior nature, which knew not God, might not be perfected before the superior nature which ought to enjoy God; and that the inferior, being renewed at the same time with the superior, might, as it were, rejoice in its own way: yes, that every creature having so glorious and excellent a consummation, might delight in its Creator and in itself, in turn, rejoicing always after its own manner, so that what the will effects in the rational nature of its own accord, this also the irrational creature naturally shows by the arrangement of God. For we are wont to rejoice in the fame of our ancestors. as when on the birthdays of the saints we delight with festive triumph, rejoicing in their honor. And this opinion derives support from the fact that, had not Adam sinned. God might vet put off the completion of that state until the number of men which he designed should be made out, and men themselves be transferred, so to speak, to an immortal state of bodily existence. For they had in paradise a kind of immortality, that is, a power not to die, but since it was possible for them to die, this power was not immortal, as if, indeed, they had not been capable of death. But if God determined to bring to perfection, at one and the same time, that intelligent and happy state and this earthly and irrational nature; it follows that either that state was not complete in the number of angels before the destruction of the wicked, but God was waiting to complete it by men, when he should renovate the material nature of the world; or that, if that kingdom were perfect in number, it was not in confirmation, and its confirmation must be deferred. even had no one sinned, until that renewal of the world to which we look forward; or that, if that confirmation could not be deferred so long, the renewal of the world must be hastened that both events might take place at the same time. But that God should determine to renew the world immediately after it was made, and to destroy in the very beginning those things which after this renewal would not exist, before any reason appeared for their creation, is simply absurd. It therefore follows that, since angels were not complete in number, their confirmation will not be long deferred on this account, because the renewal of a world just created ought soon to take place, for this is not fitting. But that God should wish to put off their confirmation to the future renewing of the world seems improper, since he so quickly accomplished it in some, and since we know that in regard to our first parents, if they had not sinned as they did,

he would have confirmed them, as well as the angels who persevered. For, although not yet advanced to that equality with angels to which men were to attain, when the number taken from among them was complete; yet, had they preserved their original holiness. so as not to have sinned though tempted, they would have been confirmed, with all their offspring, so as never more to sin; just as when they were conquered by sin, they were so weakened as to be unable, in themselves, to live afterwards without sinning. For who dares affirm that wickedness is more powerful to bind a man in servitude, after he has yielded to it at the first persuasion, than holiness to confirm him in liberty when he has adhered to it in the original trial? For as human nature, being included in the person of our first parents, was in them wholly won over to sin (with the single exception of that man whom God being able to create from a virgin was equally able to save from the sin of Adam), so had they not sinned, human nature would have wholly conquered. It therefore remains that the celestial state was not complete in its original number, but must be completed from among men.

Boso. What you say seems very reasonable to me. But what shall we think of that which is said respecting God: "He hath appointed the bounds of the people according to the number of the children of Israel;" which some, because for the expression "children of Israel" is found sometimes "angels of God," explain in this way, that the number of elect men taken should be understood as equal to that of good angels?

Anselm. This is not discordant with the previous opinion, if it be not certain that the number of angels who fell is the same as that of those who stood. For

ANSELM.

if there be more elect than evil angels, and elect men must needs be substituted for the evil angels, and it is possible for them to equal the number of the good angels, in that case there will be more holy men than evil angels. But remember with what condition I undertook to answer your inquiry, viz., that if I say anything not upheld by greater authority, though I appear to demonstrate it, yet it should be received with no further certainty than as my opinion for the present, until God makes some clearer revelation to me. For I am sure that, if I say anything which plainly opposes the Holy Scriptures, it is false; and if I am aware of it. I will no longer hold it. But if, with regard to subjects in which opposite opinions may be held without hazard, as that, for instance, which we now discuss: for if we know not whether there are to be more men elected than the number of the lost angels, and incline to either of these opinions rather than the other, I think the soul is not in danger; if, I say, in questions like this, we explain the Divine words so as to make them favor different sides, and there is nowhere found anything to decide, beyond doubt, the opinion that should be held. I think there is no censure to be given. As to the passage which you spoke of: "He hath determined the bounds of the people (or tribes) according to the number of the angels of God;" or as another translation has it: "according to the number of the children of Israel;" since both translations either mean the same thing, or are different, without contradicting each other, we may understand that good angels only are intended by both expressions, "angels of God," and "children of Israel," or that elect men only are meant, or that both angels and elect men are included, even the

whole celestial kingdom. Or by angels of God may be understood holy angels only, and by children of Israel, holy men only; or, by children of Israel, angels only, and by angels of God, holy men. If good angels are intended in both expressions, it is the same as if only "angels of God" had been used; but if the whole heavenly kingdom were included, the meaning is, that a people, that is, the throng of elect men, is to be taken, or that there will be a people in this stage of existence, until the appointed number of that kingdom, not vet completed, shall be made up from among men. But I do not now see why angels only, or even angels and holy men together, are meant by the expression "children of Israel"; for it is not improper to call holy men "children of Israel," as they are called "sons of Abraham." And they can also properly be called "angels of God," because they imitate the life of angels, and they are promised in heaven a likeness to and equality with angels, and all who live holy lives are angels of God. Therefore the confessors or martyrs are so called; for he who declares and bears witness to the truth, he is a messenger of God, that is, his angel. And if a wicked man is called a devil, as our Lord says of Judas, because they are alike in malice: why should not a good man be called an angel, because he follows holiness? Wherefore I think we may say that God hath appointed the bounds of the people according to the number of elect men, because men will exist and there will be a natural increase among them, until the number of elect men is accomplished; and when that occurs, the birth of men, which takes place in this life, will cease. But if by "angels of God" we only understand holy angels, and by "children of Israel" only holy men; it may

ANSELM.

be explained in two ways: that "God hath appointed the bounds of the people according to the number of the angels of God," viz., either that so great a people, that is, so many men, will be taken as there are holy angels of God, or that a people will continue to exist upon earth, until the number of angels is completed from among men. And I think there is no other possible method of explanation: "he hath appointed the bounds of the people according to the number of the children of Israel," that is, that there will continue to be a people in this stage of existence, as I said above, until the number of holy men is completed. And we infer from either translation that as many men will be taken as there were angels who remained steadfast. Yet, although lost angels must have their ranks filled by men, it does not follow that the number of lost angels was equal to that of those who persevered. But if any one affirms this, he will have to find means of invalidating the reasons given above, which prove, I think, that there was not among angels, before the fall, that perfect number before mentioned, and that there are more men to be saved than the number of evil angels.

Boso. I by no means regret that I urged you to these remarks about the angels, for it has not been for nought. Now let us return from our digression.

CHAPTER XIX.

How man cannot be saved without satisfaction for sin.

Anselm. It was fitting for God to fill the places of the fallen angels from among men.

Boso. That is certain.

Anselm. Therefore there ought to be in the heav-

enly empire as many men taken as substitutes for the angels as would correspond with the number whose place they shall take, that is, as many as there are good angels now; otherwise they who fell will not be restored, and it will follow that God either could not accomplish the good which he begun, or he will repent of having undertaken it; either of which is absurd.

Boso. Truly it is fitting that men should be equal with good angels.

Anselm. Have good angels ever sinned? Boso. No.

Anselm. Can you think that man, who has sinned, and never made satisfaction to God for his sin, but only been suffered to go unpunished, may become the equal of an angel who has never sinned?

Boso. These words I can both think of and utter, but can no more perceive their meaning than I can make truth out of falsehood.

Anselm. Therefore it is not fitting that God should take sinful man without an atonement, in substitution for lost angels; for truth will not suffer man thus to be raised to an equality with holy beings.

Boso. Reason shows this.

Anselm. Consider, also, leaving out the question of equality with the angels, whether God ought, under such circumstances, to raise man to the same or a similar kind of happiness as that which he had before he sinned.

Boso. Tell your opinion, and I will attend to it as well as I can.

Anselm. Suppose a rich man possessed a choice pearl which had never been defiled, and which could not be taken from his hands without his permission; and that he determined to commit it to the treasury of his dearest and most valuable possessions.

Boso. I accept your supposition.

Anselm. What if he should allow it to be struck from his hand and cast in the mire, though he might have prevented it; and afterwards taking it all soiled by the mire and unwashed, should commit it again to his beautiful and loved casket; will you consider him a wise man?

Boso. How can I? for would it not be far better to keep and preserve his pearl pure, than to have it polluted?

Anselm. Would not God be acting like this, who held man in paradise, as it were in his own hand, without sin, and destined to the society of angels, and allowed the devil, inflamed with envy, to cast him into the mire of sin, though truly with man's consent? For, had God chosen to restrain the devil, the devil could not have tempted man. Now I say, would not God be acting like this, should he restore man, stained with the defilement of sin, unwashed, that is, without any satisfaction, and always to remain so; should He restore him at once to paradise, from which he had been thrust out?

Boso. I dare not deny the aptness of your comparison, were God to do this, and therefore do not admit that he can do this. For it should seem either that he could not accomplish what he designed, or else that he repented of his good intent, neither of which things is possible with God.

Anselm. Therefore, consider it settled that, without satisfaction, that is, without voluntary payment of the debt, God can neither pass by the sin unpunished, nor can the sinner attain that happiness, or happiness

224

like that, which he had before he sinned; for man cannot in this way be restored, or become such as he was before he sinned.

Boso. I am wholly unable to refute your reasoning. But what say you to this: that we pray God, "put away our sins from us," and every nation prays the God of its faith to put away its sins. For, if we pay our debt, why do we pray God to put it away? Is not God unjust to demand what has already been paid? But if we do not make payment, why do we supplicate in vain that he will do what he cannot do, because it is unbecoming?

Anselm. He who does not pay says in vain: "Pardon"; but he who pays makes supplication, because prayer is properly connected with the payment; for God owes no man anything, but every creature owes God; and, therefore, it does not become man to treat with God as with an equal. But of this it is not now needful for me to answer you. For when you think why Christ died, I think you will see yourself the answer to your question.

Boso. Your reply with regard to this matter suffices me for the present. And, moreover, you have so clearly shown that no man can attain happiness in sin, or be freed from sin without satisfaction for the trespass, that, even were I so disposed, I could not doubt it.

CHAPTER XX.

That satisfaction ought to be proportionate to guilt; and that man is of himself unable to accomplish this

Anselm. Neither, I think, will you doubt this, that satisfaction should be proportionate to guilt.

Boso. Otherwise sin would remain in a manner ex-

empt from control (*inordinatum*), which cannot be, for God leaves nothing uncontrolled in his kingdom. But this is determined, that even the smallest unfitness is impossible with God.

Anselm. Tell me, then, what payment you make God for your sin?

Boso. Repentance, a broken and contrite heart, self-denial, various bodily sufferings, pity in giving and forgiving, and obedience.

Anselm. What do you give to God in all these?

Boso. Do I not honor God, when, for his love and fear, in heartfelt contrition I give up worldly joy, and despise, amid abstinence and toils, the delights and ease of this life, and submit obediently to him, freely bestowing my possessions in giving to and releasing others?

Anselm. When you render anything to God which you owe him, irrespective of your past sin, you should not reckon this as the debt which you owe for sin. But you owe God every one of those things which you have mentioned. For, in this mortal state, there should be such love and such desire of attaining the true end of your being, which is the meaning of prayer, and such grief that you have not yet reached this object, and such fear lest you fail of it, that you should find joy in nothing which does not help you or give encouragement of your success. For you do not deserve to have a thing which you do not love and desire for its own sake, and the want of which at present, together with the great danger of never getting it, causes you no grief. This also requires one to avoid ease and worldly pleasures such as seduce the mind from real rest and pleasure, except so far as you think suffices for the accomplishment of that object.

But you ought to view the gifts which you bestow as a part of your debt, since you know that what you give comes not from yourself, but from him whose servant both you are and he also to whom you give. And nature herself teaches you to do to your fellow servant, man to man, as you would be done by; and that he who will not bestow what he has ought not to receive what he has not. Of forgiveness, indeed, I speak briefly, for, as we said above, vengeance in no sense belongs to you, since you are not your own, nor is he who injures you yours or his, but you are both the servants of one Lord, made by him out of nothing. And if you avenge yourself upon your fellow servant, you proudly assume judgment over him when it is the peculiar right of God, the judge of all. But what do you give to God by your obedience, which is not owed him already, since he demands from you all that you are and have and can become?

Boso. Truly I dare not say that in all these things I pay any portion of my debt to God.

Anselm. How then do you pay God for your transgression?

Boso. If in justice I owe God myself and all my powers, even when I do not sin, I have nothing left to render to him for my sin.

Anselm. What will become of you then? How will you be saved?

Boso. Merely looking at your arguments, I see no way of escape. But, turning to my belief, I hope through Christian faith, "which works by love," that I may be saved, and the more, since we read that if the sinner turns from his iniquity and does what is right, all his transgressions shall be forgotten.

Anselm. This is only said of those who either

ANSELM.

looked for Christ before his coming, or who believe in him since he has appeared. But we set aside Christ and his religion as if they did not exist, when we proposed to inquire whether his coming were necessary to man's salvation.

Boso. We did so.

Anselm. Let us then proceed by reason simply.

Boso. Though you bring me into straits, yet I very much wish you to proceed as you have begun.

CHAPTER XXI.

How great a burden sin is.

Anselm. Suppose that you did not owe any of those things which you have brought up as possible payment for your sin, let us inquire whether they can satisfy for a sin so small as one *look* contrary to the will of God.

Boso. Did I not hear you question the thing, I should suppose that a single repentant feeling on my part would blot out this sin.

Anselm. You have not as yet estimated the great burden of sin.

Boso. Show it me then.

Anselm. If you should find yourself in the sight of God, and one said to you: "Look thither;" and God, on the other hand, should say: "It is not my will that you should look;" ask your own heart what there is in all existing things which would make it right for you to give that *look* contrary to the will of God.

Boso. I can find no motive which would make it right; unless, indeed I am so situated as to make it necessary for me either to do this, or some greater sin.

Anselm. Put away all such necessity, and ask with

regard to this sin only whether you can do it even for your own salvation.

Boso. I see plainly that I cannot.

Anselm. Not to detain you too long; what if it were necessary either that the whole universe, except God himself, should perish and fall back into nothing, or else that you should do so small a thing against the will of God?

Boso. When I consider the action itself, it appears very slight; but when I view it as contrary to the will of God, I know of nothing so grievous, and of no loss that will compare with it; but sometimes we oppose another's will without blame in order to preserve his property, so that afterwards he is glad that we opposed him.

Anselm. This is in the case of man, who often does not know what is useful for him, or cannot make up his loss; but God is in want of nothing, and, should all things perish, can restore them as easily as he created them.

Boso. I must confess that I ought not to oppose the will of God even to preserve the whole creation.

Anselm. What if there were more worlds as full of beings as this?

Boso. Were they increased to an infinite extent, and held before me in like manner, my reply would be the same.

Anselm. You cannot answer more correctly, but consider, also, should it happen that you gave the look contrary to God's will, what payment you can make for this sin?

Boso. I can only repeat what I said before.

Anselm. So heinous is our sin whenever we knowingly oppose the will of God even in the slightest: thing; since we are always in his sight, and he always enjoins it upon us not to sin.

Boso. I cannot deny it.

Anselm. Therefore you make no satisfaction unless you restore something greater than the amount of that obligation, which should restrain you from committing the sin.

Boso. Reason seems to demand this, and to make the contrary wholly impossible.

Anselm. Even God cannot raise to happiness any being bound at all by the debt of sin, because He ought not to.

Boso. This decision is most weighty.

Anselm. Listen to an additional reason which makes it no less difficult for man to be reconciled to God.

Boso. This alone would drive me to despair, were it not for the consolation of faith.

Anselm. But listen.

Boso. Say on.

CHAPTER XXII.

What contempt man brought upon God, when he allowed himself to be conquered by the devil; for which he can make no satisfaction.

Anselm. Man being made holy was placed in paradise, as it were in the place of God, between God and the devil, to conquer the devil by not yielding to his temptation, and so to vindicate the honor of God and put the devil to shame, because that man, though weaker and dwelling upon earth, should not sin though tempted by the devil, while the devil, though stronger and in heaven, sinned without any to tempt him. And when man could have easily effected this, he, without

compulsion and of his own accord, allowed himself to be brought over to the will of the devil, contrary to the will and honor of God.

Boso. To what would you bring me?

Anselm. Decide for yourself if it be not contrary to the honor of God for man to be reconciled to Him, with this calumnious reproach still heaped upon God; unless man first shall have honored God by overcoming the devil, as he dishonored him in yielding to the devil. Now the victory ought to be of this kind, that, as in strength and immortal vigor, he freely yielded to the devil to sin, and on this account justly incurred the penalty of death; so, in his weakness and mortality, which he had brought upon himself, he should conquer the devil by the pain of death, while wholly avoiding sin. But this cannot be done, so long as from the deadly effect of the first transgression, man is conceived and born in sin.

Boso. Again I say that the thing is impossible, and reason approves what you say.

Anselm. Let me mention one thing more, without which man's reconciliation cannot be justly effected, and the impossibility is the same.

Boso. You have already presented so many obligations which we ought to fulfil, that nothing which you can add will alarm me more.

Anselm. Yet listen.

Boso. I will.

CHAPTER XXIII.

What man took from God by his sin, which he has no power to repay.

Anselm. What did man take from God, when he allowed himself to be overcome by the devil?

Boso. Go on to mention, as you have begun, the evil things which can be added to those already shown for I am ignorant of them.

Anselm. Did not man take from God whatever He had purposed to do for human nature?

Boso. There is no denying that.

Anselm. Listen to the voice of strict justice; and judge according to that whether man makes to God a real satisfaction for his sin, unless, by overcoming the devil, man restore to God what he took from God in allowing himself to be conquered by the devil; so that, as by this conquest over man the devil took what belonged to God, and God was the loser, so in man's victory the devil may be despoiled, and God recover his right.

Boso. Surely nothing can be more exactly or justly conceived.

Anselm. Think you that supreme justice can violate this justice?

Boso. I dare not think it.

Anselm. Therefore man cannot and ought not by any means to receive from God what God designed to give him, unless he return to God everything which he took from him; so that, as by man God suffered loss, by man, also, He might recover His loss. But this cannot be effected except in this way: that, as in the fall of man all human nature was corrupted, and, as it were, tainted with sin, and God will not choose one of such a race to fill up the number in his heavenly kingdom; so, by man's victory, as many men may be justified from sin as are needed to complete the number which man was made to fill. But a sinful man can by no means do this, for a sinner cannot justify a sinner. Boso. There is nothing more just or necessary; but, from all these things, the compassion of God and the hope of man seems to fail, as far as regards that happiness for which man was made.

Anselm. Yet wait a little.

Boso. Have you anything further?

CHAPTER XXIV.

How, as long as man does not restore what he owes God, he cannot be happy, nor is he excused by want of power.

Anselm. If a man is called unjust who does not pay his fellow-man a debt, much more is he unjust who does not restore what he owes God.

Boso. If he can pay and yet does not, he is certainly unjust. But if he be not able, wherein is he unjust?

Anselm. Indeed, if the origin of his inability were not in himself, there might be some excuse for him. But if in this very impotence lies the fault, as it does not lessen the sin, neither does it excuse him from paying what is due. Suppose one should assign his slave a certain piece of work, and should command him not to throw himself into a ditch, which he points out to him and from which he could not extricate himself; and suppose that the slave, despising his master's command and warning, throws himself into the ditch before pointed out, so as to be utterly unable to accomplish the work assigned; think you that his inability will at all excuse him for not doing his appointed work?

Boso. By no means, but will rather increase his crime, since he brought his inability upon himself. For doubly hath he sinned, in not doing what he was commanded to do and in doing what he was forewarned not to do.

Anselm. Just so inexcusable is man, who has voluntarily brought upon himself a debt which he cannot pay, and by his own fault disabled himself, so that he can neither escape his previous obligation not to sin. nor pay the debt which he has incurred by sin. For his very inability is guilt, because he ought not to have it; nay, he ought to be free from it; for as it is a crime not to have what he ought, it is also a crime to have what he ought not. Therefore, as it is a crime in man not to have that power which he received to avoid sin, it is also a crime to have that inability by which he can neither do right and avoid sin, nor restore the debt which he owes on account of his sin. For it is by his own free action that he loses that power, and falls into this inability. For not to have the power which one ought to have, is the same thing as to have the inability which one ought not to have. Therefore man's inability to restore what he owes to God, an inability brought upon himself for that very purpose, does not excuse man from paying; for the result of sin cannot excuse the sin itself.

Boso. This argument is exceedingly weighty, and must be true.

Anselm. Man, then, is unjust in not paying what he owes to God.

Boso. This is very true; for he is unjust, both in not paying, and in not being able to pay.

Anselm. But no unjust person shall be admitted to happiness; for as that happiness is complete in which there is nothing wanting, so it can belong to no one who is not so pure as to have no injustice found in him.

Boso. I dare not think otherwise.

Anselm. He, then, who does not pay God what he owes can never be happy.

Boso. I cannot deny that this is so.

Anselm. But if you choose to say that a merciful God remits to the suppliant his debt, because he cannot pay: God must be said to dispense with one of two things, viz., either this which man ought voluntarily to render but cannot, that is, an equivalent for his sin, a thing which ought not to be given up even to save the whole universe besides God; or else this, which, as I have before said, God was about to take away from man by punishment, even against man's will, viz., happiness. But if God gives up what man ought freely to render, for the reason that man cannot repay it, what is this but saying that God gives up what he is unable to obtain? But it is mockery to ascribe such compassion to God. But if God gives up what he was about to take from unwilling man, because man is unable to restore what he ought to restore freely. He abates the punishment and makes man happy on account of his sin, because he has what he ought not to have. For he ought not to have this inability, and therefore as long as he has it without atonement it is his sin. And truly such compassion on the part of God is wholly contrary to the Divine justice, which allows nothing but punishment as the recompense of sin. Therefore, as God cannot be inconsistent with himself, his compassion cannot be of this nature.

Boso. I think, then, we must look for another mercy than this.

Anselm. But suppose it were true that God par-

dons the man who does not pay his debt because he cannot.

Boso. I could wish it were so.

Anselm. But while man does not make payment, he either wishes to restore, or else he does not wish to. Now, if he wishes to do what he cannot, he will be needy, and if he does not wish to, he will be unjust.

Boso. Nothing can be plainer.

Anselm. But whether needy or unjust, he will not be happy.

Boso. This also is plain.

Anselm. So long, then, as he does not restore, he will not be happy.

Boso. If God follows the method of justice, there is no escape for the miserable wretch, and God's compassion seems to fail.

Anselm. You have demanded an explanation; now hear it. I do not deny that God is merciful, who preserveth man and beast, according to the multitude of his mercies. But we are speaking of that exceeding pity by which he makes man happy after this life. And I think that I have amply proved, by the reasons given above, that happiness ought not to be bestowed upon any one whose sins have not been wholly put away; and that this remission ought not to take place, save by the payment of the debt incurred by sin, according to the extent of sin. And if you think that any objections can be brought against these proofs, you ought to mention them.

Boso. I see not how your reasons can be at all invalidated.

Anselm. Nor do I, if rightly understood. But even if one of the whole number be confirmed by impreg-

nable truth, that should be sufficient. For truth is equally secured against all doubt, if it be demonstrably proved by one argument as by many.

Boso. Surely this is so. But how, then, shall man be saved, if he neither pays what he owes, and ought not to be saved without paying? Or, with what face shall we declare that God, who is rich in mercy above human conception, cannot exercise this compassion?

Anselm. This is the question which you ought to ask of those in whose behalf you are speaking, who have no faith in the need of Christ for man's salvation, and you should also request them to tell how man can be saved without Christ. But, if they are utterly unable to do it, let them cease from mocking us, and let them hasten to unite themselves with us, who do not doubt that man can be saved through Christ; else let them despair of being saved at all. And if this terrifies them, let them believe in Christ as we do, that they may be saved.

Boso. Let me ask you, as I have begun, to show me how a man is saved by Christ.

CHAPTER XXV.

How man's salvation by Christ is necessarily possible.

Anselm. Is it not sufficiently proved that man can be saved by Christ, when even infidels do not deny that man can be happy somehow, and it has been sufficiently shown that, leaving Christ out of view, no salvation can be found for man? For, either by Christ or by some one else can man be saved, or else not at all. If, then, it is false that man cannot be saved at all, or that he can be saved in any other way, his salvation must necessarily be by Christ.

Boso. But what reply will you make to a person who perceives that man cannot be saved in any other way, and yet, not understanding how he can be saved by Christ, sees fit to declare that there cannot be any salvation either by Christ or in any other way?

Anselm. What reply ought to be made to one who ascribes impossibility to a necessary truth, because he does not understand how it can be?

Boso. That he is a fool.

Anselm. Then what he says must be despised.

Boso. Very true; but we ought to show him in what way the thing is true which he holds to be impossible.

Anselm. Do you not perceive, from what we have said above, that it is necessary for some men to attain to felicity? For, if it is unfitting for God to elevate man with any stain upon him, to that for which he made him free from all stain, lest it should seem that God had repented of his good intent, or was unable to accomplish his designs; far more is it impossible, on account of the same unfitness, that no man should be exalted to that state for which he was made. Therefore, a satisfaction such as we have above proved necessary for sin, must be found apart from the Christian faith, which no reason can show; or else we must accept the Christian doctrine. For what is clearly made out by absolute reasoning ought by no means to be questioned, even though the method of it be not understood.

Boso. What you say is true.

Anselm. Why, then, do you question further?.

Boso. I come not for this purpose, to have you remove doubts from my faith, but to have you show me the reason for my confidence. Therefore, as you have brought me thus far by your reasoning, so that *f* perceive that man as a sinner owes God for his sin what he is unable to pay, and cannot be saved without paying; I wish you would go further with me, and enable me to understand, by force of reasoning, the fitness of all those things which the Catholic faith enjoins upon us with regard to Christ, if we hope to be saved; and how they avail for the salvation of man, and how God saves man by compassion; when he never remits his sin, unless man shall have rendered what was due on account of his sin. And, to make your reasoning the clearer, begin at the beginning, so as to rest it upon a strong foundation.

Anselm. Now God help me, for you do not spare me in the least, nor consider the weakness of my skill, when you enjoin so great a work upon me. Yet I will attempt it, as I have begun, not trusting in myself but in God, and will do what I can with his help. But let us separate the things which remain to be said from those which have been said, by a new introduction, lest by their unbroken length, these things become tedious to one who wishes to read them.

BOOK SECOND.

CHAPTER I.

How man was made holy by God, so as to be happy in the enjoyment of God.

Anselm. It ought not to be disputed that rational nature was made holy by God, in order to be happy in enjoying Him. For to this end is it rational, in order to discern justice and injustice, good and evil, and between the greater and the lesser good. Other-

wise it was made rational in vain. But God made it not rational in vain. Wherefore, doubtless, it was made rational for this end. In like manner is it proved that the intelligent creature received the power of discernment for this purpose, that he might hate and shun evil, and love and choose good, and especially the greater good. For else in vain would God have given him that power of discernment, since man's discretion would be useless unless he loved and avoided according to it. But it does not befit God to give such power in vain. It is, therefore, established that rational nature was created for this end, viz., to love and choose the highest good supremely, for its own sake and nothing else; for if the highest good were chosen for any other reason, then something else and not itself would be the thing loved. But intelligent nature cannot fulfil this purpose without being holy. Therefore that it might not in vain be made rational. it was made, in order to fulfil this purpose, both rational and holy. Now, if it was made holy in order to choose and love the highest good, then it was made such in order to follow sometimes what it loved and chose, or else it was not. But if it were not made holy for this end, that it might follow what it loves and chooses, then in vain was it made to love and choose holiness; and there can be no reason why it should be ever bound to follow holiness. Therefore, as long as it will be holy in loving and choosing the supreme good, for which it was made, it will be miserable; because it will be impotent despite of its will. inasmuch as it does not have what it desires. But this is utterly absurd. Wherefore rational nature was made holy, in order to be happy in enjoying the supreme good, which is God. Therefore man, whose

CUR DEUS HOMO.

nature is rational, was made holy for this end, that he might be happy in enjoying God.

CHAPTER II.

How man would never have died, unless he had sinned.

Anselm. Moreover, it is easily proved that man was so made as not to be necessarily subject to death; for, as we have already said, it is inconsistent with God's wisdom and justice to compel man to suffer death without fault, when he made him holy to enjoy eternal blessedness. It therefore follows that had man never sinned he never would have died.

CHAPTER III.

How man will rise with the same body which he has in this world.

Anselm. From this the future resurrection of the dead is clearly proved. For if man is to be perfectly restored, the restoration should make him such as he would have been had he never sinned.

Boso. It must be so.

Anselm. Therefore, as man, had he not sinned, was to have been transferred with the same body to an immortal state, so when he shall be restored, it must properly be with his own body as he lived in this world.

Boso. But what shall we say to one who tells us that this is right enough with regard to those in whom humanity shall be perfectly restored, but is not necessary as respects the reprobate?

Anselm. We know of nothing more just or proper than this, that as man, had he continued in holiness, would have been perfectly happy for eternity, both in

body and in soul; so, if he persevere in wickedness, he shall be likewise completely miserable forever.

Boso. You have promptly satisfied me in these matters.

CHAPTER IV.

How God will complete, in respect to human nature, what he has begun.

Anselm. From these things, we can easily see that God will either complete what he has begun with regard to human nature, or else he has made to no end so lofty a nature, capable of so great good. Now if it be understood that God has made nothing more valuable than rational existence capable of enjoying him; it is altogether foreign from his character to suppose that he will suffer that rational existence utterly to perish.

Boso. No reasonable being can think otherwise.

Anselm. Therefore is it necessary for him to perfect in human nature what he has begun. But this, as we have already said, cannot be accomplished save by a complete expiation of sin, which no sinner can effect for himself.

Boso. I now understand it to be necessary for God to complete what he has begun, lest there be an unseemly falling off from his design.

CHAPTER V.

How, although the thing may be necessary, God may not do it by a compulsory necessity; and what is the nature of that necessity which removes or lessens gratitude, and what necessity increases it.

Boso. But if it be so, then God seems as it were compelled, for the sake of avoiding what is unbecom-

ing, to secure the salvation of man. How, then, can it be denied that he does it more on his own account than on ours? But if it be so, what thanks do we owe him for what he does for himself? How shall we attribute our salvation to his grace, if he saves us from necessity?

Anselm. There is a necessity which takes away or lessens our gratitude to a benefactor, and there is also a necessity by which the favor deserves still greater thanks. For when one does a benefit from a necessity to which he is unwillingly subjected, less thanks are due him, or none at all. But when he freely places himself under the necessity of benefiting another, and sustains that necessity without reluctance, then he certainly deserves greater thanks for the favor. For this should not be called necessity but grace, inasmuch as he undertook or maintains it, not with any constraint, but freely. For if that which to-day you promise of your own accord you will give to-morrow, you do give to-morrow with the same willingness; though it be necessary for you, if possible, to redeem your promise, or make yourself a liar; notwithstanding, the recipient of your favor is as much indebted for your precious gift as if you had not promised it, for you were not obliged to make yourself his debtor before the time of giving it: just so is it when one undertakes, by a vow, a design of holy living. For though after his vow he ought necessarily to perform, lest he suffer the judgment of an apostate, and, although he may be compelled to keep it even unwillingly, yet, if he keep his vow cheerfully, he is not less but more pleasing to God than if he had not vowed. For he has not only given up the life of the world, but also his personal liberty, for the sake of God; and

he cannot be said to live a holy life of necessity, but with the same freedom with which he took the vow. Much more, therefore, do we owe all thanks to God for completing his intended favor to man; though, indeed, it would not be proper for him to fail in his good design, because wanting nothing in himself he begun it for our sake and not his own. For what man was about to do was not hidden from God at his creation; and yet by freely creating man, God as it were bound himself to complete the good which he had begun. In fine, God does nothing by necessity, since he is not compelled or restrained in anything. And when we say that God does anything to avoid dishonor, which he certainly does not fear, we must mean that God does this from the necessity of maintaining his honor; which necessity is after all no more than this, viz., the immutability of his honor, which belongs to him in himself, and is not derived from another; and therefore it is not properly called necessity. Yet we may say, although the whole work which God does for man is of grace, that it is necessary for God, on account of his unchangeable goodness, to complete the work which he has begun.

Boso. I grant it.

CHAPTER VI.

How no being, except the God-man, can make the atonement by which man is saved.

Anselm. But this cannot be effected, except the price paid to God for the sin of man be something greater than all the universe besides God.

Boso. So it appears.

Anselm. Moreover, it is necessary that he who can

give God anything of his own which is more valuable than all things in the possession of God, must be greater than all else but God himself.

Boso. I cannot deny it.

Anselm. Therefore none but God can make this satisfaction.

Boso. So it appears.

Anselm. But none but a man ought to do this, other wise man does not make the satisfaction.

Boso. Nothing seems more just.

Anselm. If it be necessary, therefore, as it appears, that the heavenly kingdom be made up of men, and this cannot be effected unless the aforesaid satisfaction be made, which none but God can make and none but man ought to make, it is necessary for the Godman to make it.

Boso. Now blessed be God! we have made a great discovery with regard to our question. Go on, therefore, as you have begun. For I hope that God will assist you.

Anselm. Now must we inquire how God can become man.

CHAPTER VII.

How necessary it is for the same being to be perfect God and perfect man.

Anselm. The Divine and human natures cannot alternate, so that the Divine should become human or the human Divine; nor can they be so commingled as that a third should be produced from the two which is neither wholly Divine nor wholly human. For, granting that it were possible for either to be changed into the other, it would in that case be only God and not man, or man only and not God. Or, if they were so commingled that a third nature sprung from the combination of the two (as from two animals, a male and a female of different species, a third is produced. which does not preserve entire the species of either parent, but has a mixed nature derived from both), it would neither be God nor man. Therefore the Godman, whom we require to be of a nature both human and Divine, cannot be produced by a change from one into the other, nor by an imperfect commingling of both in a third; since these things cannot be, or, if they could be, would avail nothing to our purpose. Moreover, if these two complete natures are said to be joined somehow, in such a way that one may be Divine while the other is human, and yet that which is God not be the same with that which is man, it is impossible for both to do the work necessary to be accomplished. For God will not do it, because he has no debt to pay; and man will not do it, because he cannot. Therefore, in order that the God-man may perform this, it is necessary that the same being should be perfect God and perfect man, in order to make this atonement. For he cannot and ought not to do it, unless he be very God and very man. Since, then, it is necessary that the God-man preserve the completeness of each nature, it is no less necessary that these two natures be united entire in one person, just as a body and a reasonable soul exist together in every human being; for otherwise it is impossible that the same being should be very God and very man.

Boso. All that you say is satisfactory to me.

CHAPTER VIII.

How it behoved God to take a man of the race of Adam, and born of a woman.

Anselm. It now remains to inquire whence and how God shall assume human nature. For he will either take it from Adam, or else he will make a new man, as he made Adam originally. But, if he makes a new man, not of Adam's race, then this man will not belong to the human family, which descended from Adam, and therefore ought not to make atonement for it, because he never belonged to it. For, as it is right for man to make atonement for the sin of man, it is also necessary that he who makes the atonement should be the very being who has sinned, or else one of the same race. Otherwise, neither Adam nor his race would make satisfaction for themselves. Therefore, as through Adam and Eve sin was propagated among all men, so none but themselves, or one born of them, ought to make atonement for the sin of men. And, since they cannot, one born of them must fulfil this work. Moreover, as Adam and his whole race, had he not sinned, would have stood firm without the support of any other being, so, after the fall, the same race must rise and be exalted by means of itself. For, whoever restores the race to its place, it will certainly stand by that being who has made this restoration. Also, when God created human nature in Adam alone, and would only make woman out of man, that by the union of both sexes there might be increase, in this he showed plainly that he wished to produce all that he intended with regard to human nature from man alone. Wherefore, if the race of Adam be reinstated by any being not of the same race, it will not be restored to that dignity which it would have had, had not Adam sinned, and so will not be completely restored; and, besides, God will seem to have failed of his purpose, both which suppositions are incongruous. It is, therefore, necessary that the man by whom Adam's race shall be restored be taken from Adam.

Boso. If we follow reason, as we proposed to do, this is the necessary result.

Anselm. Let us now examine the question, whether the human nature taken by God must be produced from a father and mother, as other men are, or from man alone, or from woman alone. For, in whichever of these three modes it be, it will be produced from Adam and Eve, for from these two is every person of either sex descended. And of these three modes, no one is easier for God than another, that it should be selected on this account.

Boso. So far, it is well.

Anselm. It is no great toil to show that that man will be brought into existence in a nobler and purer manner, if produced from man alone, or woman alone, than if springing from the union of both, as do all other men.

Boso. I agree with you.

Anselm. Therefore must he be taken either from man alone, or woman alone.

Boso. There is no other source.

Anselm. In four ways can God create man, viz., either of man and woman, in the common way; or neither of man nor woman, as he created Adam; or of man without woman, as he made Eve; or of woman without man, which thus far he has never done. Wherefore, in order to show that this last mode is also under his power, and was reserved for this very purpose, what more fitting than that he should take that man whose origin we are seeking from a woman without a man? Now whether it be more worthy that he be born of a virgin, or one not a virgin, we need not discuss, but must affirm, beyond all doubt, that the God-man should be born of a virgin.

Boso. Your speech gratifies my heart.

Anselm. Does what we have said appear sound, or is it unsubstantial as a cloud, as you have said infidels declare?

Boso. Nothing can be more sound.

Anselm. Paint not, therefore, upon baseless emptiness, but upon solid truth, and tell how clearly fitting it is that, as man's sin and the cause of our condemnation sprung from a woman, so the cure of sin and the source of our salvation should also be found in a woman. And that women may not despair of attaining the inheritance of the blessed, because that so dire an evil arose from woman, it is proper that from woman also so great a blessing should arise, that their hopes may be revived. Take also this view. If it was a virgin which brought all evil upon the human race, it is much more appropriate that a virgin should be the occasion of all good. And this also. If woman, whom God made from man alone, was made of a virgin (de virgine), it is peculiarly fitting for that man also, who shall spring from a woman, to be born of a woman without man. Of the pictures which can be superadded to this, showing that the God-man ought to be born of a virgin, we will say nothing. These are sufficient.

Boso. They are certainly very beautiful and reasonable.

CHAPTER IX.

How of necessity the Word only can unite in one person with man.

Anselm. Now must we inquire further, in what person God, who exists in three persons, shall take upon himself the nature of man. For a plurality of persons cannot take one and the same man into a unity of person. Wherefore in one person only can this be done. But, as respects this personal unity of God and man, and in which of the Divine persons this ought to be effected, I have expressed myself, as far as I think needful for the present inquiry, in a letter on the Incarnation of the Word, addressed to my lord, the Pope Urban.

Boso. Yet briefly glance at this matter, why the person of the Son should be incarnated rather than that of the Father or the Holy Spirit.

Anselm. If one of the other persons be incarnated, there will be two sons in the Trinity, viz., the Son of God, who is the Son before the incarnation, and he also who, by the incarnation, will be the son of the virgin; and among the persons which ought always to be equal there will be an inequality as respects the dignity of birth. For the one born of God will have a nobler birth than he who is born of the virgin. Likewise, if the Father become incarnate, there will be two grandsons in the Trinity; for the Father, by assuming humanity, will be the grandson of the parents of the virgin, and the Word, though having nothing to do with man, will yet be the grandson of the virgin, since he will be the son of her son. But all these

things are incongruous and do not pertain to the incarnation of the Word. And there is yet another reason which renders it more fitting for the Son to become incarnate than the other persons. It is, that for the Son to pray to the Father is more proper than for any other person of the Trinity to supplicate his fellow. Moreover, man, for whom he was to pray, and the devil, whom he was to vanquish, have both put on a false likeness to God by their own will. Wherefore they have sinned, as it were, especially against the person of the Son, who is believed to be the very image of God. Wherefore the punishment or pardon of guilt is with peculiar propriety ascribed to him upon whom chiefly the injury was inflicted. Since, therefore, infallible reason has brought us to this necessary conclusion, that the Divine and human natures must unite in one person, and that this is evidently more fitting in respect to the person of the Word than the other persons, we determine that God the Word must unite with man in one person.

Boso. The way by which you lead me is so guarded by reason that I cannot deviate from it to the right or left.

Anselm. It is not I who lead you, but he of whom we are speaking, without whose guidance we have no power to keep the way of truth.

CHAPTER X.

How this man dies not of debt; and in what sense he can or cannot sin; and how neither he nor an angel deserves praise for their holiness, if it is impossible for them to sin.

Anselm. We ought not to question whether this man was about to die as a debt, as all other men do.

For, if Adam would not have died had he not committed sin, much less should this man suffer death, in whom there can be no sin, for he is God.

Boso. Let me delay you a little on this point. For in either case it is no slight question with me whether It be said that he can sin or that he cannot. For if it be said that he cannot sin. it should seem hard to be believed. For to say a word concerning him, not as of one who never existed in the manner we have spoken hitherto, but as of one whom we know and whose deeds we know; who, I say, will deny that he could have done many things which we call sinful? For, to say nothing of other things, how shall we say that it was not possible for him to commit the sin of lying? For, when he says to the Jews, of his Father: "If I say that I know him not, I shall be a liar. like unto you," and, in this sentence, makes use of the words: "I know him not," who says that he could not have uttered these same four words, or expressing the same thing differently, have declared, "I know him not?" Now had he done so, he would have been a liar, as he himself says, and therefore a sinner. Therefore, since he could do this, he could sin.

Anselm. It is true that he could say this, and also that he could not sin.

Boso. How is that?

Anselm. All power follows the will. For, when I say that I can speak or walk, it is understood, if I choose. For, if the will be not implied as acting, there is no power, but only necessity. For, when I say that I can be dragged or bound unwillingly, this is not my power, but necessity and the power of another; since I am able to be dragged or bound in no other sense than this, that another can drag or bind

me. So we can say of Christ, that he could lie, so long as we understand, if he chose to do so. And, since he could not lie unwillingly and could not wish to lie, none the less can it be said that he could not lie. So in this way it is both true that he could and could not lie.

Boso. Now let us return to our original inquiry with regard to that man, as if nothing were known of him. I say, then, if he were unable to sin, because, according to you, he could not wish to sin, he maintains holiness of necessity, and therefore he will not be holy from free will. What thanks, then, will he deserve for his holiness? For we are accustomed to say that God made man and angel capable of sinning on this account, that, when of their own free will they maintained holiness, though they might have abandoned it, they might deserve commendation and reward, which they would not have done had they been necessarily holy.

Anselm. Are not the angels worthy of praise, though unable to commit sin?

Boso. Doubtless they are, because they deserved this present inability to sin from the fact that when they could sin they refused to do so.

Anselm. What say you with respect to God, who cannot sin, and yet has not deserved this, by refusing to sin when he had the power? Must not he be praised for his holiness?

Boso. I should like to have you answer that question for me; for if I say that he deserves no praise, I know that I speak falsely. If, on the other hand, I say that he does deserve praise, I am afraid of invalidating my reasoning with respect to the angels.

Anselm. The angels are not to be praised for their

holiness because they could sin, but because it is owing to themselves, in a certain sense, that now they cannot sin. And in this respect are they in a measure like God, who has, from himself, whatever he possesses. For a person is said to give a thing, who does not take it away when he can; and to do a thing is but the same as not to prevent it, when that is in one's power. When, therefore, the angel could depart from holiness and yet did not, and could make himself unholy yet did not, we say with propriety that he conferred virtue upon himself and made himself holy. In this sense, therefore, has he holiness of himself (for the creature cannot have it of himself in any other way), and, therefore, should be praised for his holiness, because he is not holy of necessity but freely; for that is improperly called necessity which involves neither compulsion nor restraint. Wherefore, since whatever God has he has perfectly of himself, he is most of all to be praised for the good things which he possesses and maintains not by any necessity, but, as before said, by his own infinite unchangeableness. Therefore, likewise, that man who will be also God. since every good thing which he possesses comes from himself, will be holy not of necessity but voluntarily. and, therefore, will deserve praise. For, though human nature will have what it has from the Divine nature, yet it will likewise have it from itself, since the two natures will be united in one person.

Boso. You have satisfied me on this point; and I see clearly that it is both true that he could not sin, and yet that he deserves praise for his holiness. But now I think the question arises, since God could make such a man, why he did not create angels and our first parents so as to be incapable of sin, and yet praiseworthy for their holiness?

Anselm. Do you know what you are saying?

Boso. I think I understand, and it is therefore I ask why he did not make them so.

Anselm. Because it was neither possible nor right for any one of them to be the same with God, as we say that man was. And if you ask why he did not bring the three persons, or at least the Word, into unity with men at that time, I answer: Because reason did not at all demand any such thing then, but wholly forbade it, for God does nothing without reason.

Boso. I blush to have asked the question. Go on with what you have to say.

Anselm. We must conclude, then, that he should not be subject to death, inasmuch as he will not be a sinner.

Boso. I must agree with you.

CHAPTER XI.

How Christ dies of his own power, and how mortality does not inhere in the essential nature of man.

Anselm. Now, also, it remains to inquire whether, as man's nature is, it is possible for that man to die?

Boso. We need hardly dispute with regard to this, since he will be really man, and every man is by nature mortal.

Anselm. I do not think mortality inheres in the essential nature of man, but only as corrupted. Since, had man never sinned, and had his immortality been unchangeably confirmed, he would have been as really man; and, when the dying rise again, incorruptible, they will no less be really men. For, if mortality was an essential attribute of human nature, then he who was immortal could not be man. Wherefore, neither corruption nor incorruption belong essentially to human nature, for neither makes nor destroys a man; but happiness accrues to him from the one, and misery from the other. But since all men die, mortality is included in the definition of man, as given by philosophers, for they have never even believed in the possibility of man's being immortal in all respects. And so it is not enough to prove that that man ought to be subject to death, for us to say that he will be in all respects a man.

Boso. Seek then for some other reason, since I know of none, if you do not, by which we may prove that he can die.

Anselm. We may not doubt that, as he will be God, he will possess omnipotence.

Boso. Certainly.

Anselm. He can, then, if he chooses, lay down his life and take it again.

Boso. If not, he would scarcely seem to be omnipotent.

Anselm. Therefore is he able to avoid death if he chooses, and also to die and rise again. Moreover, whether he lays down his life by the intervention of no other person, or another causes this, so that he lays it down by permitting it to be taken, it makes no difference as far as regards his power.

Boso. There is no doubt about it.

Anselm. If, then, he chooses to allow it, he could be slain; and if he were unwilling to allow it, he could not be slain. Boso. To this we are unavoidably brought by reason.

Anselm. Reason has also taught us that the gift which he presents to God, not of debt but freely, ought to be something greater than anything in the possession of God.

Boso. Yes.

Anselm. Now this can neither be found beneath him nor above him.

Boso. Very true.

Anselm. In himself, therefore, must it be found. Boso. So it appears.

Anselm. Therefore will he give himself, or something pertaining to himself.

Boso. I cannot see how it should be otherwise.

Anselm. Now must we inquire what sort of a gift this should be? For he may not give himself to God, or anything of his, as if God did not have what was his own. For every creature belongs to God.

Boso. This is so.

Anselm. Therefore must this gift be understood in this way, that he somehow gives up himself, or something of his, to the honor of God, which he did not owe as a debtor.

Boso. So it seems from what has been already said.

Anselm. If we say that he will give himself to God by obedience, so as, by steadily maintaining holiness, to render himself subject to his will, this will not be giving a thing not demanded of him by God as his due. For every reasonable being owes his obedience to God.

Boso. This cannot be denied.

Anselm. Therefore must it be in some other way

that he gives himself, or something belonging to him, to God.

Boso. Reason urges us to this conclusion.

Anslem. Let us see whether, perchance, this may be to give up his life or to lay down his life, or to deliver himself up to death for God's honor. For God will not demand this of him as a lebt; for, as no sin will be found, he ought not to die, as we have already said.

Boso. Else I cannot understand it.

Anselm. But let us further observe whether this is according to reason.

Boso. Speak you, and I will listen with pleasure.

Anselm. If man sinned with ease, is it not fitting for him to atone with difficulty? And if he was overcome by the devil in the easiest manner possible, so as to dishonor God by sinning against him, is it not right that man, in making satisfaction for his sin, should honor God by conquering the devil with the greatest possible difficulty? Is it not proper that, since man has departed from God as far as possible in his sin, he should make to God the greatest possible satisfaction?

Boso. Surely, there is nothing more reasonable.

Anselm. Now, nothing can be more severe or difficult for man to do for God's honor, than to suffer death voluntarily when not bound by obligation; and man cannot give himself to God in any way more truly than by surrendering himself to death for God's honor.

Boso. All these things are true.

Anselm. Therefore, he who wishes to make atonement for man's sin should be one who can die if he chooses.

Boso. I think it is plain that the man whom we

seek for should not only be one who is not necessarily subject to death on account of his omnipotence, and one who does not deserve death on account of his sin, but also one who can die of his own free will, for this will be necessary.

Anselm. There are also many other reasons why it is peculiarly fitting for that man to enter into the common intercourse of men. and maintain a likeness to them, only without sin. And these things are more easily and clearly manifest in his life and actions than they can possibly be shown to be by mere reason without experience. For who can say how necessary and wise a thing it was for him who was to redeem mankind, and lead them back by his teaching from the way of death and destruction into the path of life and eternal happiness, when he conversed with men, and when he taught them by personal intercourse, to set them an example himself of the way in which they ought to live? But how could he have given this example to weak and dying men, that they should not deviate from holiness because of injuries, or scorn, or tortures, or even death, had they not been able to recognise all these virtues in himself?

CHAPTER XII.

How, though he share in our weakness, he is not therefore miserable.

Boso. All these things plainly show that he ought to be mortal and to partake of our weaknesses. But all these things are our miseries. Will he then be miserable?

Anselm. No, indeed! For as no advantage which one has apart from his choice constitutes happiness,

so there is no misery in choosing to bear a loss, when the choice is a wise one and made without compulsion.

Boso. Certainly, this must be allowed.

CHAPTER XIII.

How, along with our other weaknesses, he does not partake of our ignorance.

Boso. But tell me whether, in this likeness to men which he ought to have, he will inherit also our ignorance, as he does our other infirmities?

Anselm. Do you doubt the omnipotence of God? Boso. No! but, although this man be immortal in respect to his Divine nature, yet will he be mortal in his human nature. For why will he not be like them in their ignorance, as he is in their mortality?

Anselm. That union of humanity with the Divine person will not be effected except in accordance with the highest wisdom; and, therefore, God will not take anything belonging to man which is only useless, but even a hindrance to the work which that man must accomplish. For ignorance is in no respect useful, but very prejudicial. How can he perform works, so many and so great, without the highest wisdom? Or, how will men believe him if they find him ignorant? And if he be ignorant, what will it avail him? If nothing is loved except as it is known, and there be no good thing which he does not love, then there can be no good thing of which he is ignorant. But no one perfectly understands good, save he who can distinguish it from evil: and no one can make this distinction who does not know what evil is. Therefore, as he of whom we are speaking perfectly comprehends

what is good, so there can be no evil with which he is unacquainted. Therefore must he have all knowledge, though he do not openly show it in his intercourse with men.

Boso. In his more mature years, this should seem to be as you say; but, in infancy, as it will not be a fit time to discover wisdom, so there will be no need, and therefore no propriety, in his having it.

Anselm. Did not I say that the incarnation will be made in wisdom? But God will in wisdom assume that mortality, which he makes use of so widely, because for so great an object. But he could not wisely assume ignorance, for this is never useful, but always injurious, except when an evil will is deterred from acting, on account of it. But, in him an evil desire never existed. For if ignorance did no harm in any other respect, yet does it in this, that it takes away the good of knowing. And to answer your question in a word: that man, from the essential nature of his being, will be always full of God; and, therefore, will never want the power, the firmness or the wisdom of God.

Boso. Though wholly unable to doubt the truth of this with respect to Christ, yet, on this very account, have I asked for the reason of it. For we are often certain about a thing, and yet cannot prove it by reason.

CHAPTER XIV.

How his death outweighs the number and greatness of our sins.

Boso. Now I ask you to tell me how his death can outweigh the number and magnitude of our sins, when the least sin we can think of you have shown to be so monstrous that, were there an infinite number of

worlds as full of created existence as this, they could not stand, but would fall back into nothing, sooner than one look should be made contrary to the just will of God.

Anselm. Were that man here before you, and you knew who he was, and it were told you that, if you did not kill him, the whole universe, except God, would perish, would you do it to preserve the rest of creation?

Boso. No! not even were an infinite number of worlds displayed before me.

Anselm. But suppose you were told: "If you do not kill him, all the sins of the world will be heaped upon you."

Boso. I should answer, that I would far rather bear all other sins, not only those of this world, past and future, but also all others that can be conceived of, than this alone. And I think I ought to say this, not only with regard to killing him, but even as to the slightest injury which could be inflicted on him.

Anselm. You judge correctly; but tell me why it is that your heart recoils from one injury inflicted upon him as more heinous than all other sins that can be thought of, inasmuch as all sins whatsoever are committed against him?

Boso. A sin committed upon his person exceeds beyond comparison all the sins which can be thought of, that do not affect his person.

Anselm. What say you to this, that one often suffers freely certain evils in his person, in order not to suffer greater ones in his property?

Boso. God has no need of such patience, for all things lie in subjection to his power, as you answered a certain question of mine above.

Anselm. You say well; and hence we see that no enormity or multitude of sins, apart from the Divine person, can for a moment be compared with a bodily injury inflicted upon that man.

Boso. This is most plain.

Anselm. How great does this good seem to you, if the destruction of it is such an evil?

Boso. If its existence is as great a good as its destruction is an evil, then is it far more a good than those sins are evils which its destruction so far surpasses.

Anselm. Very true. Consider, also, that sins are as hateful as they are evil, and that life is only amiable in proportion as it is good. And, therefore, it follows that that life is more lovely than sins are odious.

Boso. I cannot help seeing this.

Anselm. And do you not think that so great a good in itself so lovely, can avail to pay what is due for the sins of the whole world?

Boso. Yes! it has even infinite value.

Anselm. Do you see, then, how this life conquers all sins, if it be given for them?

Boso. Plainly.

Anselm. If, then, to lay down life is the same as to suffer death, as the gift of his life surpasses all the sins of men, so will also the suffering of death.

CHAPTER XV.

How this death removes even the sins of his murderers.

Boso. This is properly so with regard to all sins not affecting the person of the Deity. But let me ask you one thing more. If it be as great an evil to slay him as his life is a good, how can his death overcome

and destroy the sins of those who slew him? Or, if it destroys the sin of any one of them, how can it not also destroy any sin committed by other men? For we believe that many men will be saved, and a vast many will not be saved.

Anselm. The Apostle answers the question when he says: "Had they known it, they would never have crucified the Lord of glory." For a sin knowingly committed and a sin done ignorantly are so different that an evil which they could never do, were its full extent known, may be pardonable when done in ignorance. For no man could ever, knowingly at least, slay the Lord; and, therefore, those who did it in ignorance did not rush into that transcendental crime with which none others can be compared. For this crime, the magnitude of which we have been considering as equal to the worth of his life, we have not looked at as having been ignorantly done, but knowingly; a thing which no man ever did or could do.

Boso. You have reasonably shown that the murderers of Christ can obtain pardon for their sin.

Anselm. What more do you ask? For now you see how reason of necessity shows that the celestial state must be made up from men, and that this can only be by the forgiveness of sins, which man can never have but by man, who must be at the same time Divine, and reconcile sinners to God by his own death. Therefore have we clearly found that Christ, whom we confess to be both God and man, died for us; and, when this is known beyond all doubt, all things which he says of himself must be acknowledged as true, for God cannot lie, and all he does must be received as wisely done, though we do not understand the reason of it.

Boso. What you say is true; and I do not for a moment doubt that his words are true, and all that he does reasonable. But I ask this in order that you may disclose to me, in their true rationality, those things in Christian faith which seem to infidels improper or impossible; and this, not to strengthen me in the faith, but to gratify one already confirmed by the knowledge of the truth itself.

CHAPTER XVI.

How God took that man from a sinful substance, and yet without sin; and of the salvation of Adam and Eve.

Boso. As, therefore, you have disclosed the reason of those things mentioned above, I beg you will also explain what I am now about to ask. First, then, how does God, from a sinful substance, that is, of human species, which was wholly tainted by sin, take a man without sin, as an unleavened lump from that which is leavened? For, though the conception of this man be pure, and free from the sin of fleshly gratification, yet the virgin herself, from whom he sprang, was conceived in iniquity, and in sin did her mother bear her, since she herself sinned in Adam, in whom all men sinned.

Anselm. Since it is fitting for that man to be God, and also the restorer of sinners, we doubt not that he is wholly without sin; yet will this avail nothing, unless he be taken without sin and yet of a sinful substance. But if we cannot comprehend in what manner the wisdom of God effects this, we should be surprised, but with reverence should allow of a thing of so great magnitude to remain hidden from us. For the restoring of human nature by God is more wonderful than its creation; for either was equally easy for God: but before man was made he had not sinned. so that he ought not to be denied existence. But after man was made he deserved, by his sin, to lose his existence together with its design; though he never has wholly lost this, viz., that he should be onecapable of being punished, or of receiving God's compassion. For neither of these things could take effect if he were annihilated. Therefore God's restoring man is more wonderful than his creating man, inasmuch as it is done for the sinner contrary to his deserts; while the act of creation was not for the sinner, and was not in opposition to man's deserts. How great a thing it is, also, for God and man to unite in one person, that, while the perfection of each nature is preserved, the same being may be both God and man! Who, then, will dare to think that the human mind can discover how wisely, how wonderfully, so incomprehensible a work has been accomplished?

Boso. I allow that no man can wholly discover so great a mystery in this life, and I do not desire you to do what no man can do, but only to explain it according to your ability. For you will sooner convince me that deeper reasons lie concealed in this matter, by showing some one that you know of, than if, by saying nothing, you make it appear that you do not understand any reason.

Anselm. I see that I cannot escape your importunity; but if I have any power to explain what you wish, let us thank God for it. But if not, let the things above said suffice. For, since it is agreed that God ought to become man, no doubt He will not lack the wisdom or the power to effect this without sin.

Boso. This I readily allow.

Anselm. It was certainly proper that that atonement which Christ made should benefit not only those who lived at that time but also others. For, suppose there were a king against whom all the people of his provinces had rebelled, with but a single exception of those belonging to their race, and that all the rest were irretrievably under condemnation. And suppose that he who alone is blameless had so great favor with the king, and so deep love for us, as to be both able and willing to save all those who trusted in his guidance; and this because of a certain very pleasing service which he was about to do for the king, according to his desire; and, inasmuch as those who are to be pardoned cannot all assemble upon that day, the king grants, on account of the greatness of the service performed, that whoever, either before or after the day appointed, acknowledged that he wished to obtain pardon by the work that day accomplished, and to subscribe to the condition there laid down, should be freed from all past guilt; and, if they sinned after this pardon, and yet wished to render atonement and to be set right again by the efficacy of this plan, they should again be pardoned, only provided that no one enter his mansion until this thing be accomplished by which his sins are removed. In like manner, since all who are to be saved cannot be present at the sacrifice of Christ, yet such virtue is there in his death that its power is extended even to those far remote in place or time. But that it ought to benefit not merely those present is plainly evident, because there could not be so many living at the time of his death as are necessary to complete the heavenly state, even if all who were upon the earth at that time were admitted to the benefits of redemption. For the number of evil

angels which must be made up from men is greater than the number of men at that time living. Nor may we believe that, since man was created, there was ever a time when the world, with the creatures made for the use of man, was so unprofitable as to contain no human being who had gained the object for which he was made. For it seems unfitting that God should even for a moment allow the human race, made to complete the heavenly state, and those creatures which he made for their use, to exist in vain.

Boso. You show by correct reasoning, such as nothing can oppose, that there never was a time since man was created when there has not been some one who was gaining that reconciliation without which every man was made in vain. So that we rest upon this as not only proper but also necessary. For if this is more fit and reasonable than that at any time there should be no one found fulfilling the design for which God made man, and there is no further objection that can be made to this view, then it is necessary that there always be some person partaking of this promised pardon. And, therefore, we must not doubt that Adam and Eve obtained part in that forgiveness, though Divine authority makes no mention of this.

Anselm. It is also incredible that God created them, and unchangeably determined to make all men from them, as many as were needed for the celestial state, and yet should exclude these two from this design.

Boso. Nay, undoubtedly we ought to believe that God made them for this purpose, viz., to belong to the number of those for whose sake they were created.

Anselm. You understand it well. But no soul, before the death of Christ, could enter the heavenly kingdom, as I said above, with regard to the palace of the king.

Boso. So we believe.

Anselm. Moreover, the virgin, from whom that man was taken of whom we are speaking, was of the number of those who were cleansed from their sins before his birth, and he was born of her in her purity.

Boso. What you say would satisfy me, were it not that he ought to be pure of himself, whereas he appears to have his purity from his mother and not from himself.

Anselm. Not so. But as the mother's purity, which he partakes, was only derived from him, he also was pure by and of himself.

CHAPTER XVII.

How he did not die of necessity, though he could not be born, except as destined to suffer death.

Boso. Thus far it is well. But there is yet another matter that needs to be looked into. For we have said before that his death was not to be a matter of necessity; yet now we see that his mother was purified by the power of his death, when without this he could not have been born of her. How, then, was not his death necessary, when he could not have been, except in view of future death? For if he were not to die, the virgin of whom he was born could not be pure, since this could only be effected by true faith in his death, and, if she were not pure, he could not be born of her. If, therefore, his death be not a necessary consequence of his being born of the virgin, he never could have been born of her at all; but this is an absurdity.

Anselm. If you had carefully noted the remarks made above, you would easily have discovered in them, I think, the answer to your question.

Boso. I see not how.

Anselm. Did we not find, when considering the question whether he would lie, that there were two senses of the word *power* in regard to it, the one referring to his disposition, the other to the act itself; and that, though having the power to lie, he was so constituted by nature as not to wish to lie, and, therefore, deserved praise for his holiness in maintaining the truth?

Boso. It is so.

Anselm. In like manner, with regard to the preservation of his life, there is the power of preserving and the power of wishing to preserve it. And when the question is asked whether the same God-man could preserve his life, so as never to die, we must not doubt that he always had the power to preserve his life, though he could not wish to do so for the purpose of escaping death. And since this disposition, which forever prevents him from wishing this, arises from himself, he lays down his life not of necessity, but of free authority.

Boso. But those powers were not in all respects similar, the power to lie and the power to preserve his life. For, if he wished to lie, he would of course be able to; but, if he wished to avoid the other, he could no more do it than he could avoid being what he is. For he became man for this purpose, and it was on the faith of his coming death that he could receive birth from a virgin, as you said above.

Anselm. As you think that he could not lie, or that his death was necessary, because he could not avoid being what he was, so you can assert that he could not wish to avoid death, or that he wished to die of necessity, because he could not change the constitution of his being; for he did not become man in order that he should die, any more than for this purpose, that he should wish to die. Wherefore, as you ought not to say that he could not help wishing to die, or that it was of necessity that he wished to die, it is equally improper to say that he could not avoid death, or that he died of necessity.

Boso. Yes, since dying and wishing to die are included in the same mode of reasoning, both would seem to fall under a like necessity.

Anselm. Who freely wished to become man, that by the same unchanging desire he should suffer death, and that the virgin from whom that man should be born might be pure, through confidence in the certainty of this?

Boso. God, the Son of God.

Anselm. Was it not above shown, that no desire of God is at all constrained; but that it freely maintains itself in his own unchangeableness, as often as it is said that he does anything necessarily?

Boso. It has been clearly shown. But we see, on the other hand, that what God unchangeably wishes cannot avoid being so, but takes place of necessity. Wherefore, if God wished that man to die, he could but die.

Anselm. Because the Son of God took the nature of man with this desire, viz., that he should suffer death, you prove it necessary that this man should not be able to avoid death.

Boso. So I perceive.

Anselm. Has it not in like manner appeared from

the things which we have spoken that the Son of God and the man whose person he took were so united that the same being should be both God and man, the Son of God and the son of the virgin?

Boso. It is so.

Anselm. Therefore the same man could possibly both die and avoid death.

Boso. I cannot deny it.

Anselm. Since, then, the will of God does nothing by any necessity, but of his own power, and the will of that man was the same as the will of God, he died not necessarily, but only of his own power.

Boso. To your arguments I cannot object; for neither your propositions nor your inferences can I invalidate in the least. But yet this thing which I have mentioned always recurs to my mind: that, if he wished to avoid death, he could no more do it than he could escape existence. For it must have been fixed that he was to die, for had it not been true that he was about to die, faith in his coming death would not have existed, by which the virgin who gave him birth and many others also were cleansed from their sin. Wherefore, if he could avoid death, he could make untrue what was true.

Anselm. Why was it true, before he died, that he was certainly to die?

Boso. Because this was his free and unchangeable desire.

Anselm. If, then, as you say, he could not avoid death because he was certainly to die, and was on this account certainly to die because it was his free and unchangeable desire, it is clear that his inability to avoid death is nothing else but his fixed choice to die.

Boso. This is so; but whatever be the reason, it

still remains certain that he could not avoid death, but that it was a necessary thing for him to die.

Anselm. You make a great ado about nothing, or, as the saying is, you stumble at a straw.

Boso. Are you not forgetting my reply to the ex cuses you made at the beginning of our discussion, viz., that you should explain the subject, not as to learned men, but to me and my fellow inquirers? Suffer me, then, to question you as my slowness and dullness require, so that, as you have begun thus far, you may go on to settle all our childish doubts.

CHAPTER XVIII (a).1

How, with God there is neither necessity nor impossibility. and what is a coercive necessity, and what one that is not so.

Anselm. We have already said that it is improper to affirm of God that he does anything, or that he cannot do it, of necessity. For all necessity and impossibility is under his control. But his choice is subject to no necessity nor impossibility. For nothing is necessary or impossible save as He wishes it. Nav. the very choosing or refusing anything as a necessity or an impossibility is contrary to truth. Since, then, he does what he chooses and nothing else, as no necessity or impossibility exists before his choice or refusal, so neither do they interfere with his acting or not acting, though it be true that his choice and action are immutable. And as, when God does a thing, since it has been done it cannot be undone, but must remain an actual fact; still, we are not correct in saying that it is impossible for God to prevent a past action

This and the succeeding chapter are numbered differently in the different editions of Anselm's texts.

from being what it is. For there is no necessity or impossibility in the case whatever but the simple will of God, which chooses that truth should be eternally the same, for he himself is truth. Also, if he has a fixed determination to do anything, though his design must be destined to an accomplishment before it comes to pass, yet there is no coercion as far as he is concerned, either to do it or not to do it, for his will is the sole agent in the case. For when we say that God cannot do a thing, we do not deny his power: on the contrary, we imply that he has invincible authority and strength. For we mean simply this, that nothing can compel God to do the thing which is said to be impossible for him. We often use an expression of this kind, that a thing can be when the power is not in itself, but in something else; and that it cannot be when the weakness does not pertain to the thing itself, but to something else. Thus we say: "Such a man can be bound," instead of saving, "Somebody can bind him," and, "He cannot be bound," instead of, "Nobody can bind him." For to be able to be overcome is not power but weakness, and not to be able to be overcome is not weakness but power. Nor do we say that God does anything by necessity, because there is any such thing pertaining to him, but because it exists in something else, precisely as I said with regard to the affirmation that he cannot do anything. For necessity is always either compulsion or restraint; and these two kinds of necessity operate variously by turn, so that the same thing is both necessary and impossible. For whatever is obliged to exist is also prevented from non-existence; and that which is compelled not to exist is prevented from existence. So that whatever exists from necessity can-

not avoid existence, and it is impossible for a thing to exist which is under a necessity of non-existence, and vice versa. But when we say with regard to God, that anything is necessary or not necessary, we do not mean that, as far as he is concerned, there is any necessity either coercive or prohibitory, but we mean that there is a necessity in everything else, restraining or driving them in a particular way. Whereas we say the very opposite of God. For, when we affirm that it is necessary for God to utter truth, and never to lie, we only mean that such is his unwavering disposition to maintain the truth that of necessity nothing can avail to make him deviate from the truth, or utter a lie. When, then, we say that that man (who, by the union of persons, is also God, the Son of God) could not avoid death, or the choice of death, after he was born of the virgin, we do not imply that there was in him any weakness with regard to preserving or choosing to preserve his life, but we refer to the unchange ableness of his purpose, by which he freely became man for this design, viz., that by persevering in his wish he should suffer death. And this desire nothing could shake. For it would be rather weakness than power if he could wish to lie, or deceive, or change his disposition, when before he had chosen that it should remain unchanged. And, as I said before, when one has freely determined to do some good action, and afterwards goes on to complete it, though, if unwilling to pay his vow, he could be compelled to do so, yet we must not say that he does it of necessity, but with the same freedom with which he made the resolution. For we ought not to say that anything is done, or not done, by necessity or weakness, when free choice is the only agent in the case. And, if this

is so with regard to man, much less can we speak of necessity or weakness in reference to God: for he does nothing except according to his choice, and his will no force can drive or restrain. For this end was accomplished by the united natures of Christ, viz., that the Divine nature should perform that part of the work needful for man's restoration which the human nature could not do; and that in the human should be manifested what was inappropriate to the Divine. Finally, the virgin herself, who was made pure by faith in him, so that he might be born of her, even she. I say. never believed that he was to die, save of his own choice. For she knew the words of the prophet, who said of him: "He was offered of his own will." Therefore, since her faith was well founded. it must necessarily turn out as she believed. And, if it perplexes you to have me say that it is necessary. remember that the reality of the virgin's faith was not the cause of his dying by his own free will; but, because this was destined to take place, therefore her faith was real. If, then, it be said that it was necessary for him to die of his single choice, because the antecedent faith and prophecy were true, this is no more than saving that it must be because it was to be. But such a necessity as this does not compel a thing to be, but only implies a necessity of its existence. There is an antecedent necessity which is the cause of a thing, and there is also a subsequent necessity arising from the thing itself. Thus, when the heavens are said to revolve, it is an antecedent and efficient necessity, for they must revolve. But when I say that you speak of necessity, because you are speaking, this is nothing but a subsequent and inoperative necessity. For I only mean that it is im-

276

possible for you to speak and not to speak at the same time, and not that some one compels you to speak. For the force of its own nature makes the heaven revolve; but no necessity obliges you to speak. But wherever there is an antecedent necessity, there is also a subsequent one; but not vice versa. For we can say that the heaven revolves of necessity, because it revolves; but it is not likewise true that, because you speak, you do it of necessity. This subsequent necessity pertains to everything, so that we say: Whatever has been, necessarily has been. Whatever is, must be. Whatever is to be, of necessity will be. This is that necessity which Aristotle treats of ("de propositionibus singularibus et futuris"), and which seems to destroy any alternative and to ascribe a necessity to all things. By this subsequent and imperative necessity, was it necessary (since the belief and prophecy concerning Christ were true, that he would die of his own free will), that it should be so. For this he became man; for this he did and suffered all things undertaken by him; for this he chose as he did. For therefore were they necessary, because they were to be, and they were to be because they were, and they were because they were; and, if you wish to know the real necessity of all things which he did and suffered, know that they were of necessity, because he wished them to be. But no necessity preceded his will. Wherefore if they were not save by his will, then, had he not willed they would not have existed. So then, no one took his life from him, but he laid it down of himself and took it again; for he had power to lay it down and to take it again, as he himself said.

Boso. You have satisfied me that it cannot be proved that he was subjected to death by any necessity; and I cannot regret my importunity in urging you to make this explanation.

Anselm. I think we have shown with sufficient clearness how it was that God took a man without sin from a sinful substance; but I would on no account deny that there is no other explanation than this which we have given, for God can certainly do what human reason cannot grasp. But since this appears adequate, and since in search of other arguments we should involve ourselves in such questions as that of original sin, and how it was transmitted by our first parents to all mankind, except this man of whom we are speaking; and since, also, we should be drawn into various other questions, each demanding its own separate consideration; let us be satisfied with this account of the matter, and go on to complete our intended work.

Boso. As you choose; but with this condition that, by the help of God, you will sometime give this other explanation, which you owe me, as it were, but which now you avoid discussing.

Anselm. Inasmuch as I entertain this desire myself, I will not refuse you; but because of the uncertainty of future events, I dare not promise you, but commend it to the will of God. But say now, what remains to be unravelled with regard to the question which you proposed in the first place, and which involves many others with it?

Boso. The substance of the inquiry was this, why God became man, for the purpose of saving men by his death, when he could have done it in some other way. And you, by numerous and positive reasons, have shown that the restoring of mankind ought not to take place, and could not, without man paid the debt which he owed God for his sin. And this debt was so great that, while none but man must solve the debt. none but God was able to do it; so that he who does it must be both God and man. And hence arises a necessity that God should take man into unity with his own person; so that he who in his own nature was bound to pay the debt, but could not, might be able to do it in the person of God. In fine, you have shown that that man, who was also God, must be formed from the virgin, and from the person of the Son of God, and that he could be taken without sin, though from a sinful substance. Moreover, you have clearly shown the life of this man to have been so excellent and so glorious as to make ample satisfaction for the sins of the whole world, and even infinitely more. It now, therefore, remains to be shown how that payment is made to God for the sins of men.

CHAPTER XVIII (b.)

How Christ's life is paid to God for the sins of men, and in what sense Christ ought, and in what sense he ought not, or was not bound, to suffer.

Anselm. If he allowed himself to be slain for the sake of justice, he did not give his life for the honor of God?

Boso. It should seem so, but I cannot understand, although I do not doubt it, how he could do this reasonably. If I saw how he could be perfectly holy, and yet forever preserve his life, I would acknowledge that he freely gave, for the honor of God, such a gift as surpasses all things else but God himself, and is able to atone for all the sins of men.

Anselm. Do you not perceive that when he bore

with gentle patience the insults put upon him, violence and even crucifixion among thieves that he might maintain strict holiness; by this he set men an example that they should never turn aside from the holiness due to God on account of personal sacrifice? But how could he have done this, had he, as he might have done, avoided the death brought upon him for such a reason?

Boso. But surely there was no need of this, for many persons before his coming, and John the Baptist after his coming but before his death, had sufficiently enforced this example by nobly dying for the sake of the truth.

Anselm. No man except this one ever gave to God what he was not obliged to lose, or paid a debt he did not owe. But he freely offered to the Father what there was no need of his ever losing, and paid for sinners what he owed not for himself. Therefore he set a much nobler example, that each one should not hesitate to give to God, for himself, what he must at any rate lose before long, since it was the voice of reason; for he, when not in want of anything for himself and not compelled by others, who deserved nothing of him but punishment, gave so precious a life, even the life of so illustrious a personage, with such willingness.

Boso. You very nearly meet my wishes; but suffer me to make one inquiry, which you may think foolish, but which, nevertheless, I find no easy thing to answer. You say that when he died he gave what he did not owe. But no one will deny that it was better for him, or that so doing he pleased God more than if he had not done it. Nor will any one say that he was not bound to do what was best to be done, and what he knew would be more pleasing to God. How then can we affirm that he did not owe God the thing which he did, that is, the thing which he knew to be best and most pleasing to God, and especially since every creature owes God all that he is and all that he knows and all that he is capable of?

Anselm. Though the creature has nothing of himself, yet when God grants him the liberty of doing or not doing a thing, he leaves the alternative with him, so that, though one is better than the other, yet neither is positively demanded. And, whichever he does. it may be said that he ought to do it; and if he takes the better choice, he deserves a reward; because he renders freely what is his own. For, though celibacy be better than marriage, yet neither is absolutely enjoined upon man; so that both he who chooses marriage and he who prefers celibacy, may be said to do as they ought. For no one says that either celibacy or marriage ought not to be chosen; but we say that what a man esteems best before taking action upon any of these things, this he ought to do. And if a man preserves his celibacy as a free gift offered to God, he looks for a reward. When you say that the creature owes God what he knows to be the better choice, and what he is able to do, if you mean that he owes it as a debt, without implying any command on the part of God, it is not always true. Thus, as I have already said, a man is not bound to celibacy as a debt, but ought to marry if he prefers it. And if you are unable to understand the use of this word "debere," when no debt is implied, let me inform you that we use the word "debere" precisely as we sometimes do the words "posse," and "non posse;" and also "necessitas," when the ability, etc., is not in the things

themselves, but in something else. When, for instance, we say that the poor ought to receive alms from the rich, we mean that the rich ought to bestow alms upon the poor. For this is a debt not owed by the poor but by the rich. We also say that God ought to be exalted over all, not because there is any obligation resting upon him, but because all things ought to be subject to him. And he wishes that all creatures should be what they ought; for what God wishes to be ought to be. And, in like manner, when any creature wishes to do a thing that is left entirely at his own disposal, we say that he ought to do it, for what he wishes to be ought to be. So our Lord Iesus, when he wished, as we have said, to suffer death, ought to have done precisely what he did; because he ought to be what he wished, and was not bound to do anything as a debt. As he is both God and man, in connection with his human nature, which made him a man, he must also have received from the Divine nature that control over himself which freed him from all obligation, except to do as he chose. In like manner, as one person of the Trinity, he must have had whatever he possessed of his own right, so as to be complete in himself, and could not have been under obligations to another, nor have need of giving anything in order to be repaid himself.

Boso. Now I see clearly that he did not give himself up to die for the honor of God, as a debt; for this my own reason proves, and yet he ought to have done what he did.

Anselm. That honor certainly belongs to the whole Trinity; and, since he is very God, the Son of God, he offered himself for his own honor, as well as for that of the Father and the Holy Spirit; that is, he gave his humanity to his divinity, which is one person of the Triune God. But, though we express our idea more definitely by clinging to the precise truth, yet we may say, according to our custom, that the Son freely gave himself to the Father. For thus we plainly affirm that in speaking of one person we understand the whole Deity, to whom as man he offered himself. And, by the names of Father and Son, a wondrous depth of devotion is excited in the hearts of the hearers, when it is said that the Son supplicates the Father on our behalf.

Boso. This I readily acknowledge.

CHAPTER XIX.

How human salvation follows upon his death.

Anselm. Let us now observe, if we can, how the salvation of men rests on this.

Boso. This is the very wish of my heart. For, although I think I understand you, yet I wish to get from you the close chain of argument.

Anselm. There is no need of explaining how precious was the gift which the Son freely gave.

Boso. That is clear enough already.

Anselm. But you surely will not think that he deserves no reward, who freely gave so great a gift to God.

Boso. I see that it is necessary for the Father to reward the Son; else he is either unjust in not wishing to do it, or weak in not being able to do it; but neither of these things can be attributed to God.

Anselm. He who rewards another either gives him something which he does not have, or else remits some rightful claim upon him. But anterior to the great offering of the Son, all things belonging to the Father were his, nor did he ever owe anything which could be forgiven him. How then can a reward be bestowed on one who needs nothing, and to whom no gift or release can be made?

Boso. I see on the one hand a necessity for a reward, and on the other it appears impossible; for God must necessarily render payment for what he owes, and yet there is no one to receive it.

Anselm. But if a reward so large and so deserved is not given to him or any one else, then it will almost appear as if the Son had done this great work in vain.

Boso. Such a supposition is impious.

Anselm. The reward then must be bestowed upon some one else, for it cannot be upon him.

Boso. This is necessarily so.

Anselm. Had the Son wished to give some one else what was due to him, could the Father rightfully prevent it, or refuse to give it to the other person?

Boso. No! but I think it would be both just and necessary that the gift should be given by the Father to whomsoever the Son wished; because the Son should be allowed to give away what is his own, and the Father cannot bestow it at all except upon some other person.

Anselm. Upon whom would he more properly bestow the reward accruing from his death, than upon those for whose salvation, as right reason teaches, he became man; and for whose sake, as we have already said, he left an example of suffering death to preserve holiness? For surely in vain will men imitate him, if they be not also partakers of his reward. Or whom could he more justly make heirs of the inheritance, which he does not need, and of the superfluity of his possessions, than his parents and brethren? What more proper than that, when he beholds so many of them weighed down by so heavy a debt, and wasting through poverty, in the depth of their miseries, he should remit the debt incurred by their sins, and give them what their transgressions had forfeited?

Boso. The universe can hear of nothing more reasonable, more sweet, more desirable. And I receive such confidence from this that I cannot describe the joy with which my heart exults. For it seems to me that God can reject none who come to him in his name.

Anselm. Certainly not, if he come aright. And the Scriptures, which rest on solid truth as on a firm foundation, and which, by the help of God, we have somewhat examined,—the Scriptures, I say, show us how to approach in order to share such favor, and how we ought to live under it.

Boso. And whatever is built on this foundation is founded on an immovable rock.

Anselm. I think I have nearly enough answered your inquiry, though I might do it still more fully, and there are doubtless many reasons which are beyond me and which mortal ken does not reach. It is also plain that God had no need of doing the thing spoken of, but eternal truth demanded it. For though God is said to have done what that man did, on account of the personal union made; yet God was in no need of descending from heaven to conquer the devil, nor of contending against him in holiness to free mankind. But God demanded that man should conquer the devil, so that he who had offended by sin should atone by holiness. As God owed nothing to the devil but punishment, so man must only make amends by

conquering the devil as man had already been conquered by him. But whatever was demanded of man, he owed to God and not to the devil.

CHAPTER XX.

How great and how just is God's compassion.

Now we have found the compassion of God which appeared lost to you when we were considering God's holiness and man's sin; we have found it, I say, so great and so consistent with his holiness, as to be incomparably above anything that can be conceived. For what compassion can excel these words of the Father, addressed to the sinner doomed to eternal torments and having no way of escape: "Take my only begotten Son and make him an offering for yourself;" or these words of the Son: "Take me, and ransom your souls." For these are the voices they utter, when inviting and leading us to faith in the Gospel. Or can anything be more just than for him to remit all debt since he has earned a reward greater than all debt, if given with the love which he deserves.

CHAPTER XXI.

How it is impossible for the devil to be reconciled.

IF you carefully consider the scheme of human salvation, you will perceive the reconciliation of the devil, of which you made inquiry, to be impossible. For, as man could not be reconciled but by the death of the God-man, by whose holiness the loss occasioned by man's sin should be made up; so fallen angels cannot be saved but by the death of a God-angel who by his holiness may repair the evil occasioned by the sins of his companions. And as man must not be restored by a man of a different race, though of the same nature, so no angel ought to be saved by any other angel, though all were of the same nature, for they are not like men, all of the same race. For all angels were not sprung from one, as all men were. And there is another objection to their restoration, viz, that, as they fell with none to plot their fall, so they must rise with none to aid them ; but this is impossible. But otherwise they cannot be restored to their original dignity. For, had they not sinned, they would have been confirmed in virtue without any foreign aid, simply by the power given to them from the first. And, therefore, if any one thinks that the redemption of our Lord ought to be extended even to the fallen angels, he is convinced by reason, for by reason he has been deceived. And I do not say this as if to deny that the virtue of his death far exceeds all the sins of men and angels, but because infallible reason rejects the reconciliation of the fallen angels.

CHAPTER XXII.

How the truth of the Old and New Testament is shown in the things which have been said.

Boso. All things which you have said seem to me reasonable and incontrovertible. And by the solution of the single question proposed do I see the truth of all that is contained in the Old and New Testament. For, in proving that God became man by necessity, leaving out what was taken from the Bible, viz., the remarks on the persons of the Trinity, and on Adam, you convince both Jews and Pagans by the mere force of reason. And the God-man himself originates

the New Testament and approves the Old. And, as we must acknowledge him to be true, so no one can dissent from anything contained in these books.

Anselm. If we have said anything that needs correction, I am willing to make the correction if it be a reasonable one. But, if the conclusions which we have arrived at by reason seem confirmed by the testimony of the truth, then ought we to attribute it, not to ourselves, but to God, who is blessed forever.—Amen.

288